FRIDA BY FRIDA

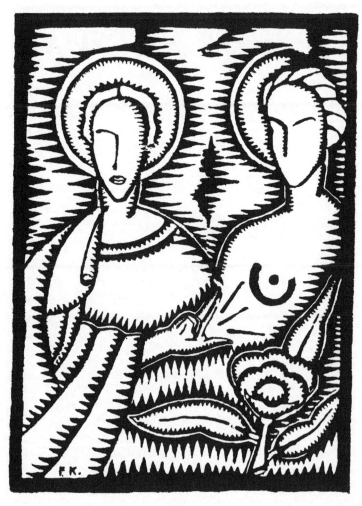

Caracol de distancias, *a volume of poems by Ernesto Hernández Bordes. Printed in October, 1933 at the FABULA printing press by Miguel N. Lira and Fidel Guerrero. Numbers 1 to 50 of the 250 copies printed were* hors commerce.

FRIDA

BY

FRIDA

SELECTION OF LETTERS
AND TEXTS, FORWARD AND NOTES BY
RAQUEL TIBOL

Translated by Gregory Dechant

MÉXICO · EDITORIAL RM

2003

Forward

On May 25, 1953 I arrived at the home of Frida Kahlo in Coyoacán, located at the corner of Allende and Londres (now the Frida Kahlo Museum). I was coming from Santiago de Chile in the company of Diego Rivera, after a brief detour to La Paz, Bolivia. In the Mexico City airport we had been received by Ruth Rivera Marín, Emma Hurtado, Elena Vázquez Gómez and Teresa Proenza. The group decided that I should live with Frida, who was plunged into an intense and uncontrollable anguish prior to the upcoming amputation of her right leg. Cristina Kahlo, who helped her sister as much as she was able, approved the proposal, which would allow her to take a rest from a surveillance that could not be interrupted until someone replaced her.

In Chile and during the long trip from South America, Rivera had infected me with his admiration for Frida, whose physical and spiritual state was rendering him desperate at the time. But he had not warned me of a densely morbid atmosphere, which would have required a certain preparation, a

spiritual passport to allow me to circulate with less strangeness in that singular environment my presence invaded so suddenly for visitor and hostess alike.

I tried to adapt myself to the unexpected circumstances by recourse to what had been my work in Santiago: cultural journalism. I suggested to Frida that she dictate her biography to me: she accepted enthusiastically and we soon set to work. The complicated consequences of an overdose of Demerol, which endangered the life of that "wounded -gravely wounded-deer", put an end to the project. When I came to understand that the complex interrelationships and tense energies of the house in Coyoacán were beyond my powers of assimilation, I decided on a change of scene.

The quality of those first biographical notes made me cherish the wish for some time to continue them. Towards February of 1954 I came to realize that that would not be possible and decided to publish what I had in the supplement *México en la Cultura* of the newspaper *Novedades*. It appeared, under the title "Fragmentos para una vida de Frida Kahlo" [Fragments for a Life of Frida Kahlo], on March 7, 1954. The complete text went to form part of my books *Frida Kahlo. Crónica, testimonios y aproximaciones* (1977) and *Frida Kahlo: una vida abierta* (1983) [English translation *Frida Kahlo: An Open Life* (1993)]. It is only necessary to consult what has since been written about Frida's life and work to confirm that the "Fragmentos" have been quoted again and again, with or without credit being given to their source. Entire paragraphs have been printed under other names. These appropriations are the fullest proof of the success of that account, a literal transcription of Frida's own words.

In 1974 I was able for the first time to publish some of the many letters addressed by Frida to her youthful passion,

Alejandro Gómez Arias, in an article entitled "Frida Kahlo a veinte años de su muerte" [Frida Kahlo Twenty Years after Her Death] (supplement *Diorama de la Cultura* of the newspaper *Excelsior*, July 14). The unreserved, imaginative language, heart and intimacy laid bare, led me to suppose that in Frida's writings there must be many compartments very different from those contained in the *Diario*, which, as is well known, is not a register of lived experience, but rather a series of allegories, oblique confessions, poetic compliments, complaints, in which verbal and visual expressions complement one another with surrealist intensity.

When Hayden Herrera in her major work *Frida: A Biography of Frida Kahlo* (1983) published numerous letters from Frida to friends and lovers, I realized it was necessary to gather everything written by her in strictly chronological order, whether letters, notes, messages, confessions, receipts, *corridos*, requests, protests, thank-you notes, entreaties and other more finished texts, in order to reap unequivocal fruits: a tacit autobiography and the placement of Frida within the intimate, confessional literature of the twentieth century in Mexico.

With the mythification of the figure of Frida in the last twenty years, I realized how difficult it would be to add to what had already been published and gain access to what is now (commercial successes in mind) guarded with excessive zeal. I have managed to obtain something, very little to be sure. But my aim was different, as I have explained: the sequence, the first-person discourse, without interpretations or over-interpretations, without the interference of other styles. I have placed what is undated where I suppose it should go.

Here the reader will find Frida's (incomplete) writings gathered and delivered to their fate, without any narrative or interpretive framework to support them. They do not need one.

Frida by Frida, swinging back and forth between sincerity and manipulation, self-complacency and self-flagellation, with her insatiable need for affection, her erotic upheavals, her touches of humor, setting no limits for herself, with a capacity for self-analysis and a deep humility.

I must thank those who gained access before I did to archives that I found already unlocked. I acknowledge my debts, which are numerous. I would ask that no one feel his or her rights have been abused in what is a question of taking one more step in the public construction of a figure who belongs to us all, because all of us have gone about laying bare her most hidden intimacy.

Frida took shelter under many roofs, occupied various lodgings, had numerous addresses, but she was born in the house in Coyoacán and she died there (July 6, 1907-July 13, 1954), in the family space that she managed to transform into her personal kingdom.

Raquel Tibol

TRANSLATOR'S NOTE

Frida Kahlo's letters and miscellaneous writings pose some formidable challenges to a translator. Apart from the author's fondness for complicated and, at times, virtually untranslatable word play, the letters reflect an astonishing variety of verbal registers, changing over time, as she grew from the candid and lively fifteen-year-old of the first letters to her adolescent passion into the invalid, tempered by countless sufferings, of the final years, and varying still more in accordance with her different correspondents. Like her paintings, Frida's language is a medium for that difficult conquest of liberty and self-realization to which she dedicated her life.

It is perhaps the Mexican context which places the most insurmountable obstacles in the path of the translator. First, the extreme richness of "off-color" language in Mexico, and the equally rich means to which a well-brought-up woman will recur in skirting it, euphemistically. Some of Frida's ploys are explained in the Translator's Notes; I have attempted to convey others in rather free renderings into English. In the case,

however, of some of Frida's favorite words, many of which possess a marked and unmistakable Mexican flavor, it was thought preferable to allow her to speak with her own voice. Little is to be gained, and much lost, by rendering the Mexican word *cuate* (derived from Nahuatl *coatl* "serpent", but also "twin") by its various English equivalents: friend, pal, buddy, etc. The problem is aggravated by Frida's transformation of the word through a series of Spanish augmentative and affective suffixes: *cuatucho* and *cuatacha*, *cuatezón*, etc. The same reasoning applies to many other terms, often of Nahuatl origin, that strongly evoke a traditional Mexican context or which themselves designate specifically Mexican realities. Some of these terms (rebozo, pulque, sarape, jarana, quesadilla, etc.) will pose no problem to many readers in the United States, and can in any case be found in Webster's Third New International Dictionary. Others that the reader will also encounter may be less familiar: *chamaco, chamaca* and *escuincle, escuincla* "boy, girl, kid"; *chilpayate* "infant, kid" *buten* "very much, extremely", a word particularly dear to Frida, of Spanish origin according to the lexicographer María Moliner but fallen into general disuse; *cursi* "corny, sentimental"; and even *novio, novia* "fiancé, fiancée" or simply "boyfriend, girlfriend", but with the implication of a courtship and commitment expected to lead to marriage in the Mexico into which Frida was born.

In the same spirit, I decided to leave Frida's verses in their original Spanish, and to offer a literal, rather than a literary, translation at the bottom of the page to aid the decipherment of those readers with a little Spanish. Ranging from the amiable doggerel addressed to Carlos Chávez to the haunting lines on the wounded deer that accompany one of her paintings, Frida's verses adopt the ballad-like form known as a *corrido* in Mexico. Ultimately derived from the poetry of the Spanish *romancero*, the

corrido gained wide popularity during the Mexican Revolution, which broke out shortly after Frida Kahlo was born, and employs a variety of conventions and verbal turns which are delightfully exploited and parodied in Frida's versions.

Apart from the letters written originally in English -a vigorous and expressive, if highly idiosyncratic, variety of English-, Frida liberally sprinkles her Spanish with English words and phrases. These have been indicated with an asterisk (*). A small number of Translator's Notes have been placed in italics at the end of some of the letters, after Raquel Tibol's annotations. They are marked *TN*.

[1]

MEMORY

I had smiled. Nothing more. But brightness was in me, and in the depths of my silence.

He was following me. Like my shadow, irreproachable and light.

In the night, there sobbed a song...

The Indians wound in long lines through the narrows streets of the village. Wrapped in sarapes, they moved with dancing steps, after drinking mezcal. A harp and a jarana were the music, and smiling dark-skinned women were the gaiety.

In the background, behind the Zócalo, the river shimmered. And moved on, like the minutes of my life.

He was following me.

I ended up weeping. Curled up in a corner of the parish churchyard, cloaked in my rebozo *de bolita*, which was drenched with tears.

౩ఞ

This piece of poetic prose was found by Dr. Luis Mario Schneider on page 61 of El Universal Ilustrado *(November 30, 1922).*

[2]

Note for Isabel Campos

[*Undated*]

Cuatezona of my heart.

Tell me for sure when you're coming to bathe so I can pick you up.

Sorry for not sending you the *knickers* till today, but the maid hasn't had time to drop them off.

You know that you and me, until the tomb, your powerful *cuate*.

Frieda

᠅

Isabel Campos (1906–1994) was born, like Frida, in Coyoacán. Their friendship was very close for thirty years, but gradually faded as Frida entered other circles.

[3]

LETTERS TO ALEJANDRO GÓMEZ ARIAS

{a}

December 15th, 1922

Alejandro: I am terribly sorry about what has happened to you and truly my heart goes out to you with my deepest condolences.

The only thing that as a friend I can advise you is to maintain a will strong enough to bear such sorrows, which Our Lord God sends us as an ordeal, since we have been put on earth to suffer.

I have felt this sorrow in my soul and I ask God to give you grace and strength enough to accept it.

Frieda

ᘓᑎ

The condolences to Alejandro Gómez Arias (Oaxaca, 1906 — Mexico City, 1990) are for the death of his father Gildardo Gómez, a medical doctor who was federal deputy for Sonora at the time. Gómez Arias recounted to Víctor Díaz Arciniega (Memoria personal de un país, Grijalbo, 1990)*: "My relationship with Frida Kahlo began in the Preparatoria (which she entered in 1920), where we were classmates. She had been a pupil at the Colegio Alemán and when she arrived at the Preparatoria, still very young, she dressed and possessed the mentality of a girl from that college... On her arrival at the Preparatoria she was very restive and very much against all family rules. So naturally, she sought out the friendship of those children least subject to discipline... She moved gradually closer to our group and finally formed part of Los Cachuchas, of whom she became the most interesting figure". In addition to Gómez Arias and Frida, the members of Los Cachuchas were: José Gómez Robleda, Miguel N. Lira, Ernestina Marín, Agustín Lira, Carmen Jaimes, Alfonso Villa, Jesús Ríos Ibáñez y Valle and Manuel González Ramírez.*

On the relationship between them, Gómez Arias explained: "Between Frida and me there was a certain intimacy; thus, the existence of the letters she sent me... We were young lovers, with neither the intentions nor the plans that a steady relationship creates, such as marriage and that sort of thing".

Coyoacán, August 10th, 1923

Alex: I received your letter at seven o'clock last night when I least expected anyone to remember me, and least of all Don Alejandro, but luckily I was mistaken. I can't tell you how thrilled I was that you trusted me as a true friend and spoke to me as you had never spoken to me before, for though you tell me with a touch of irony that I am so superior and so far from you, I understand the essence of those lines and not what other girls would understand... and you ask my advice, something I would give you with all my heart if my slight experience of 15 years were worth anything, but if good intentions are enough for you, then not only my humble advice is yours but my whole self.

Well then Alex, write me often and at great length, the longer the better, and meanwhile accept *all* my affection.

Frieda

P.S. Say hello to Chong Lee and your little sister.

ᘐ

Frida says she is 15 years old when in fact she had already turned 16. She was born in the Villa de Coyoacán on July 6, 1907. Chong Lee was the nickname of Miguel N. Lira. The name of Gómez Arias's sister was Alicia.

{c}

December 16th, 1923

Alex: I'm so sorry I didn't make it to the university at four o'clock yesterday, my mother wouldn't let me go to Mexico City because they'd told her there was going to be trouble. What's more, I didn't enroll and now I don't know what to do. I beg you

to forgive me, though you'll say I was very rude, but it wasn't my fault; as much as I tried, my mother had it in her head not to let me go out, so what was there to do but grin and bear it.

Tomorrow Monday I'm going to tell her I have my modeling exam and have to spend the whole day in Mexico City, it's not at all sure, since first I have to see what kind of mood my dear Mommy is in and then make up my mind to tell the lie; if I go, I'll see you at eleven-thirty at the Law School, wait for me please on the corner with the ice-cream parlor so you don't have to go to the university. The *posada* is still going to be at the Rouaix's house, the first one, that is, right now; I'm determined not to go, but who knows at the last minute...

But now that we're going to see each other so little, I want you to write me Alex because otherwise I'm not going to write you either and if you have nothing to say to me send me blank paper or say the same thing 50 times, but that will show me that you remember me at least...

Well then, lots of kisses and all my affection.

<div align="right">Yours
Frieda</div>

Excuse the change of ink.

<div align="center">{d}</div>

<div align="right">December 19th, 1923</div>

[...] I'm angry for I've been punished because of that idiotic *escuincla* Cristina, because I gave her a smack (because she'd taken some of my things) and she started to bawl for half an hour and then they gave me a hiding I'll never forget and they didn't let me go to the *posada* yesterday and they barely let me out on the street, so I can't write you much, but even so I'm

writing you so you'll see that I always remember you, though I'm sadder than can be, since just imagine, not able to see you, punished and not doing anything all day because I'm so angry. Just now in the afternoon I asked my mother for permission to come to the plaza to buy a snack and I came to the post office... so I could write you.

Lots of kisses from your *chamaca* who misses you a lot. Regards to Carmen James and Chong Lee (please).

<div align="right">Frieda</div>

Frida changes the name of Carmen Jaimes to Carmen James.

<div align="center">{e}</div>

<div align="right">December 22nd, 1923</div>

Alex: I couldn't write you last night because it was very late when we got back from the Navarros', but now I do have plenty of time to devote to you; the dance that night was so-so, or rather lousy, but we had a bit of fun in the end. Tonight there's going to be a *posada* at Mrs. Roca's, and Cristina and I are going there to have lunch, I think it will be very pleasant, because lots of girls and boys are going and Mrs. Roca is very nice. Tomorrow I'll write you and tell you how it was.

At the Navarros' dance I didn't dance much because I wasn't in a very good mood. Rouaix was the one I danced with most because the rest were very disagreeable.

There's also a *posada* now at the Rochas' but who knows if we'll go...

Write me, don't be mean.

<div align="right">Lots of kisses</div>

<div align="right">Your Frieda</div>

Someone lent me *The Portrait of Dorian Gray*. Please send me Guevara's address so I can send him his Bible.

࿐

Frida had five sisters: María Luisa and Margarita, children from Guillermo Kahlo's first marriage, and Matilde, Adriana and Cristina, born of his union with Matilde Calderón.

{f}

January 1ˢᵗ, 1924

My Alex:

[...] Where did you finally spend New Year's? I went to the Campos' and it was so-so, since we prayed almost the whole time and afterwards since I was very sleepy I fell asleep and didn't dance at all. I took communion this morning and prayed to God for all of you...

Just imagine, I went to confession yesterday afternoon and I forgot three sins and I took communion even so and they were big ones, now who knows what I'll do, but the fact is I've got it into my head not to believe in confession, and even if I want to, I can't confess properly anymore. I'm very silly, right?

Well, my life, let it go on record that I wrote you. I suppose it's because I don't love you at all.

Your Frieda

Forgive me for writing you on such *cursi* paper, but Cristina traded it to me for some white and even though I later regretted it what's there to do. (It's not so ugly, so ugly.)

࿐

The reference is to the family of Isabel Campos, Frida's closest friend among the young people of Coyoacán.

19

April 16th, 1924

[...] The exercises of the retreat were beautiful because the priest who directed them was very intelligent, almost a saint. At general communion we were given the papal blessing and many indulgences were granted, as many as one wished, I prayed for my sister Maty, and as the priest knows her he said he would also pray a lot for her. I also prayed to God and the Virgin Mary that everything will turn out well for you and that you will always love me, and for your mother and your little sister. [...]

۰ٮ

When Matilde Kahlo Calderón was eighteen years old, in 1923, Frida helped her run away to Veracruz with her boyfriend. Frida recalled (Raquel Tibol: "Fragmentos para una vida de Frida Kahlo", supplement México en la Culture *of the newspaper* Novedades, *Mexico City, March 7, 1954): "Matita was my mother's favorite and her flight drove her hysterical. When Mati left, my father didn't say a word. He had such mettle that it was difficult to believe he was an epileptic... We didn't see Mati for four years. One day, in a tram, my father said to me: 'We'll never find her!' I consoled him and my hopes were truly sincere... A classmate in the Preparatoria mentioned to me: 'There's a woman living in the Doctores neighborhood who looks exactly like you. Her name is Matilde Kahlo'. At the end of a courtyard, in the fourth room down a long corridor, I found her. It was a room full of light and birds. Matita was taking a bath with a hose. She lived there with Paco Hernández, whom she later married. They were well off and had no children. The first thing I did was to tell my father I had found her. I visited her several times and tried to convince my mother they should see each other, but she didn't want to".*

Day of the Gringos (July 4th), 1924

[...] I just don't know what to do to find a job, because that's the only way I could see you as before, daily, at school.

{i}

August 4th, 1924

[…] I'm sad and bored in this village. Though it's rather picturesque, a certain *I don't know who* is missing, who goes to the Iberoamérica every day. […]

ॐ

The reference is to the Biblioteca Iberoamericana (the library) of the Ministry of Education.

{j}

Alejandrito:

They tell me you're very sad and worried about a wireless radiotelephony invention because you're suffering from migraines at night and that's why I'm sending you this medicine, eh?

[*Two small drawings. A young man in front of a speaker and Frida standing beside him.*] My last portrait. I'm giving a concert and you're listening to it on your apparatus. Air waves.

[*A drawing of a tram with a conductor and girls trying to climb onto it as it moves away, houses in the background.*] Here Reynita and I are riding for free on a Peralvillo tram. It's a magnificent photograph of the kind you like. That's how the houses looked to us. Girls who are going to fall off.

[*A drawing of piles of books, a mouse and a figure before a bookshelf.*] As I would like to be when you are very very happy. It's not nougat, they're books. A little mouse that has made its nest in a book by Anatole France. You reading Don Ramón of the Goatee.

<div align="right">Your friend

Friedita</div>

ॐ

The reference is to the Spanish writer Ramón del Valle-Inclán.

21

Monday, August 18th, 1924, 8 o'clock at night

Alex: This afternoon when you called on the phone I couldn't be in the dairy at three-thirty on the dot, but they came to get me and when I arrived the receiver had been hung up and I couldn't talk to you, forgive me Alex, but you can see it wasn't my fault.

Look how I went completely broke this afternoon, because when I left the dentist's I went to buy a sucker at "La Carmela", remember, where we bought one the last time, and when I was buying it in came Rouaix and gave me a shove and I broke the glass on the counter, so we're both going to be broke, because now we have to pay 2.50 each, but since he's going to the USA on the 1st he tells me now I have to face the music because he's going to stick me with the bill. Things were working out just fine but nothing to do, now I'll have to pawn something to pay my half, don't you think? Hey, in ten days or so there's going to be a big dance at your *cuate* Chelo's place and it's going to be a costume ball, so I'll have to go and get something to wear and that will be a pretext to take a little walk with the owner of Panchito Pimentel, right?

If I can't see you these days, come to the village, call me on Wednesday at three-thirty, I'll be sure to be there, eh? But first answer this letter as soon as you can little brother, because if not, you know, I'm going to think you don't care for the young lady who asked you if they had laid flat the damsel of the train in question: and that really is terrible. So long without speaking and by surprise!

Now I'm going to read *Salammbô* until ten-thirty, it's 8 o'clock now, and then the Bible in three volumes and, finally, to think for a bit about *buten* scientific problems and then get into bed to sleep until seven-thirty in the morning, eh? Until tomorrow, I wish us both a good night and hope we both think about how great *cuates*

should love each other very much, much, much, much, much, much, much, much.......... with m as in music or in moon.

Major premise.- Great *cuates* should love each other very much.

Minor premise.- Alex and Frida are great *cuates*.

Conclusion.- Therefore Alex and Frieducha should love each other very much.

Mark 4. *M. Cevallos.*

A little kiss without Pancho Pimentel's lot raising a ruckus.

A damsel who loves you more than ever.

<div align="right">Frieda</div>

[*A small drawing of her head on a pedestal.*] Statue of your *cuata*. I've got such a small snout I was almost born with my head chopped off.

[*Drawing of a heart pierced by an arrow.*] I love you very much, etc., kisses.*

<div align="center">{1}</div>

<div align="right">September 14th, 1924</div>

[*Beside a drawing of a woman's head with stylized traits.*]
Don't tear it out because it's very pretty... From this little doll you can see how I'm progressing in drawing, right? Now you know I'm a prodigy as far as art is concerned! So be careful in case the dogs get close to this admirable psychological and artistic study of a "payChekz"* (*one** ideal type).

<div align="center">{m}</div>

<div align="right">[*Drawing of a cat curled up on its back*] Other* ideal type</div>

<div align="right">September 20th, 1924</div>

My Alex:

I can see you don't want to write me, so let's see if maybe you

feel like answering this letter that I am sending you today on this September 20th.

This morning when I went to see you, you were very serious, but since I couldn't say anything in front of Reyna, I'm writing you now to ask you why you were so serious with me, because perhaps it was nothing but my own worrying or maybe it really happened.

Listen Alex, if you get this letter Monday morning, maybe I can go and see you in the Library and if I don't go it's because I had to go to Tlalpan and in that case I'll see you for sure on Tuesday in the Ibero or wherever else you are good enough to tell me, if it's no bother, because for my part I wish to be with you very much, but who knows if it bores you a lot to talk with this *novia* of yours who loves you very much but is a bit of a dunce.

Today my ears started ringing twice and I asked for a number and was told 7th, I hope it was you who were thinking about Me....lvin of I.

Your darling Friducha. One kiss.*

Please write me. Sorry about the paper.

{n}

Thursday, December 25th, 1924

My Alex: I have loved you since I saw you. What do you say? Since we're probably not going to see each other for a few days, I beg you not to forget your lovely little woman, eh?... Sometimes I'm very afraid at night and I would like you to be with me so you wouldn't let me be so fearful and would tell me you love me as before, as last December, though I'm an "easy thing", right Alex? You have to start liking easy things... I would like to be still easier, a tiny little thing that you could just carry around in your pocket

for ever and ever… Alex, write me often and even if it's not true
tell me you love me very much and can't live without me…
Your child, *escuincla* or woman or whatever you want.

Frieda

On Saturday I'll take you your sweater and your books and a
bunch of violets, because there's lots in the house…

{o}

Answer me, answer me, answer me, answer me, answer me.
" " " " "
" " " " "
" " " " "

Have you heard the news? There are no more *pelonas*.

January 1st, 1925

My Alex: I picked up your letter this morning at eleven
o'clock, but I didn't answer you right away because as you will
understand one can't do anything when one is surrounded by
people; but now that it's 10 o'clock at night and I am alone
with my soul, it's the fittest moment to tell you what I think.
(Though I don't have a head line on my left hand. S. Mallén.)
Concerning what you say about Anita Reyna, naturally I
wouldn't be angry in the least, firstly because you're only telling
the truth, that she is and always will be very pretty and very love-
ly, and secondly because I love everyone you love or have loved
(!) for the very simple reason that you love them. Nevertheless,
I didn't much like that part about the caresses, because even
though I understand that she is very lovely, I feel something
like… well, how can I put it? like envy, you know? but that's
only natural. Whenever you feel like caressing her, even if it's

just a memory, caress me instead and just pretend it's her, eh? My Alex? You'll say I'm very demanding, but there's no other way to console me. I know that even if there's a very lovely Anita Reyna, there's another no less lovely Frida Kahlo, since Alejandro Gómez Arias likes her according to him and her. Anyway Alex, I loved the fact that you were so frank with me and told me you thought she looked nice and that she looked at you with the same hate as ever; it shows you're a bit different and that you remember with affection those who you imagine have not loved you... something that is sure to happen to me who have loved you more than I have ever loved anyone, but since you're a really good *cuatezón* to me you're going to love me even if you know I love you a lot, right Alex?

Listen little brother, now in 1925 we're going to love each other a lot, eh? † Sorry about constantly repeating the word "love", five times in a row, but it's just that I'm very silly. Don't you think we're arranging the trip to the *United States** just fine? I want you to tell me what you think of our going in December of this year, there's plenty of time to arrange everything, don't you think? Tell me all the pros and cons you find and whether you can really go; because look Alex, it would be good for us to do something in life, don't you think? Since we're just going to be like a couple of fools here in Mexico all our lives; since there's nothing lovelier than traveling for me, it really makes me suffer to think I don't have enough will-power to do what I'm telling you; you'll say you don't need just will-power, but first of all money-power or cash, but that can be gotten by working for a year and then the rest is easier, right? But since, to tell you the truth, I don't know much about these things, it would be best if you told me what advantages and what disadvantages there are and if the gringos are really so awful. Because you have to realize that in all this that I'm writing you, from the little cross to *this**

line, there are a lot of castles in Spain and it would be best if you undeceived me once and for all in order not to see beyond good and evil. (Because I'm still a bit of a dunce, believe me.)

At 12 o'clock midnight I thought of you my Alex, and you? I think so because my left ear was ringing. Well, since you know "a New Year a new start", your little woman's not going to be a two-bit shrew this year, but the best and sweetest that has been known to exist till now so you can eat her up with nothing but kisses.

Your *chamaca* Friduchita who adores you.

Answer me and send me a kiss.
(Happy New Year to your mother and sister.)

∽

S. Mallén is Rubén Salazar Mallén (1905-1986), a lawyer and writer who combined journalism with an academic career. Gómez Arias would marry his sister Teresa Salazar Mallén.

{p}

January 8th, 1925. Thursday

Alex (insured property): I've been *buten* sad because you're sick and I would have liked to have been at your side the whole time, but since that can't be I just have to grin and bear it till you get better, which I hope will be very soon.

These days in the mornings I've been going to the old man's office and in the afternoon I was at your *cuate* Reynilla's, as you will doubtless have guessed when you received the little package I sent you with the maid or maidservant of Reynis, right?

Last night the only one I saw was Salas who told me you had wished him happy New Year in a *buten* extravagant and amusing way, and he even thought you and I had done it together, but since I didn't know anything about it I told him it must surely

have been you, because it would be odd that anyone else had thought of doing it in such an original and clever way. (You must already know what the greeting was so I don't need to explain.)

The day before yesterday I really didn't see anyone except Reyna and we went looking for decorations for the little theater that is going to be called Teatro-Pello and trying the surest way to get some work we sent Chola a telegram of the following extravagance:

Dear Miss:

Students respectfully beg you to be so good as to grant them an interview.

Reply to Pimentel 31. Misses A. Reyna and F.K.

I think we just gave away our 50 centavo piece to the telegraph operator, but the important thing is to try. Monday at 8:30 in the morning we're going to start taking classes in shorthand and typing at the Oliver so that we're not so thick on that question, but even so I'm sadder than What'll it be? because I just can't get any work at all quickly and time is flying. The *Güera* Olaguíbel is probably going to work in El Globo de Palavicini and the other day when I met her on the bus she told me she was being offered a job in the Education Library, but she needed a letter of recommendation from one of those big shots, and if I could get one she would let me have the job because she's almost sure to have something in El Globo, and that's why I want to see Chola or see whoever the hell I see to do me the favor. They pay 4 or 4.50, which doesn't seem bad to me at all, but first of all I need to know something about typewriters and scribbling. So that's how it is, just look how dense your friend is!

But right now the only thing I want is for you to get better and all the rest is in 5th and 6th place, because in 1st to 4th place is that you get better and that you love me, etc., etc. I

must have bored you to death with so many things, so I'll say good-bye now but I'll be back soon (Song of the Woodpecker). Write to Chong Lee to say hello to me in your letters and write to me yourself or if you're all better tell me when you're going to go out to be able to go and see you because you can see I'm a real crybaby and if I don't see you I won't be able to help myself from weeping like Saint Peter.

For you to get better very very soon and to think a little bit about me, that's what your sister (*novia*, *cuata*, wife) wants.

Frieda

Answer me right away in letters of condolence because I like them a lot.

{q}

January 15th, 1925

[...] Tell me if you don't love me anymore Alex, I love you even if you don't care for me any more than for a flea. [...]

{r}

July 25th, 1925

[...] Tell me what's new in Mexico City, in your life and anything you'd like to talk about, because you know that here there's nothing more than fields and fields, Indians and more Indians, huts and more huts from which one can't escape, so even though you don't believe me I'm bored with b as in burro... when you come for the love of God bring me something to read, because I'm becoming more and more ignorant every day. (Forgive me for being so lazy.)

{s}

[...] During the day I work in the factory I told you about, while I look for something better, because there's nothing else to do, imagine how I must be, but what's there to do? Though the work doesn't interest me in the least, it's not possible to change it for the moment and I'll have to bear it somehow...

I'm prey to the most terrible sadness, but you know that not everything is as one would like it to be and what's the point of talking about that. [...]

{t}

Tuesday, October 13ᵗʰ, 1925

Alex of my life:
You know better than anyone how sad I have been in this filthy hospital, since you must imagine it, and also I suppose the boys have told you. Everyone tells me not to despair; but they don't know what it is for me to be in bed for three months, which is what I need to be, after having been a first-class stray cat all my life, but what's there to do, since the *pelona* didn't carry me away. Don't you think?

Imagine how anxious I must have been not knowing how you were that day and the day after; after I had been operated on, Salas and Olmedo arrived; it was certainly good to see them! Especially Olmedo, you have no idea; I asked them about you and they told me what had happened was very painful, but not serious and you don't know how I have cried for you my Alex, at the same time as for my pains, because I'm telling you in the first treatments my hands felt like paper and I sweated from the pain of the wound... which went right through my hip and out the front; I was all but left a ruin for the rest of my life or

30

almost died, but now it's all over, one wound has closed, and the doctor says the other will soon close. They must have explained to you what I have, right? and it's all a question of lots of time for the fracture in my pelvis to close, and for my elbow to get better and for the other small wounds in my foot to heal...

A "crowd of folk" and a "cloud of smoke" have come to visit me, even Chucho Ríos y Valles asked about me several times by telephone and they say he came once, but I didn't see him... Fernández is still giving me some dough and it turned out I have even more talent for drawing than before, since he says that when I get better he's going to pay me 60 a week (just empty talk, but anyway), and all the gang from the village come to visit every day and Señor Rouaix even started crying, the father, eh, don't think it was the son, and well, you can imagine how many others...

But I would give anything, instead of all the people from Coyoacán and instead of all the old women who also come, if you came one day. I think the day I see you Alex, I'm going to kiss you, there's no help for it; now I see more than ever how I love you with all my soul and I won't trade you for anyone; you see how suffering something is always worthwhile.

In addition to having been pretty mangled physically, even though as I told Salas I don't think it's too serious, I have suffered very much emotionally, since you know how ill my mom was, just like my dad, and dealing them this blow hurt me more than forty wounds; just imagine, my poor little mother says she cried like a madwoman for three days, and my dad, who was getting much better, got very ill. They have only brought my mom to see me twice since I've been here, 25 days today which have seemed like a thousand years to me, and my dad once; so I want to go home as soon as possible; but that won't be until the swelling goes down completely and all the wounds heal, so there's no chance of infection

and so I don't go… to ruin. What do you think? In any case I don't think it will be longer than this week… anyway I'm counting the hours as I wait for you wherever, here or at home, because that way, seeing you, the months in bed will go by much faster.

Listen, my Alex, if you can't come yet write to me, you can't know how much your letter helped me feel better, I think I've read it twice a day since I got it and it always seems as if it were the first time I'm reading it.

I have lots of things to tell you, but I can't write them because I'm still very weak, my head and eyes ache when I read or write a lot, but I'll tell you them soon.

Changing the subject, I'm hungry like I can't tell you brother… and I can't eat anything but some disgusting things so be forewarned; when you come bring me some gumdrops and a *balero* like the one we lost the other day.

Your *cuate* who has grown as thin as a rake.

<div align="right">Friducha</div>

(I was very sad about the parasol!) Life begins tomorrow…!

-I adore you-

<div align="center">ᔓ</div>

Frida described her accident to me as follows ("Fragmentos…"): The buses of my time were absolutely flimsy; they were just beginning to circulate and were very popular; the trams circulated empty. I got on the bus with Alejandro Gómez Arias. I sat down along the side, beside the guardrail, and Alejandro beside me. Moments later the bus collided with a tram of the Xochimilco line. The tram flattened the bus against the corner. It was a strange collision; it wasn't violent, but rather dull, slow and injured everyone. And me much more. I remember that it occurred on exactly September 17, 1925, the day after the festivities on the 16th… The collision happened shortly after getting on the bus. We had taken another bus before; but I had lost a parasol; we got off to look for it, and that's how it happened that we came to get on that bus that destroyed me. The accident occurred at a corner, across from the San Juan market, exactly across… The first thing I thought

about was the brightly-colored balero *I had bought that day and that I was carrying with me. I tried to look for it, thinking all that would be without consequences".*

The music student Ángel Salas and the engineering student Agustín Olmedo formed part of the circle of mutual friends. Frida did a portrait of Olmedo in 1928.

Shortly before the accident Frida had entered the workshop of the printer Fernando Fernández as an apprentice engraver.

{u}

Tuesday, October 20ᵗʰ, 1925

My Alex:

I got to the village at one o'clock on Saturday; Salitas saw me leaving the hospital and he must have told you how I came, right? They brought me very slowly, but even so I had two days of an infernal inflammation, but now I'm feeling better to be at home and with my mother. Now I'm going to explain everything I have, as you say in your letter, without leaving out a single detail; according to Dr. Díaz Infante, who was the one who treated me at the Red Cross, there's no danger and I'm going to be more or less fine; the right side of my pelvis is out of line and fractured, I had a dislocation and a small fracture, and the wounds I told you about in the other letter; the biggest one went right through my hip between my legs, so there were two, one which has already closed and the other which is about two centimeters long and one and a half deep, but I think it will close very soon, my right foot full of very deep scrapes and something else is that it's the 20ᵗʰ and F. Moon hasn't come to visit me and that is extremely serious. Dr. Díaz Infante (who is a dear) didn't want to keep treating me because he says Coyoacán is very far away and he couldn't leave a patient and come when I called, so they have changed him for Pedro Calderón of Coyoacán. Do you remember him? Well then, since every doctor says something different about the same

illness, of course Pedro said everything was quite fine, except my arm, and he doubts very much whether I'll be able to stretch out my arm, because the joint is fine but the tendon is contracted and doesn't allow me to open my arm toward the front and if I managed to stretch it, it would be very slowly and thanks to lots of massage and hot baths; you have no idea how it hurts, I cry a pint of tears every time he jerks me, in spite of what they say about not believing a limping dog and a weeping woman; my foot also hurts a lot, since you have to realize it's all beat up and also I have horrible shooting pains all up my leg and I'm very uncomfortable, as you can imagine, but they say with rest it will heal soon, and little by little I'll be able to walk.

How are you and I also want to know exactly, since you can see that there in the hospital I couldn't ask the gang anything, and now it's much more unlikely I'll see them, but I don't know if they'll want to come to my house... and I don't suppose you want to come either... what's needed is for you not to be ashamed to see any of my relatives and still less my mother. Ask Salas how nice Adriana and Mati are. Now Mati can't come very often to the house, since every time she comes my mother gets upset, and the day she comes my mother doesn't come in, poor thing, after behaving so well to me this time, but as you know everyone has their own ideas and there's no help for it, you have to accept it. So I'm telling you, it's not fair that you just write me and don't come to see me, because it would hurt me as nothing in my life has hurt me. You can come with the rest of the gang one Sunday or whatever day you like, don't be mean, just put yourself in my place: laid up for five (5) months and just for good measure dreadfully bored, since except for the flock of old ladies who come to see me and the *escuincles* from around here, when from time to time they remember I exist, I have to be all by my lonesome and I suffer much more, look, only Kity, whom you know,

34

is with me, and that's all, I tell Mati to come whenever you want and she knows the gang and is very nice, Adriana too, the *Güero* isn't here, neither is my father, my mother doesn't say anything to me, I don't understand why you are ashamed since you haven't done anything; every day they take me out onto the veranda in my bed, because Pedro Calderas wants me to get fresh air and sun, so I'm not so shut in as in that dreadful hospital.

Well, my Alex, I'm tiring you and I'll say goodbye in the hope of seeing you very very soon, eh? don't forget the *balero* and my candies, I'm warning you I want something edible because now I can eat more than before.

Regards to your folks and please tell the gang not to be mean and forget me just because I'm at home.

<div align="right">Your chamaca</div>

<div align="right">Friducha</div>

<div align="center">∿</div>

About her sister Matilde's reaction to the accident Frida remembered ("Fragmentos..."): "Matilde read the news in the papers and was the first person to arrive [at the Red Cross] and she didn't abandon me... day and night at my side".

The letter was written 33 days after the accident; the five months Frida refers to are the time she was told she would have to stay in bed. The Güero to whom she refers must have been Alberto Veraza, the husband of her sister Adriana. By the name F. Moon, Frida designated menstruation. Pedro Calderas is Dr. Pedro Calderón.

<div align="center">{v}</div>

<div align="right">Monday, October 26th, 1925</div>

Alex: I just got your letter, and though I was expecting it much sooner, it did a lot to get rid of the pains I had, since just imagine, yesterday Sunday at nine o'clock they chloroformed me for the 3rd time to bring down the tendon in my arm, which as I told

you is contracted, at 10 the chloroform wore off and I was screaming until six in the afternoon when they gave me an injection of Sedol and that didn't do a thing, because the pains continued but a little less acute, then they gave me some cocaine, and that caused them to die down a bit, but the queaziness (I don't know how to spell it) didn't leave me all day, I threw up green, pure bile, because just imagine the other day when Mati came to see me, my mother had an attack and I was the first one to hear her cry out and since I was asleep, I forgot for a moment that I was ill and I wanted to get up but I felt a terrible pain in the abdomen and such a frightful anxiety that you cannot imagine, Alex, because I wanted to stand up and couldn't until I called Kity and all this did me a lot of harm and I'm very nervous. Well, I was telling you that I didn't do anything all last night but throw up and it was horribly upsetting; Villa came to see me, but they didn't let him into my bedroom, because I was very uncomfortable with these pains. Verastigué also came but I didn't see him either. Now this morning I woke up with an inflammation where I have the fracture in the pelvis (how I hate that name), and I didn't know what to do, since I would drink water and throw it up because of the same inflammation in the stomach from screaming so much yesterday. Now I don't have a headache anymore, but I tell you I'm desperate from being in bed so long and in the same posture; I would like to be able to start sitting up even little by little, but I have no choice but to endure it.

As for those who come to see me, I'll tell you they are not so very few, but they aren't the 3rd part of those I like best; a crowd of old ladies and girls who come less out of affection than out of curiosity; the boys are all those you can imagine... but they don't even keep me from being bored during the time they are with me; they go through all the drawers, they want to bring me a victrola; just imagine the *güera* Olaguíbel brought me hers and since

Lalo Ordóñez arrived on Saturday from Canada he brought some pretty nice records from the United States, but I can't bear more than one piece, since by the 2nd my head is aching; the Galáns come almost every day and so do the Camposes, the Italians, the Canets, et cetera, all Coyoacán; among the more serious are Patiño and Chava, who brings me books like *The 3 Musketeers*, et cetera, you can imagine how glad I must be; I've told my mother and Adriana that I want you to come, that is, you and the rest of the gang (I forgot)... Listen Alex, I want you to tell me what day you're going to come so that if by chance a crowd of old ladies wants to come the same day I won't receive them, because I want to talk to you and no one else. Please tell Chong Lee (the Prince of Manchuria) and Salas that I'm very eager to see them as well, and not to be mean and not come and see me, etc., the same to Reyna, but I wouldn't want Reyna to come the same day as you, since it's no use having to talk to her without being free to talk to you and the rest of the gang; but if it's easier to come with her, you know that as long as I can see you it wouldn't matter if you came with the *puper** Dolores Ángela...

Come soon Alex, as soon as you can, don't be mean to your *chamaca* who loves you so.

Frieda

じつ

About her mother's fits of hysteria, Frida explained ("Fragmentos..."): "My mother was hysterical from dissatisfaction... because she was not in love with my father... she showed me a book bound in Russia leather where she kept the letters of her first sweetheart. On the last page she had written that the author of the letters, a young German, had committed suicide in her presence. This man lived forever in her memory... My mother arrived at hysteria through religion".

Among Frida's closest friends were Esperanza Ordóñez and Agustina Reyna.

37

November 5th, 1925

Alex: You will say I haven't written you because I don't remember
you, but that's not it at all; the last time you came you told me you
would return very soon, one of these days, isn't that right? I have
done nothing but wait for that day which hasn't yet arrived...

Pancho Villa came on Sunday, but F. Moon hasn't put in
an appearance yet, I'm losing hope. Now I'm sitting up in an
armchair and I'm sure to able to stand up by the 18th, but I
don't have any strength at all, so who knows how I'll get along;
my arm is still the same (nor fore nor aft), I'm *buten* desperate
now with d as in dentist.

Come see me, don't be so mean, *hombre*, it's unbelievable
that now that I need you most you turn a deaf ear; tell Chong
Lee to remember Jacobo Valdés who said so beautifully: on the
sickbed and in prison you find out who your friends are. And
I'm still waiting for you.

[...] If you don't come it's because you don't love me at all,
eh? Meanwhile, write me and receive all her affection from
your sister who adores you.

Frieda

ڑ

Both Frida and the other Cachuchas took pleasure in the invention of words and grammatical and
verbal alterations. Gómez Arias explained the term as follows (Memoria personal...): "The
name Los Cachuchas came from the fact that instead of hats we wore caps. As simple as that, but
as subversive as that, because the custom of wearing a hat or "spool", depending on the time of
year, was very rigid, even for students of the Preparatoria. José Gómez Robleda, who among other
things was a tailor, supplied us with the caps. He sewed them and gave them to us as gifts".

{x}

November 12th, 1925

November 12th, 1925

[...] At seven o'clock on Sunday there is sure to be a mass to give thanks for the fact that I survived and it will be my first outing; but afterwards I want to go out on the street, even if it's just for a few steps and perhaps you would like it if we took a stroll through the village, would you like to?

{y}

Thursday, November 26th, 1925

My beloved Alex: I can't explain everything that is happening now, just imagine my mother had an attack and I was with her, because Cristina went out when you came, and the rotten scullery maid told you I wasn't home, and I'm so angry you can't imagine; I so wanted to see you, to be alone with you for a while, as we haven't been for such a long time, that I feel like saying all the *picardías* I know to the miserable, accursed scullion; afterwards I went out on the balcony to call you and sent her to look for you, but she couldn't find you, so there was nothing left but to cry from mere anger and suffering. [...]

Believe me Alex, I want you to come and see me because I'm just a mess and all I can do is endure it, since it would be worse if I despaired, don't you think? I want you to come and talk as before, to forget everything else and come and see me for the love of your blessed mother and to tell me you love me even if it's not true, eh? (the pen doesn't write very well with so many tears).

I would like to tell you many things, Alex, but I feel like crying and the only thing I can do is convince myself that you're going to come. [...] Forgive me, but it wasn't my fault you came in vain, my Alex.

Write me soon.

<div style="text-align:center">Your beloved Friducha</div>

<div style="text-align:center">{z}</div>

Alex: Yesterday I went to Mexico City just for a visit; the first thing I did was go to your house (I don't know if that was a good or a bad thing to do), but I went because I sincerely wanted to see you. I went at 10 and you weren't there, I waited for you until a quarter past one in the libraries, in the store, I went back to your house at four and you weren't there then either; I don't know where you can have been. What? Is your uncle still sick?

I spent the whole day with Agustina Reyna; from what she said, she doesn't like to spend much time with me because you told her she was the same or worse than I am, and that's a great discredit to her, and I think she's right, because I'm starting to realize that "Mr. Olmedo" was speaking the truth when he said I'm not worth a "centavo", that is, for all those who once called themselves my friends, because, for myself naturally, I'm worth much more than a centavo, because I love myself the way I am. [...]

She says that on various occasions you have told her some of the things I have told you, details that I never told Reyna because there was no reason for her to know them and I don't understand your reason for telling them to her. The fact is that no one wants to be my friend because I have such a bad reputation, which is something I can't help. I'll just have to be a friend to those who love me as I am. [...]

Lira told the lie that I had given him a kiss and if I continue the list I would fill whole pages; naturally all this affected me at first, but later it started not to matter at all (that was precisely the problem), you know?

<div style="text-align:center">40</div>

From all of them, Alex, I would have considered it of no importance at all, because it's what *all of them* do, do you understand?, but I will never forget that you, whom I have loved as I love myself or more, thought of me as a sort of Nahui Olín or even worse than her, who is an example of all that type. Every time you have told me you don't want to speak to me anymore, you have done it as though you were taking a weight off yourself. And you had the courage, Alex, to insult me, saying I had done certain things with someone else the day I did it for the first time in my life because I loved you as I have loved no one else.

I'm a liar because no one believes me, not even you, and so little by little and without noticing, one is sent to the devil by all. Well, Alex, I would like to tell you everything, everything, because I do believe in you, but the pity is that you will never ever believe in me.

I'll probably go into Mexico City, if you want to see me I'll be at the door of the library of the Ministry of Education at 11. I'll wait for you till one.

<div style="text-align:center">Yours, Frieda</div>

<div style="text-align:center">ઝ</div>

Nahui Olín (Carmen Mondragón, 1893-1978), poet, painter and painters' model. She had given by that time numerous and very public instances of her enthusiastic adhesion to the concept of free love.

<div style="text-align:center">{aa}</div>

<div style="text-align:right">December 26th, 1925</div>

[...] I start work on Monday, that is, not this coming Monday but the following. [...]

December 27th, 1925

[…] I can't stop speaking to you for anything in the world. I won't be your *novia*, but I will always speak to you even if you treat me in the worst way […] because I love you more than ever, now that you are leaving me. […]

[4]

Card from 1926

LEONARDO

BORN IN THE RED CROSS IN THE YEAR OF OUR
LORD 1925 IN THE MONTH OF SEPTEMBER AND
BAPTIZED IN THE VILLA OF COYOACÁN
THE FOLLOWING YEAR

HIS MOTHER WAS
FRIDA KAHLO
HIS GODPARENTS WERE
ISABEL CAMPOS AND
ALEJANDRO GÓMEZ ARIAS

LETTERS TO ALEJANDRO GÓMEZ ARIAS

{a}

February 19th, 1926

[...] willing to make any sacrifice to do this for you, since with it I would compensate a little the harm I have done you [...] in exchange for all I have been unable to give you, I'm going to offer you the only thing I would give to you alone and no one else, I will be yours, whenever you want, so that you have that at least as proof to justify me a little bit. [...]

{b}

March 13th, 1926

[...] You told me on Wednesday that it was time for everything to end and for me to carry on as I could. You don't think that hurts me at all, because many circumstances make you think I don't have a drop of shame and that, in the first place, I'm worthless and I have nothing left to lose; but its seems to me I have told you before that even if I'm worthless to you, for myself I'm worth more that many other girls, something that you will interpret as a pretension to being an exceptional girl (a title that you gave me once, now I don't understand why), and that's why I still call an offense what you say to me so sincerely and with such goods intentions. [...]

{c}

March 17th, 1926

[...] I waited for you until six-thirty in the convento and I would

have waited for you all my life, but I had to get home at a decent hour [...] since you have been so good to me, since you are the only one who has loved me, I ask of you from the bottom of my soul never to leave me, remember that I can't say I can count on my parents because you know perfectly well how I am; so the only one who could watch over me is you, and you are leaving me because you imagined the worst, which grieves me just to think of it. You say you don't want to be my *novio* anymore. [...] Then what do want to do with me? Where do you want me to go? (It's a pity you can't do what I thought of when I was young, carry me in your pocket); though you don't say it, you know that for all the stupid things I have done with others, they are nothing compared to you. [...] It will be a long time still before we forget each other, we can be good *novios*, good husband and wife, don't tell me it isn't so, for the sake of what's most dear to you. [...] Every day I'm going to wait for you in Churubusco until 6, maybe one day you will have pity on and understand as you do yourself

> your Frieda

{d}

> April 12th, 1926

[...] if one day we get married, you'll see, I'll be *buten* good, almost as if made to measure for you. [...]

{e}

> August 21st, 1926

My Alex:
I'm not a *pelada* as you thought last night, because I didn't say goodbye to you, because as much as I tried, I couldn't get out at the signal. But I hope you will pardon me, no?

If you want tomorrow Friday you can see in the evening, at the little tree... to give ourselves up to love...

[...] I need you to tell me several times... "don't be a crybaby" -it's very sweet for me.

I love you very much. Do you believe me?

Well, I implore you to forgive me about yesterday, it was because of my mom.

Yours for ever.

> Frieda
> crybaby of Gómez Arias
> or the virgin lacrimorum

You haven't written me because of what happened last night, right?

[...]

My mouth was here for a long time.

I adore you Alex.

For the simpleton verbi gracia (I charge $2.00 to illustrate letters).

<p style="text-align:center">↝</p>

The last phrase is to be explained by the fact that the letter is profusely illustrated, with stylized capitals. (The letter in its original version is a mixture of Spanish and English, shifting from one language to the other every other word or phrase. TN)

<p style="text-align:center">{f}</p>

<p style="text-align:right">September 28th, 1926</p>

[...] Though I have said "I love you" to many and have kissed or been given ribbons by others, at the bottom of my heart I have only loved you. [...]

The portrait will be at your house within a few days. Forgive

me for giving it to you without a frame. I implore you to put it somewhere low, where you can look at it as if you were looking at me. [...]

৵

Frida refers to the Self-Portrait *of 1926.*

{g}

[...] Why do you study so much? What secrets are you looking for? Life will reveal it to you all of a sudden. I already know everything, without reading or writing. A little while ago, almost a few days ago, I was a little girl who walked through a world of colors, of hard and tangible forms. Everything was mysterious and concealed something; I took pleasure in deciphering, in learning, as in a game. If only you knew how terrible it is suddenly to know everything, as if a flash of lightning lit up the earth. Now I live on a dolorous planet, transparent like ice; but which conceals nothing, it's as if I had learned everything in seconds, all at once. My girlfriends, my companions have slowly become women, I grew up in a few instants and today everything is pliant and lucid. I know there is nothing behind, if there were I would see it. [...]

{h}

January 8th, 1927

[...] Bring me a comb from Oaxaca if you can, one of those wooden ones eh. You'll say I'm very gimme-gimme right [...]

January 10th, 1927

Alex: I want you to come, you don't know how I have needed you during this time and how every day I love you more.

I'm as always, bad, you know how boring this is, I don't know what to do anymore, since I've been like this for more than a year and it's something I'm just fed up with, having so many pains, like an old lady, I don't know how I'll be when I'm thirty, you'll have to keep me wrapped in cotton all day long and carry me about, because then it won't be possible, as I told you one day, in your pocket, since there's no way I'll fit.

Listen, tell me about your trip to Oaxaca and what kind of swell things you've seen, I need you to tell me something new, because to tell the truth I was born to be a flowerpot and I don't leave the porch... I'm *buten buten* bored!!!!!! You'll say it's because I don't do anything useful, et cetera, but I don't even feel like it, I'm good for nothing at all, you understand, so I don't have to explain. I dream every night of this room where I sleep and as much as I turn it around and around in my head, I just don't know to blot out its image (which in any case looks more and more like a bazaar every day). Well, what's there to do, just wait and wait... The only person who has remembered me is Carmen Jaimes and that was only once, she wrote me a letter, that's all... no one, no one else...

And I who have so often dreamed of being a navigator and traveler! Patiño would reply that it's *one** irony of life, hahahaha! (don't laugh). But I've only been stationed in my village for seventeen years. Later on I'm sure I'll be able to say [...] I'm just passing through, I don't have time to talk. Well, after all, getting to know China, India and other countries comes second... In first place, when are you coming? I don't suppose it will be neces-

sary to send you a telegram telling you I'm at death's door, will it?

I hope it will be very very soon, not to give you anything new but just so the same Frida as ever can kiss you...

Hey, check among your acquaintances if anyone knows a good recipe for blondifying my hair (don't forget).

And pretend that with you in Oaxaca is your

Frieda

For Frida buten *meant "very much, excessively". She was not 17, but 19, at the date of this letter.*

Alejandro Gómez was on the point of leaving for Germany at the time. As he recounted to Víctor Díaz Arciniega (Memoria personal...)*: "...Finishing high school, getting a good place in the* El Universal *oratory competition and the accident of the bus where Frida and I were traveling all coincide in my confusion. In spite of my desire not to refute or contradict the versions of others, there is something here that touches me very intimately. In studies and biographies of Frida it has been said or insinuated that my trip to Europe was owed to family pressures in order to get me away from her. That is incorrect. It is false. My family did not apply pressure in any sense. They always respected my decisions. I had had the idea of the trip for a long time. My uncertainties and intimate and personal explorations were previous. The accident, I am sorry to say, was a fatal coincidence with a desire that had been forming in me for years".*

{j}

Sunday, March 27th, 1927

My Alex: You can't imagine how gladly I was waiting for you on Saturday, for I was sure you would come and that there was something to do on Friday [...] at four in the afternoon I received your letter from Veracruz. [...] Imagine my sorrow, I don't know how to explain it to you. I don't wish to torture you and I want to be strong, above all to have as much faith as you do, but I can't, I can't console myself at all, and now I'm afraid that just as you didn't tell me when you were going, you are deceiving

49

me when you say you are only going to be away for four months. [...] I can't forget you for a single moment, you are everywhere, in all my things, especially in my room, and in my books and my paintings. It was only today at 12 o'clock that I got your first letter, who knows when you will receive this one of mine, but I'm going to write you twice a week and you can tell me if they are getting to you alright or what address I can send them to. [...]

Now, since you have gone, I don't do anything during the day, nothing, I can't do anything, not even read [...] because when you were with me, everything I did was for you, so that you would know and see it, but now I don't feel like doing anything. Still, I realize I shouldn't be this way, on the contrary, I'm going to study everything I can and as soon as I get better I'm going to paint and do a lot of things so that when you come I am a little better. It all depends on how long I am sick. There are still 18 days to go to make one month lying down and who knows how long in this box, so for the moment I don't do anything; I just cry and I hardly sleep because it's at night, when I'm alone, that I can best think of you, I go traveling with you...

Listen Alex, you're sure to spend April 24th in Berlin, and just that day you will have been out of Mexico for one month, let's hope it's not Friday and that you spend it more or less happily. How horrible it is to be so far from you! Every time I think that the steamship is carrying you farther and farther from me, I just feel like running and running to catch up with you, but all of the things I think and feel, et cetera, I resolve them as any other woman, by crying and crying, what can I do?, nothing "I am* a *buten* crybaby". Well Alex, when I write you again on Wednesday, I'll say almost the same things as in this letter, a little sadder and at the same time a little less so because three more days will have passed and three days less [...] so, little by little, suffering unspeakably, the day will come when I see you again

[...] and then you'll never have to go to Berlin again.

[*Signed with a triangle*]

༄

Painting had already begun to occupy some of Frida's time. Confined to her home by the doctors again, she decided in September of 1926 to paint the Self-Portrait with Velvet Gown *(oil on canvas, 79.7 cm x 59.9 cm). Torso, right hand crossing the waistline, gaze directed proudly at the viewer. In the background, a dark landscape of sea and mountains. The long décolleté accentuates her slenderness and pale skin. On the back of the canvas she wrote: "Frieda Kahlo at the age of 17. September of 1926 –Coyoacán– Heute ist Immer Noch [Today still remains]". When she sent it to Gómez Arias she wrote this note: "Forgive me for giving it to you without a frame. I implore you to put it somewhere low, where you can look at it as if you were looking at me".*

{k}

March 29th, 1927

Alex: Your* "Botticelli" has become very sad, but I told her she will be "Sleeping Beauty" until you return, and in spite of that, she always remembers you. [...]

༄

Frida calls her Self-Portrait *a "Botticelli".*

[6]

Letter to Alicia Gómez Arias

March 30th, 1927

[...] I beg you not to think badly of me if I don't invite you to my home, but first I don't know what Alejandro would think, and second you can't believe how horrible this house is, and I would be very embarrassed if you came; but I want you to know that my wishes would be just the opposite... I have been lying in an armchair for eighteen days and I have to remain in the same position for nineteen more (Alejandro must have told you that as a result of the bus accident my spine is bad) and after those nineteen days they will probably have to line me with splints or put me in a plaster corset, so you can just imagine how desperate I shall be. But I go through all these sufferings to see if that way I get better, because I'm completely bored of not doing anything because I'm always sick.

[...] I'm trying to find out the address of one of my father's sisters who lives in Pforzheim, in the state of Baden, for it would be very easy to communicate with Alejandro through her. I rather doubt I'll be able to get it as it's been a long time since we had news of my father's family, because of the war. [...]

∽

The marriage of Jakob Heinrich Kahlo (merchant in jewelry and photographic articles) and Henriette Kaufmann (housewife) produced various children, among them Guillermo (Wilhelm), María Enriqueta and Paula.

LETTERS TO ALEJANDRO GÓMEZ ARIAS

{a}

April 6th, 1927

[...] I've been in this armchair for seventeen days and I don't feel any better at all, I'm in as much pain or more than at the beginning, and I'm completely convinced this doctor was pulling my leg, because it hasn't done me any good to do what he told me to do. Now that a month has passed I'm going to speak to him clearly, because I'm not going to be just as he wishes all my life. [...] If I keep on like this, it would be better to eliminate me from the planet, but the only thing that gives me hope is that by July at the latest [...]. But the only visitor I'm really looking forward to seeing will arrive from Veracruz one day in July -and as always... he'll whistle- he'll leave... Obregón La Preparatoria! (It's not a Stridentist poem.) [...]

Speaking of painters, your "Botticelli" is fine, but deep down you can see a certain sadness in her that, naturally, she can't hide; in the triangle you know in the garden the plants have grown, they will surely be ready by spring, but they won't blossom until you arrive [...] and so many other things that await you. [...]

ↄ

Gómez Arias would actually return in November.

[...] In addition to so many other things that grieve me, my mother is not well either, my father has no money; I suffer, to tell you the truth, even because Cristina doesn't pay me attention and doesn't dust my room, I have to ask her everything as a favor, she mails my letters whenever she feels like it and takes anything of mine she wants [...] The only thing that amuses a little is reading, I've read *John Gabriel Borkman* five times now and *La bien plantada* six or seven; in the newspaper, an article that appears daily on "The Russian Revolution" by Alexander Kerensky (today will be the last), and what's happening in Shanghai. I'm learning German, but I'm still not past the third declension because it's devilishly difficult. [...] He also asks me in his paper if I want to do a "very modern" portrait of him, but there's no help for it, I can't. I'm sure he'd like one with the Ocotlán chapel in the background or something purely Tlaxcalteca or dark red. This time things aren't going to turn out as he imagines [...]

This coming Sunday my father is going to take a portrait of me with "Cañita" so I can send you his effigy, eh? If you can take a nice photograph of yourself over there, send it to me so when I'm a bit better I can do your portrait.

Write to me -write to me- write to me and write to me, and above all, even if you see the Venus of Milo herself in the Louvre, don't forget me.

Even if you see the greatest architecture in the world, don't forget me.

It's the only thing that will make me get better, don't forget me.

[Signed with a triangle and continued the next day]

Alex: I was going to send this letter to Spain for you, but this evening the gang came (Salas, Chong, el Flaquer and el Crispetín) and they told me Orteguita had gone to Paris and they gave me his new address.

Only el Crispetín and I have received letters from you, well and of course your mom as well, but none of the rest of the gang; I'm waiting for a letter from Havana, but I find it strange it's taking so long. (You can't imagine how sad I was when I saw the gang and you weren't with them my Alex.)

ॐ

It was very probably Miguel N. Lira who asked for the portrait. Frida would paint him some three months later.

{c}

Good Friday, April 22nd, 1927

My Alex: Alicia has written to me; but since March 28th neither she nor anyone else has had the slightest news of you... There is nothing comparable to the desperation of not knowing anything about you for a month.

I'm still unwell, I'm losing a lot of weight; and the doctor decided after all to have me wear the plaster corset for three or four months, because that grooved thing, even though it's a little less bothersome than the corset, is not as effective, since as it's a question of being in it for months, the patient gets sores, and it's easier to cure the sores than the illness. With the corset I'm going to suffer horribly, because I need it to be immobile and to put it on me they are going to have to hang me from my head and wait until it dries, otherwise it would be

completely useless because of the warped position my spine is in, and by hanging me they are going to try to get me as straight as possible, but because of all this, and it's not the half of it, you can imagine how I will be suffering and what I need... The *old* doctor says the corset gives very good results when it is put on properly, but that's still to be seen and if the devil doesn't take me they are going to put it on me on Monday in the Hospital Francés... The only advantage of the filthy thing is that I can walk, but since my leg hurts so much when I walk, the advantage is self-defeating. In any case I won't go out on the street in this get-up, because they're sure to carry me off to the insane asylum. In the remote case that the corset is not effective, they would have to operate, and the operation would consist, according to this doctor, of taking a piece of bone from my leg and putting it in my spine, but before that happens I would definitely have eliminated myself from the planet. [...] What's happening to me comes down to that, I have nothing new to tell you; I'm bored with b as in boo hoo hoo! My only hope is to see you. [...]

<div align="center">

Write me

"

"

"

and above all, love me

"

"

[Signed with a triangle]

</div>

Letter to Alicia Gómez Arias

Saturday, April 23rd, 1927

Alicia:

I'm very grateful to you that you were kind enough to let me know immediately how Alejandro is and believe me it made me very happy to know that he arrived safely in Hamburg.

I am exactly the same, without any improvement at all, and just imagine, the doctor changed his mind and instead of the that apparatus they were going to put on me on Monday in the Hospital Francés, they are going to plaster me up, and although that way I'll have the advantage of at least being able to walk a little, the doctor says its very bothersome, and that I'll have to be that way for three of four months; I'm desperate, but I prefer the plaster corset to the operation, which frightens me a lot because any operation on the spinal column is very dangerous.

With all of this, you can imagine how I must be suffering.

Alicia, forgive the handwriting, but I can hardly sit up to write properly. Please tell me how your mother is, because Alex recommended I find out from you, and if I can walk when I have this corset on, I will call her on the telephone whenever I can, in order not to bother her so much with letters; but I think you will forgive the annoyance as it's only been because I'm sick, as always.

Accept my sincere affection and gratitude.

Frieda

LETTERS TO ALEJANDRO GÓMEZ ARIAS

{a}

April 25th, 1927

My Alex:

Yesterday I was very ill and very sad, you cannot imagine the hopelessness one comes to feel with this illness, I feel a dreadful irritation that I can't explain and then at times there is a pain that I can't get rid of with anything. Today they were going to put the plaster corset on me, but it will probably be Tuesday or Wednesday because my father hasn't had any money -and it costs sixty pesos- and it's not so much because of the money, because he could very well get it, but rather because no one in my family really believes I am ill, since I can't even say it because my mother, who is the only one who feels any distress, falls ill, and they say it's my fault, and that I'm very imprudent. So I and I alone suffer, and feel hopeless and all. I can't write much because I can hardly bend over, I can't walk because my leg hurts horribly, I'm tired of reading -I have nothing good to read-, I can't do anything but cry and there are times when I can't even do that. I don't get any amusement at all and haven't a single distraction, but only more sorrows, and I find all those who come to see me occasionally very disagreeable. I would go through all of this if you were here, but this way it just makes me want to pop off all the sooner [...] you can't imagine how the four walls of my room exasperate me. Everything! I don't know how to describe my hopelessness to you. [...]

Sunday, April 31st, 1927. Labor Day

My Alex:

I just received your letter of the 13th and this moment has been the only happy one in all this time. Though the memory of you always helps me to be less sad, your letters are still better.

How I would like to explain my suffering to you minute by minute; I'm worse since you've been gone and I can't console myself or forget you for a single moment.

On Friday they put the plaster apparatus on me and it's been a veritable martyrdom since then, there's nothing to compare it with; I feel suffocated, a dreadful pain in my lungs and all down my back, I can't even touch my leg and I can hardly walk and still less sleep. Imagine, they had me hanging, just from my head, for two and half hours and then standing on tiptoe for more than an hour, while it was dried with hot air; but when I got home it was still completely moist. They put it on me in the Hospital de Damas Francesas, because in the Francés they would have had to intern me for at least a week, since they don't allow it otherwise, and in the other one they began to put in on me at a quarter past nine and I was able to leave around one o'clock. They didn't let Adriana or anyone come in, and I was all alone suffering horribly. I'm going to have this torture on for three or four months, and if I don't get better with this, I sincerely want to die, because I can't bear any more. It's not only the physical suffering, but also the fact that I haven't the slightest distraction, I don't leave this room, I can't do anything, I can't walk, I'm completely desperate and, above all, you're not here, and add to all of this: to be constantly hearing sorrows; my mother is still very ill, she's had seven attacks this month, and my father is the same, and penniless. It's enough to give way completely to despair, don't you think? I'm

59

getting thinner every day, and nothing amuses me anymore. The only thing I like is when the boys are going to come, on Thursday Chong, *el güero* Garay, Salas and *el Goch* came, and they're going to come back on Wednesday, but that counts as suffering too because you are not with us.

Your little sister and your mother are fine, but I'm sure they would give anything to have you here; try by all means to come back soon.

Don't doubt even for a single moment that when you come I will be exactly the same.

Don't forget me and write me often, I await your letters with something like anxiety and they do me a world of good.

Never stop writing me, at least once a week, you promised me.

Tell me if I can write you at the Mexican Legation in Berlin, or where.

How I need you Alex! Come quickly! You can't imagine how much I need you! I adore you.

$$\mathcal{S}$$

About her father, Frida recalled ("Fragmentos..."): "He suffered frequent attacks of epilepsy. He had such mettle that it was difficult to believe he was an epileptic. Though often while he was walking with his camera over his shoulder and holding me by the hand, he would suddenly fall. I learned to assist him during his attacks on the open street. I would take care that he quickly inhaled some ether or alcohol, and at the same time watch that no one stole his camera".

{c}

Saturday, May 7th, 1927

[...] When I'm a little more used to this filthy apparatus, I'm going to do Lira's portrait and we'll see what else. I'm *buten* depressed [...] Salas lent me *The Deaf Lantern* by Jules Renard and I bought *Jesus* by Barbusse. That's all I've read. I'm going to read *The Lighthouse* [...]

Letter and Dedication to Miguel Nicolás Lira

{a}

May 22nd, 1927

Little brother: I've been in Coyoacán again since Monday, and I would be very glad to see all of you again; your portrait is almost finished, so I'll expect you all on Wednesday as always; please tell the boys. My spine is still bad and I'm an absolute wreck, you can't imagine how I suffer from all this; well, there's nothing to do but grin and bear it, right?

 Regards from your sister

Frieducha

{b}

[On the back of the watercolor *Cantina tu suegra*]

This is my masterpiece and only you will be able to appreciate it with your soul child, your water sister. Friducha. July 18th, 1927.

૭

Miguel N. Lira (1905-1961) was a poet, publisher and cultural promoter. Frida did a portrait of him in the Stridentist style.

 The small watercolor given to Lira measures 18.5 cm x 24.5 cm. At the end of the 1940s, beside a self-portrait drawn in ink on wood, Frida wrote to Lira: "Chong-Lee, Mike Brother for ever, don't forget la Cachucha No. 9 Frida Kahlo".

(The sentence on the back of the watercolor is a mixture of Spanish and English. TN)

Letters to Alejandro Gómez Arias

{a}

Sunday, May 27th, 1927

[...] I don't want you to be worried about me, for though I'm very impatient, my illness is nothing dangerous. I suffer a lot from it, because you know how I am, but it's better, now that you are far away, that I am ill. [...]

{b}

Tuesday, May 29th, 1927

[...] My father told me that when I get better he's going to take me to Veracruz, but he's just dreaming, for there are no bucks (another thing that isn't news), but we'll have to wait to see if by chance he can keep his promise. It's been a while now since I started to get bored-er and bored-er and if this continues I'll end up "non compos mentis"; but when *you** get back *tute this** boredom will not exist... There are some who are born under a good star and others born smashed to bits, and though you don't wish to believe it, I'm one of the completely smashed-up ones. [...]

꜀ꙩ

(In the last sentence, Frida plays with the Spanish expressions nacer con estrella *"to be born under a good star" and* estrellado *"smashed to bits". TN)*

Last day of May, 1927

[...] I've almost finished the portrait of Chong Lee, I'll send you a photograph of it. [...] Worse every day, because I'm going to have to convince myself that it's necessary, almost certain, to be operated on, for otherwise the time goes by and then the second plaster corset they put on me is no use and it was almost a hundred pesos thrown out the window, because they were given away to a couple of thieves, which is what most doctors are, and the pains in my leg are exactly the same and there are times when my good one also hurts, so I'm worse every moment and without the least hope of getting better, since for that the main thing is lacking, which is money. My sciatic nerve is injured, as well as another whose name I don't know that ramifies with the genital organs, two vertebrae I don't know how and *buten* things that I can't explain to you because I don't understand them, so I don't know what the operation would consist of, since no one can explain it to me. You can imagine from everything I'm telling you what great hopes I have of being, I won't say well, but even better for when you get back. I understand that it is necessary in this case to have a lot of faith, but you can't imagine for a single minute how I suffer from this, precisely because I don't believe I can get better. It could be that some doctor who showed a bit of interest in me might at least be able to help me, but all those who have seen me are scoundrels who don't care about anything and just want to rob you. So I don't know what to do, and giving up hope is no use. [...] Lupe Vélez is filming her first motion picture with Douglas Fairbanks, did you know? What are the cinemas like in Germany? What other things about painting have you seen and gotten to know? Are you going to go to Paris? What's the Rhine like? German architecture? Everything. [...]

Alex, my life: I got your letter just this afternoon. […] I've given up hope that you'll be here by July, you're bewitched […] in love with the Cologne Cathedral and all you have seen! While I'm counting the days until that unexpected day when you return. It makes me sad to think you'll find me still sick, since on Monday they're going to change, for the 3rd time, the apparatus, this time to leave it in place, so I won't be able to walk for two or three months, until my spinal column solders perfectly, and I might still need an operation after that. In any case I'm bored with it all and I often think it would be better if I were… finished off once and for all, don't you agree? I'm never going to be able to do anything with this wretched illness, and if I'm like this at seventeen I don't know how I'll be later on, I'm getting thinner every day and you'll see when you get here how you're going to shrink from me when you see me in *this bloody get-up*. And I'm going to be a thousand times worse afterwards, because just imagine, after a month on my back (which is how you left me), another with two different apparatuses, and now two more months on my back, tucked into a plaster cast, then another six with the small apparatus to be able to walk, and with high hopes of an operation that could leave me like a piece of wood. […] It's enough to make one despair, don't you think? You'll probably tell me I'm being *buten* pessimistic and a crybaby, and especially now that you're completely optimistic, after having seen Rembrandt's Elbe, all of Lucas Cranach and Dürer, and especially Il Bronzino and the cathedrals. In your place I too could be wholly optimistic and an eternal child. I can't tell you how happy I was to hear you have seen the marvelous portrait of Eleanore of Toledo and all the things you've told me of. […] I'm still in a bad way, I'm sure to

need an operation later on, because even though my spine feels better with this plaster apparatus, it does nothing for the injured nerves in my leg and only an operation or the application of a (hot) electric current several times (iffy and not very effective, in the doctor's view) could help me. I can't do either because I have no money, so I have nothing at all to do and you can imagine how sad I must be. I'm doing Lira's portrait, *buten* ugly. He wanted it with a background in Gómez de la Serna style. [...]

But if you come back soon, I promise to get better.

<div align="right">Yours</div>

Don't forget me...
[*Signed with a triangle*]

<div align="center">↶</div>

The Spanish writer and art critic Ramón Gómez de la Serna (1888–1963) was an enthusiastic advocate of the avant-garde. His articles and essays circulated in Mexico at the time.

<div align="center">{e}</div>

<div align="right">July 15th, 1927</div>

[...] I still can't tell you I'm doing better, but nevertheless I feel much happier than before, I have so much hope of getting better by the time you return that you shouldn't be sad on my account for a single moment. I almost never lose hope now, and I'm very rarely a "crybaby". On August 9th I will have been in this position for two months and the doctor says they're going to take an X-ray to see how the vertebrae are and it's almost certain that I'll only need the plaster apparatus until the 9th of September, after that I don't know what they'll do with me. They are going to take the X-ray right here at home, because I absolutely mustn't move at all. I'm on a table with little wheels so they can take me out

into the sun, and you couldn't by any means imagine how bothersome it is, since I haven't moved at all for more than a month, but I'm willing to be like this for six months, if it means getting better. [...]

You can't imagine how marvelous it is to wait for you with the same serenity as the portrait. [...]

<center>{f}</center>

<center>July 22nd, 1927, Feast Day of Mary Magdalen</center>

My Alex [...] In spite of so many sufferings I do believe I am getting better; it might not be true, but I *want to believe it*, and that's better in any case, don't you think? These four months have been a continual sorrow for me, day after day; now I'm almost ashamed of not having had faith, but then no one can imagine how I have suffered. Your poor *novia*! You should have taken me with you, as I used to tell you when I was little, in one of your pockets, like the golden nugget in Velarde's poem... But now I'm so big! I have grown so much since then. [...]

Listen my Alex: how marvelous the Louvre must be; how many things I'm going to learn when you come back.

I had to look up Nice in the atlas, because I couldn't remember where it was (I've always been "*sometimes** a dunce"), but now I'll never forget... believe me.

Alex: I'm going to confess something: there are moments when I think you are forgetting me, but it's not true, is it? You couldn't fall in love with the Mona Lisa again. [...]

"Family News"

 –Maty is coming back to this* mansion. They have made up.
 All the Catholic ladies –Veladora, Abuelita, Pianista, et
 cetera, ended their days thanks to *this** anti-Catholic *chance**.

<center>**66**</center>

-My father is no longer at the "Perla", but at Uruguay #51.

"Non-Family News"
- Chelo Navarro had *one** "little girl".
- Jack Dempsey defeated Jack Sharkey in New York. Sensational!
- The Mexican Revolution** re-electionists/anti-re-electionists

"In My Heart"
- only you-

your

\-

\-

\-

\-

\-

\-

\-

Frieda

** Interesting candidates: José Vasconcelos (?)
Luis Cabrera

৵

In his memoirs dictated to Víctor Díaz Arciniega, Gómez Arias made a statement that does not seem true to the facts: "I would not like to say -and I don't believe she would like to say either- that we were novios*".*

Frida refers to the poet Ramón López Velarde (1888-1921).

Since 1922, Guillermo Kahlo (1872-1941) had had his photography studio in the jewelry store La Perla at the corner of Madero and Motolinía. In 1927 he decided to set up an independent studio.

July 23rd, 1927

My Alex: I just received your letter at this moment. [...] You say that later you're going to embark for Naples, and that it's almost certain you'll also go to Switzerland, I'm going to ask something of you, tell your aunt that you want to come home, that you don't wish to stay there for any reason past August [...] you have no idea how it is for me every day, every minute without you. [...]

Cristina is as pretty as ever, but she is *buten* rotten to me and to my mother.

I painted Lira because he asked me to, but it's so bad I don't know how he can say he likes it. *Buten* horrible. I can't send you a photograph because my father still doesn't have all the plates in order because of the change; but it's not worth the trouble, the background is very intricate and he looks like he's been cut out of cardboard. Only one detail strikes me as good (*one** angel in the background), you'll see. My father also took a photograph of the other one of Adriana, of Alicia with a veil (very bad) and of the one meant to be Ruth Quintanilla and which Salas likes. As soon as my father makes *more** copies I will send them to you. He only made one of each, but Lira took them, because he says he's going to publish them in *one revistamen** that's coming out in August (he must already have told you, no?). It's going to be called *Panorama*, in the first issue there will be contributions from, among others, Diego, Montenegro (as poet) and I don't know how many others. I doubt it will be any good.

I tore up the portrait of Ríos, because you can't imagine how much it bothered me. El Flaquer wanted the background and the portrait ended its days as Joan of Arc.

Tomorrow is Cristina's saint's day, the boys are going to

come and the two sons of licenciado Cabrera, they're not like him (they're very stupid) and they barely speak Spanish, as they have been in the United States for twelve years and only come to Mexico on vacation. The Galants are also coming, and la Pinocha, et cetera, only Chelo Navarro not because she's still in bed because of her baby, they say it's *buten* cute.

That's all that's happening in my family, but none of it interests me.

Tomorrow will make a month and a half that I've been plastered up, and *four* months that I haven't seen you, I would like life to start next month and to be able to kiss you. Is that how it will be?

Your sister

Frieda

୬

In his memoirs (Memoria personal…) Gómez Arias does not mention any aunt who accompanied him on his European travels. He does mention Frau Mosser, the proprietor of a pension in Wiesbaden, the base of operations from which he visited Vienna, Prague, Belgrade, Rome, Florence, Venice… Unlike other Germans, she treated him with great deference.

El Flaquer and la Pinocha were the nicknames of mutual friends Eduardo Bustamante and Esperanza Ordóñez.

Two of the portraits mentioned by Frida, of major dimensions given her physical limitations at the time, are still in existence: the one of Miguel N. Lira (99.2 cm x 67.5 cm) and that of Alicia Galant (107 cm x 93.5 cm).

Frida refers to the painter Roberto Montenegro (1885-1968).

{h}

Coyoacán, August 2nd, 1927

Alex: August is beginning… and I could say *life* as well if I were sure you are going to return at the end of the month. But

Bustamante told me yesterday that you're probably going to Russia, so you'll be away longer. [...] Yesterday was the saint's day of Esperanza Ordóñez (Pinocha) and they had *sam guateque* at my house because they don't have a piano. The boys were there (Salas, Mike, Flaquer), my sister Matilde and other gentlemen and damsels. They brought me into the parlor on my little wagon and I watched everyone sing and dance. The whole gang was pretty happy (I think). Lira made *one** poem for la Pinocha and the three of them talked in the dining room. Miguel amused them with anecdotes, he quoted Heliodoro Valle, Tsiu Pau, López Velarde *and sundry others*. I think la Pinocha likes the three of them (aesthetically) and they all became good friends.

I was a crybaby, as always. Even though they take me out into the sun every morning (four hours), I don't feel I've improved much as I still have the same pains and I'm pretty thin; but in spite of that, as I told you in the other letter, I want to have faith. If there's enough money, they're going to take another x-ray this month and I'll know better where I stand; but if not, in any case I'm going to get up on September 9th or 10th and then I'll know if I'm getting better with this apparatus or if the operation is still necessary (I'm frightened). But I'll still have to wait quite a while to know if the absolute rest of these three months (I could almost say the martyrdom) has produced results or not. From what you tell me the Mediterranean is marvelously blue, will I ever see it? I don't think so, because I have very bad luck, and my greatest wish for a long time has been to travel. I'll just be left with the melancholy of those who have read travel books.

I'm not reading anything now. I don't want to. I'm not studying German or doing anything except thinking of you. I must think I'm *buten* learned. And apart from the arrivals and departures of the steamships, I only read "the leader" in the

newspaper and what's happening in Europe.

Nothing is known about the revolution on this side, the one who seems to have influence is Obregón, but no one knows anything.

Apart from that there's nothing interesting. Alex, have you learned much French? Though it's not necessary to give you advice... give it all you've got, eh?

What museums have you visited? What are the girls like in the cities you have visited? And the boys? Don't flirt too much with the girls at the spas [...] Only in Mexico do they say "Medea" and "Meche" to the ones who are so exquisite they seem like Botticellis, with nice legs, and only here can you speak to them like this: Señorita (Sorita), would you like to be my *novia*? But not in France, nor in Italy, and definitely not in Russia where there are a lot of boorish Communist girls [...] you have no idea how happy I would be all my life just to be able to kiss you.

I think now that I've really suffered, it's just what I deserve, no? Will it be as you say in the month of August? Yes?

<div align="right">

Your Frieda
(I adore you)

</div>

Letter to Alicia Gómez Arias

August 2nd, 1927

[…] I'm still unwell, I don't talk about anything else anymore, and in addition to the illness itself, that grieves me a lot. Tomorrow will make two months with this apparatus and I still see no improvement. […] Forgive me for writing to you on this paper, but I don't have any other at the moment, and everything has to be put in my hands. […]

Letters to Alejandro Gómez Arias

{a}

[...] I can't tell you if I'm any better or not, because they haven't taken the x-ray, but the pains are still there and the day before yesterday I was *buten* unwell. Lira was kind enough to send his father to examine me with more interest than the others. It would take a long time to explain to you everything I have according to him; but I think what he considers to be pretty bad is my leg, because the sciatic nerve of the vertebrae is damaged. He says it would be necessary to give me thermocautery, I don't know why. There are about twenty different opinions, but the fact is I'm still unwell, and they all get mixed up. [...] All the optimism I had is finished and I'm desperate again, but isn't it true that I'm right to be so now? [...]

{b}

September 9, 1927

[...] Coyoacán, exactly the same, everything about it: especially the clear sky at night. Venus and Arcturus. Venus and Venus. The 17ᵗʰ makes two years since our tragedy, I especially will remember it *buten*, though it's stupid, no? I haven't painted anything new, not until you come back. Now the September afternoons are gray and sad. You liked so much the cloudy days of the Preparatoria, remember? I have suffered *buten*, and I'm almost neurasthenic, and I've become très très brutish, I'm absolutely contemptible, believe me, but [...] I'm reading *The Cities and the*

Years by Fedine, a marvel of a talent. He is the father of all the modern novelists. [...]

September 17th, 1927

[...] I'm still unwell and almost without hope. As always, no one believes it. Today is September 17th, the worst of all because I'm alone. When you come back I won't be able to offer you any of what you would like. Instead of being boorish and flirtatious I'll just be boorish and useless, which is worse. All these things constantly torment me. All of life is in you, but I won't be able to possess it. [...] I'm very simple and suffer too much for what I shouldn't. I'm very young and it's possible I'll get better. But I just can't believe it; I should believe it, right? I'm sure it will be in November. [...]

[*Undated*]

[...] Don't think I'm making it up but at times it seems I'm the most unfortunate of women (it's rather vulgar to play the martyr), but then I begin to think and I convince myself there's something to it, but there's still a long way to go to be abandoned by the hand of God.

I got into the tank just now in the morning (congratulate me).

Listen my Alex, I adore you, really, don't think it's pure optical illusion, when you come back I'm going to give my word on it, eh? Please don't forget me now that you don't see me; for the sake of what you most love tell me you're going to love me as much as if you were seeing me and you're going to write me some letters as long as Sunday newspapers.

Your *cuate* who loves you as you can't even imagine.

<div align="right">F.</div>

<div align="center">{e}</div>

<div align="right">October 15th, 1927</div>

My Alex: The second-last letter! You already know everything I could tell you.

We have always been happy in the winter, never as now. Life is before us, it's impossible to explain what that means.

It's likely I'll continue to be unwell, but I don't know anymore. In Coyoacán the nights astonish as in 1923, and the sea, symbol of my portrait, synthesizes *life*, my life.

You haven't forgotten me?

It would almost be unjust, don't you think?

<div align="right">Your Frieda</div>

<div align="center">{f}</div>

<div align="right">June 14th, 1928</div>

[...] Now more than ever I feel you no longer love me, but I confess I don't believe it, I have faith... it can't be. In your heart you understand me; you know why I did the things I did! What's more, you know I adore you! That you're not only something of mine, but my very self! [...] Irreplaceable!

LETTER TO GUILLERMO KAHLO

San Francisco, Calif., November 21ˢᵗ, 1930

Darling Daddy:

If you knew how pleased I was to receive your letter, you would write me every day, for you can't have any idea how glad I was. The only thing I didn't like is that you told me you continue to be as bad-tempered as ever, but since I'm just like you, I understand you very well and know it's very difficult to control oneself; but even so, do everything you can at least for mother who is so good to you. What you said about the Chinese made Diego laugh a lot, but he says he'll take good enough care of me that they don't rob me.

I'm well, I getting some injections with a certain Doctor Eloesser, of German origin, but who speaks better Spanish than they do in Madrid, so I can explain everything I feel to him with complete clarity. I'm learning a little bit of English every day and at least I can understand the most essential things, shopping in stores, etc., etc.

In your reply tell me how you are, and how mother is and everyone. I miss you terribly for you know *how much I love you*, but I'm sure we'll be together again in March and we can talk lots and lots.

Make sure to write me and don't hesitate to tell me if you need some money.

Diego sends very affectionate regards and says he doesn't write you and mother because he has a lot to do.

Accept all my affection and a thousand kisses from your daughter who adores you.

Frieducha

Write me about everything you do and everything that happens to you.

⌁

Frida's marriage to Diego Rivera (1886-1957) took place on August 21, 1929. In November of 1930 they traveled to San Francisco so Diego could execute various commissions for mural paintings.

CORRIDO FOR ANTONIO PUJOL AND ÁNGEL BRACHO

San Francisco, January 1ˢᵗ, 1931

To Pujol and Bracho

Hijos de la gran mañana!	*Sons of the great morning!*
los saludo desde aquí	*Greetings from here*
a la manera tehuana	*in Tehuana fashion*
pa' que les llegue allí	*to reach you over there.*
Trabajen mucho muchachos	*Work hard, boys,*
y hagan hartos cuadrotes!!!!	*and make plenty of pictures!*
pa' vender a los gringachos	*To sell to the gringachos*
y les den hartos pesotes	*who'll pay plenty of pesos.*
Vacilen hasta cansarse	*Have fun till you drop*
con las tehuanas tan chulas	*with the pretty Tehuanas;*
si no saben abusarse	*if you miss your chance,*
serán purititas mulas	*you'll be absolute dunces.*
Un saludo yo les mando	*I send you a greeting*
y me despido también	*and take my leave as well,*
pa' que se queden pensando	*so you'll never forget*
en la que los quiere bien	*one who loves you dearly.*

Your *cuate* Frieda

Bracho and Pujol were two young Mexican artists, born in 1911 and 1914, respectively. They studied in the School of Visual Arts of the National University when Diego Rivera was its director.

Paragraphs of Letters

{a}

[...] Diego began to paint three days ago, the poor dear gets home exhausted at night, because it's work for a horse not for a human being; imagine, yesterday he started at eight-thirty and came back at nine in the morning; he worked more than 24 hours without stopping, without eating or anything; he was exhausted the poor thing. He's very good to me, it's me who sometimes get the Kahlo thing into my head and get very angry, but he has a good temper and when it least seems he loves me; I love him *buten-buten*. I'm painting and hopefully the exhibition will come off. (?)

Life here is interesting at times because there's a lot to see; the people are like everywhere else, chatterers and gossipy, etc., etc., but if you mind your own business you can work in peace and live well. Yesterday Diego gave a lecture in some old ladies' club, there were something like four hundred scarecrows, all about two hundred years old, with their crops tied back, because otherwise they would hang down in folds; in short, frightful old bags but all very friendly; I was bound to be looked at like some rare bird, since I was the only young person along with two or three big girls of thirty or more, so they took to me and talked to me so much they made me dizzy; most of them spit when they talk, like Sr. Campos, and all have false teeth that move all over the place. Well, I'm telling you there was more than one ancestral iguanodon that would cure anyone's hiccups and beat Carmen Jaimes in a beauty contest!

{b}

[...] Receive all my affection which as you know goes from here to Neptune, or may even be bigger.

Your Frieducha

{c}

February 12th, 1931

[...] I'm painting, so far I've done six canvases which have been pretty well received. The people here have treated us very well, and the Mexicans there are here in San Francisco are just asses, you can't imagine; but then, there are idiots everywhere, and now and then you find a gringo, my God, as thick as a brick, but they all have, in general, many good qualities, they're not as shameless as in our beloved Mexico.

{d}

February 16th, 1931

[...] Today Diego didn't go to work and we just laid around all day, until just a moment ago when he went to the home of the president of the Stock Exchange to a little party they're throwing for him. I didn't want to go because I have an inflammation and it's worse to walk about, don't you think? A few days ago at the theater I saw a magnificent thing by some Negroes, it's what I have liked best so far.

Ribbon on the Painting
Frieda and Diego Rivera

Here you see me, Frieda Kahlo, beside my beloved husband Diego Rivera, I painted these portraits in the beautiful city of San Francisco, California, for our friend Mr. Albert Bender, and it was in the month of April in the year 1931.

≈

Albert Bender, an admirer of Rivera, got the government of the United States to grant him an entry visa in 1930 when he was invited to paint murals in San Francisco. The oil on canvas measures 100 cm. x 79 cm.

Letter to Isabel Campos

San Francisco, Calif., May 3rd, 1931

Dear *cuate*:

I got your letter *buten* ages ago, but I couldn't answer you because I wasn't in San Francisco but rather farther south and I had a pile of things to do. You can't imagine how glad I was to receive it. *You were the only friend who remembered me.* I've been very happy, except I miss my mother a lot. You have no idea how marvelous the city is. I'll only write you a little about it in order to have plenty to tell you in person.

I'm going to arrive very soon in the powerful "village". I think around the middle of this month and then I'll tell you *buten* things. Plenty of prattle...

I want to give my *very affectionate* regards to Aunt Lolita, to Uncle Panchito and to all your brothers and sisters, and especially to Mary.

The city and the bay are "swell". I don't like the gringos at all, they're very insipid and they've all got faces like unbaked biscuits (especially the women). What is really nice here is Chinatown, the flock of Chinese are really *simpáticos*. I've never seen such beautiful children in my life as the Chinese children. Well! something marvelous, I'd like to steal one for you to see.

I don't even want to tell you about my English because I'm a dunce. I bark what is absolutely necessary, but it's extremely difficult to speak it well. But I make myself understood even with the wretched shopkeepers.

I don't have any women friends. One or two that can't be called friends. So I spend my life painting. In September I'm

going to have an exhibition (the first) in New York. I didn't have enough time here and could only sell a few canvases. But in any case it helped me a lot to come because it opened my eyes and I've seen lots of swell new things.

Since you can see my mother and Kitty, tell me about them. I would truly appreciate it. There's still time (that is if you want to) to write me one letter. I ask you to do it because it would make me very, very happy. Is it too much to ask?

Say hello to everyone for me, if you see Dr. Coronadito, Landa, Sr. Guillén. To all those who remember me. And you, darling *cuatezoncita*, receive the *everlasting* affection of your *cuate* who loves you very much.

<div align="center">Frieducha</div>

Kisses to your Mommy, Dad and brothers.
My address: 716 Montgomery St.

<div align="center">Ꭳ</div>

The first exhibition would take place in New York in 1938.

LETTER TO NICKOLAS MURAY

Coyoacán, May 31, 1931

Nick,

I love you like an angel.

You are a lily of the valley, my love.

I will never forget you, never, never.

You are my whole life.

I hope you will never forget that.

Frida

Please come to Mexico as you promised me! We will go together to Tehuantepec, in *August*.*

[Added with an imprint of her lips:] This is specially for the back of your neck.*

❧

Nickolas Muray (Hungary, 1892-United States, 1965), photographer, dance critic, aviator, fencing champion, was introduced to Frida in Mexico by Rosa Rolando and Miguel Covarrubias. An initial romantic encounter became deeper when Frida arrived in New York to present her first individual exhibition in the Julien Levy Gallery from November 1 to 15, 1938. Since Frida did not speak Hungarian, someone must have helped her to write this letter, which is originally in Hungarian and contains several spelling mistakes.

(The English version was made from the Spanish translation included in Frida Kahlo, Escrituras. *TN)*

LETTERS TO DOCTOR LEO ELOESSER

{a}

Coyoacán, June 14^th, 1931

Dear Doctor:

You can't imagine how sorry we were not to see you before coming back here, but it was impossible, I called your office three times without finding you in, because no one answered, so I left a message for Clifford, asking him if he would do me the favor of explaining to you. Also, just imagine that Diego was painting until twelve o'clock on the night before we left San Francisco and we didn't have time for anything, so this letter is first of all to ask your forgiveness and also to tell you we arrived safely to this country of enchiladas and refried beans. Diego is already working in the Palacio. He's had a little problem with his mouth; and what's more, he's exhausted. If you write him, I would like you to tell him he has to rest a little for the sake of his health, because if he keeps working like this he's going to die. Don't tell him I told you he's working so much, but tell him you found out and that it's absolutely necessary for him to rest a little. I would be ever so grateful.

Diego is not happy here, because he misses the friendliness of the people in San Francisco and the city itself. He wants nothing more than to return to the United States to paint. I arrived very well, skinny as always and bored with everything, but I feel much better. I don't know how to pay you for my cure and for all your kindness to me and Diego. I know that money would be the worst way, but my deepest gratitude would never requite your kindness, so I beg you to let me know how much I owe you, since

you can't imagine how bad I feel for coming back without having given you anything that might be equal to your goodness. In your answering letter, tell me how you are, what you are doing, everything, and please give my regards to all our friends, and most especially to Ralph and to Ginette.

Mexico is as always, disorganized and gone to the devil, it has nothing left but the great beauty of the land and of the Indians. Everyday the ugliness of the United States steals a little piece of it, it's sad, but people have to eat and there's no help for the fact that the big fish eats up the little one. Diego sends you his warmest regards, and accept the affection you know I have for you,

Frieda

༜

Frida met the surgeon Leo Eloesser (1881–1976) in Mexico in 1926, but it was only in 1930 in San Francisco that they began to cultivate an ever-closer friendship. Before returning to Mexico with Diego in 1931 so that he could continue working on his murals in the stairwell of the Palacio Nacional, Frida painted a portrait of Dr. Eloesser at his home on Leavenworth Street. Ralph is the American sculptor Ralph Stackpole (Ginette was his wife), Rivera's host and collaborator in 1930 in San Francisco.

{b}

New York, November 26th, 1931

[...] I don't like the *high society** here at all and I feel a bit of indignation at all these moneybags around here, as I've seen thousands of people in the most terrible poverty, without anything to eat or anywhere to sleep, it's what has struck me most here, it's frightful to see the rich throwing *parties** day and night while thousands and thousands of people are dying of hunger. [...]

Even though all of the industrial and mechanical development of the United States interests me a lot, I find it completely lacking in sensibility and good taste.

It's as though they live in an enormous and irritating hen house. The houses look like baking ovens and all the comfort they talk about is a myth. I don't know if I might be wrong, but I'm just telling you how I feel. [...]

Frida arrived in New York with Diego, who was to present a retrospective exhibition in the recently opened Museum of Modern Art in December 1931.

LETTER TO MATILDE CALDERÓN DE KAHLO

New York, January 20th, 1932

Mommy darling:

I'm finally better, I've just got a bit of hoarseness and cough but it's nothing serious. The worst of it was that I spent a few days bored to death, stuck in this filthy hotel looking at Central Park so bare of trees it looks like a garbage dump, and listening to the roaring of the lions, tigers and bears in the Zoo across from the hotel. I've been reading detective stories at night, and then when I get really sleepy, I go to bed and dream nothing but nightmares.

That's how I have spent eight days with the flu. Yesterday I went out for a bit but I don't want to be too brave because the weather is awful and I would be worse off with a relapse, don't you think? So I prefer to get bored and stay here twiddling my thumbs in the hotel. What's more, a flock of people come during the day, and in the evening as well, and at night I'm just waiting for Diego.

Now and then we go down to dine in the hotel restaurant and if not, they bring dinner up to the room.

There's a woman here, the sister of someone from San Francisco, who comes very often to see me and says she likes me *buten*. Poor old thing, she's kind to me but I don't have much tolerance for people, I don't know why.

Sometimes the Bloch sisters come as well, some Jewish girls daughters of the best composer of modern music, Ernst Bloch; they're very kind to me. The eldest one plays the lute (a very ancient instrument that was played in the Middle Ages)

88

and the poor thing comes carting her lute to play for me and sing me songs. The other day she came to cook for me so I would have a change of food, she made me a vegetable soup that tasted just foul to me, but I had to say it was magnificent, then she made me a chocolate sweet with *soletas* that was all right, but I am very grateful to her for being so kind to me, because she doesn't have to be, don't you think? They're very poor girls who work and can hardly afford the strictly necessary, because their father is in Europe and what's more he's quite a philanderer and makes their mother suffer a lot, so they don't care for him and they live alone here with their married brother who is an electrical engineer, also very poor and a good young man.

There are various people who have treated me very well. Another girl who was in Mexico for three years and speaks Spanish very well, her name is Ella Wolfe. She is very fond of me and now that I've been ill, in spite of the fact that she works and lives very far away, she has come to see me and give me medicine and she brings me books and whatever I ask for. She's Russian, dark and chubby, she reminds me a lot of Mati, except that Mati is prettier.

Malú Cabrera has also been good to me, for in spite of the past... which you know, and of the friendship with Guadalupe Marín, she treats me well and has wanted to be friends with me.

As you can see, as far as people looking after me are concerned, I have plenty of them. And Diego also, you know, in spite of apparently never caring and just wanting to be painting and painting, loves me a lot and is a very good person. I suppose all men are equally useless when it comes to illnesses, don't you think? But he is magnificent with me, I'm the one who is too demanding sometimes and takes advantage, and I get into frightfully bad moods, but I'll get over that as time goes by.

I'm going to write to Hortensia Muñoz because I want to see her very much before leaving for Detroit.

Darling, what news can you give me? What are you doing? How do you spend your days? I don't think you can have any idea of how much I miss you. At times when I think of you and Papa I can't believe I am ever so far from you, and when I see it's really so it makes me want to run and run till I get to Coyoacán. I think by August or September Diego will have finished everything he has to do.

The Covarrubiases tell me I should go to Mexico with them in March, but I don't think I'll be able to leave Diego. He says that if he earns a bit of money this year we will be able to live in Mexico forever, but I have to put up with nuisances and old ladies and parties, etc. to be able to get what he wants. I think he's absolutely right, but I'm very anxious and impatient and I'd like everything just to happen by magic. The only thing is that I can't be happy without all of you, and everything seems horrible and bothersome and a nuisance, but really all I have is Coyoacanitis.

As soon as you have a bit of free time and can, write me darling, when I get a letter from you I'm very glad and see everything in a better light.

I wrote to my Papa, he tells me in his letters that he can't get down to painting as I tell him to because he's always worried about work and because he feels he's being maintained and can no longer give you what he wants to give you, but I tell him not to be silly and not to take things so seriously; at least you have everything you need, don't you think darling? And he can do little jobs that come his way just to keep from getting bored and so he has something to buy his cigarettes and candies. If I happen to sell a painting, I'll send him enough to pay what he owes in Foto Supply, so he needn't worry about that, and when

I get back you'll see how we fix everything and the three of us shall live very happily. I want it to be my turn to live with you, since as you saw in the months I was in Mexico I saw very little of you because I couldn't divide myself between my home and yours. If the three of us live together you'll see how good it will be and I'll be the happiest person in the world.

Darling, don't be worrying that I was very ill or imagining things. I just had the 'flu, but I'm completely better, I just have a bit of a cough.

Take care of yourself, think of me often and write me whenever you can.

Give lots and lots of kisses to my Papa, to Cristi, to the little girl, and say hello to Antonio for me. I have already written to my Grandma. I'm just waiting for a letter from you.

Has the present for Isoldita arrived yet?

I send you all my heart,

Your Frieducha

I'm sending these five dollars for you and my Papa so that you can buy something you like.

⌁

Matilde Calderón y González, Frida's mother, was the eldest of the twelve children born to Isabel, the daughter of a Spanish soldier, and Antonio, an Indian from Morelia, Michoacán, as Frida herself recounted in May 1953.

Ella Goldberg de Wolfe (1896-2000) was born in the Ukraine, emigrated with her family to the United States and lived for a long period in Mexico in the 1920s, working for TASS, the Soviet news agency. She was a member of the American Communist Party until the signing of the German-Soviet Pact, at which point she and her husband Bertram broke with the Party. Her friendship with Frida would remain very close after their meeting in New York City.

LETTERS TO ABBY A. ROCKEFELLER

[*Originally in English*]

{a}

New York, January 22nd, 1932

My dear Mrs. Rockefeller:

I want to thank you for your beautiful book that you sent me last week. I hope that in spite of my terrible English I can read it. Your flowers were marvellous, you cannot imagine how they look nice in this room. This hotel is so ugly that by the flowers I think I am in Mexico.

I am much better now and hope to see you very soon.

After this eight days indoors I am very ugly and thin, but I hope that soon I shall be better.

Please give my best regards to Mr. Rockefeller and your children.

Diego sends his love to you

Many kisses from

Frieda Rivera

Please excuse my terrible english.

{b}

New York, January 27th, 1932

My dear Mrs. Rockefeller:

Diego is very sorry, he cannot write you because he is still in bed.

He wants to thank you for your marvellous flowers and for

your kind letter you sent.

He is very bored when he is not working, but you know that he is like a child and doesn't like doctors at all; in spite of that I called one and now he is very angry with me because doctor told him to stay in bed few days more.

He misses very much your daughter's baby and he told me that he loves her more than me.

I hope that he will be better very soon and will be able to write you himself and specially to work again. He is very glad that you and Mr. Rockefeller liked his drawing of Mrs. Milton, and he thanks you.

Please excuse my English.

Our best regards.

<div align="center">Diego Rivera. Frieda Rivera</div>

Abby Aldrich Rockefeller promoted the foundation of the Museum of Modern Art in New York, together with Lille P. Bliss and Mary Quinn Sullivan. The museum was inaugurated on November 8, 1929. In 1931 Diego Rivera was invited to exhibit and produced ex profeso four al fresco panels on the premises of the MOMA.

LETTER TO CLIFFORD AND JEAN WIGTH

[Originally in English]

New York, April 12th, 1932

Cliff and Jean dear:

A week ago I received Jean's letter; I couldn't answer it right away because I have been in bed *again* with influenza and I felt very badly. I hope that you forgive me. This climate of New York ¡my god! is simply awful for me. But... what can I do? I hope Detroit will be better, otherwise I commit suicide.

It's really very nice to know that Cristina and Jack arrived already and I am sure that we will have a grand time all together. It would be very nice if we could stay in the same hotel. Don't you think so?

Diego wishes that you look for one apartment for us right away because we shall leave New York next week. The one that you describe in your letter Diego thinks is too small because there is no room to work or paint in it. And that is the more important question. It is absolutely indispensable for Diego and for me too. (I am going to paint there, because I am tired doing nothing but lying on a cautch. I don't know how do you spell this word.)

For that important reason, and if it is not too much trouble for you, we should like very much that you could find one apartment with one room with light enough where could be possible to paint in it, one bedroom with two beds, or *one* big one (that should be nicer of course), one kitchenette and bathroom. Maybe you could find it in the same Hotel Wardell on the top

of the building, even if it is a little more expensive; but, if you cannot, then in some other place near the museum.

Also if it is possible, maybe you can find one studio not very expensive, and in this case we should take the apartment in the Wardell which you describe me. I know that this is not so easy to find, but if you could, I shall appreciate you very very much. You know how difficult is to work in the living room in a hotel, because one has to eat, see people, and every thing in the same room. That is why I rather want one studio, or one bigger room in the same apartment.

Diego has finished the last lithograph, but I wonder if he will do some more, and that is why we can't leave this week, but it is sure that the next we will take the train for Detroit. I shall send you a telegram saying the exact date we leave.

There are not interesting news in New York. You must know already that Lindberg's child is not in his home yet. The chinese and japanese still fighting... etc., etc. Universal news. The only thing is that we went to the circus and we enjoyed very much, is a huge circus in Madison Garden. They have many animals, freaks, beautiful girls, and 100 clowns. Oh my goodness! I never have seen before such marvellous things.

The Blanches were here. Arnold has an exhibition very interesting. They went to a party that Malú Cabrera gave to me on account of our leaving and because I was "rebaptized". Now my name is not any more "Frieda" but "Carmen". Was very nice party. I dressed like a baby, Diego was the priest, Malú the godmother and Harry the godfather. Diego was marvellous. You would laugh to death.

Besides that, Concha Michel from Mexico (maybe Cliff remembers her) gave a concert of Mexican songs here in the Barbizon Plaza. She sings beautifully and was a great success. She dressed first like an indian, then like the tehuana, and finally

like "china poblana". Everybody was crazy about her. She gave me the words of the songs and we can sing them in Detroit if I buy a guitar.

Ella Wolfe and Bert send to Cliff their love, the same from the Block's and the Bloch's (Suzanne and Lucienne, yes! Luci).

Please tell Cristina that I want very much that she will write me. Diego and I send our love to them, and salutations to Niendorff and Dr. Valentiner.

Love to you from

Diego y la Chicuita.

Adiós.

I shall send you a telegram to let you know when we will arrive to Detroit.

Let me know if you could find the apartment and thank you very very very very very much.

Chicua.

Cliff:

I found your tape measure or tape worm (what is the name in English?) ¡Oh my English! But you know what I mean. In Spanish is *metro metálico*. Oh, then tape measure.

Write me right away, will you?

I feel much better now from the cold, but I have stomach-ache. ¡Poor Chicua! She wants to go back to Mexico, that is all. We shall go directly from Detroit to Coyoacán, D.F. Shall we?... YES. Clifford and Jean.

჻

Clifford Wight, an English sculptor, was Rivera's assistant in San Francisco and Detroit. As with his other assistants, Diego depicted him on the scaffolding of the fresco in the California School of Fine Arts. In January 1931 Frida did a portrait of Jean Wight, Clifford's wife, in oil on canvas

(65.5 cm x 46.0 cm). In the same year she did a pencil drawing (40.0 cm x 30.0 cm) of Lady Cristina Hastings, the wife of the viscount Lord John Hastings (known as Jack), another of Rivera's assistants in San Francisco.

Lucile and Arnold Blanch, both painters, cultivated Frida's friendship in New York, as did Malú Cabrera (daughter of the writer, journalist and politician Luis Cabrera) and her husband Harry Block, the journalist and writer Bertram D. Wolfe and his wife Ella, as well as the daughters of the composer Ernst Bloch.

William Niendorff was Rivera's assistant in New York.

Dr. William R. Valentiner was the director of the Detroit Institute of Arts when Rivera painted the murals there in 1932.

Letters to Doctor Leo Eloesser

{a}

Detroit, May 26th, 1932

[...] This city gives me the impression of an ancient and impoverished hamlet, it struck me as a village, I don't like it at all. But I'm glad Diego is working happily here and has found a lot of material for the frescoes he's going to do in the museum. He's delighted by the factories, the machines, et cetera, like a child with a new toy. The industrial part of Detroit is really the most interesting, the rest is like everywhere else in the United States, ugly and stupid. [...]

I have a lot to tell you about myself, though it's not very pleasant, shall we say. First, my health is not at all good. I would like to talk to you about anything other than that, for I understand you must be bored of hearing complaints from everyone and of sick people, of sicknesses, and above all of the patients, but I would like to believe that my case will be a little different because we are friends and both Diego and I love you very much. You know that well enough.

I'll start by saying I went to see Doctor Pratt, because you recommended him to the Hastings. I had to go the first time because my foot is still bad and consequently the toe, which is naturally in a worse state than when you saw me, as almost two years have passed since then. I'm not too worried about this matter, because I know perfectly well there is no remedy and not even crying helps anymore. In the Ford Hospital, which is where Doctor Pratt is, one of the doctors, I don't remember who, diagnosed it as a *trophic ulcer*. What is that? I just gaped when I found out I had such a

thing in one of my paws. The important question now and what I want to consult you about before anyone is that I'm *two* months pregnant, that's why I went back to see Doctor Pratt, who had told me he knew my general condition, because he had talked with you about me in New Orleans, and I wouldn't have to explain to him again the question of the accident, hereditary factors, et cetera, et cetera. Since I thought that, given the state of my health, it was better to abort, I told him so, and he gave me a dose of *quinine* and a very strong castor oil purge. The day after taking it I had a very slight hemorrhage, *almost nothing*. For five or six days I have had a bit of bleeding, but very little. In any case I thought I had aborted and went to see Doctor Pratt again. He examined me and told me no, that he is completely sure *I didn't abort* and that his opinion was that it would be much better, instead of having an abortion, to leave the baby alone and that in spite of the poor state of my organism, taking into account the small fracture in the pelvis, spine, et cetera, et cetera, I could have a child by Caesarian section without too much difficulty. He says that if we stay in Detroit for the seven months of pregnancy, he would undertake to look after me with the utmost care. I want you to tell me what you think, with complete frankness, because *I don't know what to do in this case*. Naturally, I'm willing to do what you think will be best for my health, and *Diego says the same*. Do you think it would be more dangerous to abort than to have the child? Two years ago I aborted in Mexico with an operation, in more or less the same conditions as now, three months pregnant. Now I'm only two months pregnant and I think it would be easier, but *I don't know why* Dr Pratt thinks it would be better for me to have the child. You know better than anyone the state I'm in. In the first place, with my heredity I don't believe the child could be very healthy. Secondly, I'm not very strong and the pregnancy would weaken me still more. Moreover, my situation is rather difficult at the moment, as I don't know

exactly how long Diego will need to finish the fresco and if, as I calculate, it were in September, the child would be born in December and I would have to go to Mexico three months before it is born. If Diego finishes later, the best thing would be to wait for the baby to be born here, and in any case there would be terrible difficulties traveling with a child just a few days old. I have no one of my family who could care for me during and after my pregnancy, since poor Diego cannot, as much as he would like to, as he's burdened with the problem of his work and a thousand other things. So I wouldn't be able to count on him for anything. The only thing I could do in that case would be to go to Mexico in August or September and have it there. I don't think Diego is very interested in having a child, since what preoccupies him most is his work and he's perfectly right about that. Kids would come in third or fourth place. For my part I can't tell you if it would be good or bad to have a child, since Diego is constantly traveling and I would by no means wish to leave him alone and stay in Mexico, that would only cause difficulties and problems for both of us, don't you think? But if you really think as Dr Pratt does, that for the sake of my health it is better not to abort and to have the baby, all these difficulties can be somehow resolved. What I want to know is your opinion, more than anyone else's, since in the first place you know my situation and I would thank you from the bottom of my heart for telling me clearly what you think would be best. If the operation to abort were most advisable, I beg you to write to Dr Pratt, because he's probably not aware of all the circumstances and since it's against the law to have an abortion, perhaps he's afraid or something and later it would be impossible to perform the operation for me.

If, on the contrary, you think that having the child could help me, in that case I want you to tell me if it would be better for me to go to Mexico in August and have it there, with my mother and

my sisters, or to wait for it to be born here. I don't want to cause you any more bothers, you can't imagine, dear doctor, how bad I feel about having to bother you with these things, but I write you not so much as a doctor but rather as the best of my friends and you have no idea how your opinion will help me, because I have *no one* I can count on here. Diego is very good to me as always, but I don't want to distract him with things like this, now that he has all the work on his shoulders and needs peace and quiet more than anything. I don't feel close enough to Jean Wight and Cristina Hastings to consult them about things like this, which are terribly important and if I blunder, the grim reaper could take me! That's why now that I still have time I want to know what you think and to do what is best for my health, which is the only thing I think would interest Diego, because I know he loves me and I'll do anything in my power to make him happy. I'm not eating at all well, I have no appetite and it's only with a great effort that I drink two glasses of cream a day and eat some meat and vegetables. But now I want to vomit all the time with this blessed pregnancy and I'm a mess! *Everything* tires me, for my spine bothers me and I'm also pretty done in by the problem with my foot, since I can't do any exercise and as a result my digestion is all messed up! Nevertheless, I have the will power to do a lot of things and I never feel *disappointed with life as* in Russian novels. I perfectly understand my situation and I'm more or less happy, firstly, because I have Diego, my mother and my father; I love them so much. I think that's enough and I don't ask miracles of life, far from it. Of my friends I love you most and that's why I dare to bother you with such silliness. Forgive me and when you answer this letter, tell me how you have been and accept Diego's and my affection and an embrace from

<div align="right">Frieda</div>

If you think I should have the operation immediately I would appreciate your sending a telegram referring to the matter in a veiled way, in order not to compromise yourself in any way. Many thanks and my best memories.

Regarding what you asked me about the ballet by Carlos Chávez and Diego, it turned out to be trash with a capital T, not because of the music or the décor, but because of the choreography. There was bunch of insipid *güeras* pretending to be Tehuantepec Indians and when they had to dance the zandunga, they seemed to have lead in their veins in place of blood. In short, pure and simple rubbish.

<p style="text-align:center">જ</p>

At this time Rivera was already painting the 26 al fresco panels of The Man and the Machine *in the central patio of the Detroit Institute of Arts.*

Among the various analyses ordered by Dr Eloesser in San Francisco in 1931 were the Wassermann and Kahn tests, which came out slightly positive.

Before arriving in Detroit, Frida and Diego had traveled to Philadelphia to attend the première of the ballet H. P.*, with music by Carlos Chávez, set designs by Rivera and the orchestra conducted by Leopold Stokowski.*

<p style="text-align:center">{b}</p>

<p style="text-align:right">Detroit, July 29th, 1932</p>

Dear doctorcito:

You can have no idea how much I have wanted to write you for so long, but so many things have happened to me that it is only now that I sit down quietly, take up the pen and send you these lines.

First, I want to thank you for your kind letter and telegram. In those days I was enthusiastic about having the child, after having considered all the difficulties it would cause me, but it must have been something biological, for I felt the need to leave myself

<p style="text-align:center">102</p>

to the baby. When your letter arrived, I felt still more encouraged, because you believed it was possible for me to have the baby and so I didn't deliver the letter you sent me for Dr Pratt, since I was sure I could endure the pregnancy, go to Mexico in time and have the child there. Almost two months passed and I was feeling fine, I was in complete repose and taking care of myself as best I could. But about two weeks before the 4$^{\text{th}}$ of July I began notice a sort of putrefied bleeding almost daily, I was alarmed and went to see Dr Pratt and he told me everything was normal and that he thought I could have the child very well with a Caesarian section. I continued until the 4$^{\text{th}}$ of July, when without even knowing why, I aborted in the blinking of an eye. The fetus had not formed, because it came out disintegrated even though I was three and a half months pregnant. Doctor Pratt didn't tell me what the cause might have been or anything and he only assured me that at some other time I could have another baby. I still don't know even now why I aborted and for what reason the fetus didn't form, so who knows how the devil I am inside, because it's very strange, don't you think? I was so excited about having a little Dieguito that I cried a lot, but now that it's over there's nothing to do but grin and bear it... After all, there are thousands of things that remain forever cloaked in the most complete mystery. In any case I have the lives of a cat, because I don't die so easily, and that's something after all...!

Get away and come to see us! We have a lot to talk about and with good friends one forgets one is in such an awful country. Write to me and don't forget your friends who love you dearly,

<div align="right">Diego and Frieda</div>

To tell you the truth, I'm just don't feel at home here, as the servants say, but I have to make the best of it and stay, since I can't leave Diego.

[25]

LETTER TO DIEGO RIVERA

<div align="right">Coyoacán, September 10th, 1932</div>

[...] Though you tell me you look very ugly in the mirror with your hair cut short, I don't believe it, I know how lovely you are in any case and the only thing I'm sorry about is not being there to kiss you and take care of you, even if at times it would be to pester you with my griping. I adore you, my Diego. I feel I have left my child alone and that he needs me... I can't live without my darling little child... The house without you is nothing. Everything seems horrible to me without you. I'm more in love with you than ever and every day more and more.

I send you all my love.

<div align="right">Your *niña chicuititita*</div>

[26]

Letters to Abby A. Rockefeller

[*Originally in English*]

{a}

Detroit, Tuesday the 24th of January, 1933

My dear Mrs. Rockefeller,

I have no words to thank you for the marvellous photograph of the babies that you sent to me. Really was very sweet of you to do it, and I wish I could write English well enough to tell you how much I appreciate your kindness.

The babies look simply divine and I imagine how proud you must be having these wonderful grandchildren. I cannot forget the sweet little face of Nelson's baby, and the photograph you sent to me is hanging now on the wall of my bedroom. You can't imagine the happy face of Diego when I opened the envelope and suddenly he saw the photograph of Mrs. Milton's babies. They are really the sweetest children we know.

Here in Detroit everything is getting all right. Diego working as always day and night. Sometimes I get worried about him because he looks very tired and there is nothing in this world that will make him rest. He is happy only when he is working and I don't blame him, but I only hope that he doesn't get sick and everything will be all right. This fresco in the Institute of Arts is really marvellous, I think it is the best he has done. I hope you'll see it sometime.

I am painting a little bit too. Not because I considered myself an artist or something like that, but simply because I have nothing else to do here, and because working I can forget a little all

the troubles I had last year. I am doing oils on small plates of aluminum, and sometimes I go to one crafts school and I made two lithograph which are absolutely rotten.

If I do some others and they are better I will show them to you in New York.

I think we are going to New York very soon. Diego is painting now the last big wall which will take him two weeks more to finish it, and then we will say good bye to Detroit for a while.

Dr. Valentiner is coming next week, I think you will see him in New York, don't you think it is very nice that he comes back?

What are the news in New York? Is the people talking about Technocracy all the time? Here everybody is discussing it and I think every where, I wonder, what is going to happen in this planet?

Let me thank you once more for your sweet present and please give my regards to Mrs. Milton, Nelson and his wife.

Many kisses for all the children and for you my best wishes for a very happy new year. Diego sends to you his best regards.

Sincerely yours

Frieda

{b}

Detroit, March the 6th, 1933

Dear Madame Rockefeller,

You can't imagine how pleased I was with your letter, we were very sorry to hear that you were sick but your letter brought good news and we are so glad that you are feeling better.

As you must know, the magnificent exhibition of Italian paintings of the Fifteenth and Sixteenth Centuries which Dr. Valentiner arranged, is to open at the Detroit Institute of Arts

on March the eight and would be marvellous if you will feel well enough to come here to see it.

Diego finished the frescoes already and if you come you could see them at the same time.

The reception for the frescoes will be later, because of changes that are to be made in the court including the removal of the central fountain.

We shall be leaving Detroit for New York next monday, and we hope that you could come here before we leave. Please tell Mr. and Mrs. Milton that we would be very glad if they could come too and Nelson and Mrs. Nelson's. How are all the babies?

I hope to see them when I am in New York. I never will forget your kindness for sending me their photograph.

I have been so lazy these days that I didn't feel like painting or anything, but as soon as I arrive in New York I will start again. I am going to show you the ones I did here even though they are awful.

Please forgive me for not replying to your letter sooner, but I was in bed with influenza when I received it and I have only just got better.

I hope to hear from you soon and in the meanwhile I send you many kisses.

Diego sends his best regards to you.

Frieda

৵

William R Valentiner was director of the Detroit Institute of Arts. Of the lithographs produced by Frida in Detroit, only The Abortion *is known to have survived.*

Letters to Clifford Wight

[Originally in English]

{a}

New York, April 11th, 1933

-Barbizon Plaza-

Cliff:

I received your two letters, but as always I find so many pretexts to be lazy that only now I can answer them. I hope you forgive me. Will you?

In first place I will tell you that New York is worse than last year, and the people are sad and pesimistic (how do you spell pesimistic?), but nevertheless the city is still beautiful in many ways and I feel better here. Diego is working like hell and half of the big wall is already finished. It is wonderful and he is very happy. (I am too.)

I have seen the same things and the same people, with the exception of *Lupe Marín* who was here two weeks. She was kind and sweet as I would never expect, and that is really something in that case.

We went together to theaters, burlesques, movies, 5 and 10 cents stores, drugstores, cheap restaurants, China Town, Harlem, etc., and... was she thrilled! Oh boy!

The very first thing she did was to fell down in the (escalators) at Macy's and she made a scandal because she said she wasn't an acrobat! She spoke in Spanish to everybody, even to the policemen and of course they thought she was "coocoo the parrot girl". We went shopping and she use to "yeal" (I don't

know how to spell that word, but you know what I mean) in Spanish to all the girls, as she were in "La Merced". Well I can't tell you in words all the things she did, but was absolutely miraculous that nobody took her to an asylum.

We saw Nelson R. and his wife and Mr. and Mrs. R., the parents. Nelson sends his regards to you.

Malú is having her baby in a month and I will be the godmother.

Ella and Bert sent their love to you, and they are as nice as always to me.

Hideo Noda is working with Diego now, and Ben Shahn and Lou Block, the brother of Harry.

Lucienne is in love with a boy, and she has changed a lot, she is more human now, and not so "important". Suzanne is in love too with a mathematician, a nice fellow.

Rosa and Miguel Covarrubias are going to Mexico and from there to Bali again for a year. I saw the Blanches, they are going to Europe this year with the Guggenheim scholarship. Everybody is going away and New York will be empty (for me), but that is all right after all.

Barbara Dunbar had a baby and she has been ill in bed four months. Poor thing. O'Keeffe was in the hospital for three months, she went to Bermuda for a rest. She didn't make love to me that time. I think on account of her weakness. Too bad.

Well that's all I can tell you until now.

Diego wants to answer your questions:

He is going to join the Union as soon as he arrives in Chicago and will pay of course the money required.

He says that if the men of the Union want to make the frames there is no way of discussion and you must let them do it.

He wants to know if Ernest is very necessary to you, otherwise is better to tell him, and pay his trip to Boston. He says you can pay it because Mr. Kahn is giving you 74 or 72 dollars a

week. 42 for you, 18 for Ernest and the rest will pay the expenses of the trip for Ernest.

Let me know what Mr. Kahn arranged about the Union men who want to stretch the canvas.

If they want 17 dollars a day to stretch it, how many days will they need to finish it?

Diego say that the workmen who told you that the majority of artists and painters in the museums are mostly junk, is absolutely right and he [...]

Well Cliff, I think that's all Diego told me and now tell me about yourself and Jean and Cristina and Jack and "pu-wad-dle" (how do you spell this name?) and Ernest.

How are you feeling? What Chicago is like? Do you think I will like it?

I saw a movie the other day called "M", is good. See it if you can. Is a german one. Also "Potemkin" and "Gabriel in the White House", this is a rotten propaganda but some parts are excellent.

OK, Cliff. Good bye and behave yourself. Be always in the shadow! The sun is dangerous.

Give many kisses to Jean and Cristina (with the permission of Jack) and un abrazo a usted y a usted y a Jack without permission at all.

Frieda

Diego sends his best wishes to all of you.

Diego thanks you for all the clippings you sent to him and he says everything in Detroit is OK now. Burroughs wrote to him a letter and sent an article he published, a very good one. We live now in the 35 floor. The view is magnificent.

New York is getting warm. To hell with the climate of this country. What a summer is going to be this year: my god. I will join the "nudisme" but that's worse... for the public.

<p align="center">〜</p>

Diego and Frida were staying in the Barbizon Plaza Hotel at the time.

Lupe Marín (1897-1981) was Rivera's second wife, from 1922 to 1927.

The R. refers to Nelson Rockefeller and his parents.

The well-known painter Ben Shahn and his colleague Hideo Noda were among Rivera's assistants when he worked on the mural for building number 1 of the Rockefeller Center.

Miguel Covarrubias (1904-1957) had married the ballet dancer Rosa Rolando in New York.

*Albert Kahn was the architect of the new General Motors building in Chicago. Rivera was going to paint a large canvas for it (*Forge and Foundry*), but the commission was cancelled after the scandal surrounding the mural in the Rockefeller Center.*

{b}

New York, October 29th, 1933

Dear Jean and Cliff.

What the hell! What the hell! What were you doing in Arizona? I bet you my boots that you had a swell time, the photos show it. But… if you go to MEXICO you will be thousand times happier, and first of all you will meet there the loveliest people on earth, the Riveras and the Hastings. What do you think of that? We are leaving New York the first week of December, and if you make up your mind and start driving towards that land, we'll be… oh boy all together!!! ¡¡¡happy!!!

Diego asks me to answer here Clifford's letter to him, and I do it, but of course you are going to forgive me for not answering it the way he told me, because as you know he […] last as h[…] and I can't remember everything he says. But in few words, he wants to thank you for the letter, the photos, the dolls, everything that so kindly you sent to us, and he wants to remind you that you have a piece of land in Mexico where you can build a little house for you and whachyoumaycallit [*she draws a small dog*] at

any time you feel like it, and that he'll be very glad if you go when we'll be there. Besides that he says that he is very happy to know that Cliff is studying communism. It is a pity that you were not here in New York while all the Rockefeller business happened, and while Diego is painting at the New Worker's School.

I have learned so many things here, and I am more and more convinced that the only way to become a man, I mean a human being and not an animal, is to be communist. Are you laughing at me? Please don't. Because it is absolutely true.

Diego is almost finishing the frescoes at the New Worker's School, they are swell and I send you here some photos that Lucienne took. They are not so hot, but anyway you can have an idea. Lucienne has been working like hell, taking photos, but she... why she herself is disappointed with the photos. But in Radio City she did swell, and her photos were the most important ones to make public the whole affair.

Sánchez got married a few weeks ago, with a girl from Texas, she weighs 76 pounds and is very small. Nice girl, anyway they are very happy... Sánchez looks pale... I don't know why????????

Lucienne and Dimitroff, as always, very very happy, both are now members of the Party, and they go to the strikes to talk to the workers, make speeches in the meetings and have a swell time.

Sánchez and Dimitroff are the only ones working for Diego now, also Lucienne helps a little.

I have been painting a little, reading and hanging around as always. Now I have packed everything, and I am just wanting to go back.

How are you kids? Tell me everything you do, your plans for the future, well, everything. Have you seen Dr. Eloesser? And Ralph? Give my love to all our friends: Emily, Joseph, Ginette, Ralph, Doctor Eloesser, Pflueger, etc. etc. etc. etc. etc. etc.

My new address is Hotel Brevoort, 5th Ave. and 8th Street,

and in Mexico, you know: Ave. Londres 127, Coyoacán, D.F., México, Air Mail.

Please write to me soon, as soon as you can, before I leave to Mexico.

Thanks again for all the things you sent me, and I hope to see you sometimes in my dreams, until we'll be together in Mexico in reality.

Good-bye.

La Chicua

Have you seen a cartoon "The 3 little pigs. Who is afraid of the big bad wolf?", and "I am no angel". Mae West? I think they are wonderful. I am sending to Cliff communist literature.

Stephen Dimitroff, who married Lucienne Bloch, was Rivera's assistant in New York. Antonio Sánchez Flores was his chemical assistant for many years.

Emily Joseph was the simultaneous translator for Rivera's lectures in San Francisco.

Ginette was the wife of Ralph Stackpole, a native of San Francisco, who had met Rivera in Paris and who was his enthusiastic promoter in California.

Timothy Pflueger was the architect of the San Francisco Stock Exchange, for which Rivera painted a mural in the stairwell.

Letter to Ella Wolfe

New York, October 30ᵗʰ, 1933

Darling Ella,

Don't be mean and accept the money from Paca. Why should you have to pay for books that others are using?

I'm sending it to you by mail because I know that otherwise you're not going to accept it.

Yesterday we heard the lecture by Roger Baldwin, it was O.K. but he's just impossible on the question of "free speech"*. Welch spoke very well and put Baldwin in his place. [...]

I'm going to see you in the School today, so good-bye good-bye good-bye.

la Chicua

Peel me a grape!*

Thanks for the letters you were kind enough to write to Mrs. Mathias and to Burroughs.

A hug for little Bertram Wolfe from *la Chicua*.

ॐ

Diego Rivera's friendship with the American writer Bertram Wolfe (1896-1977) began in Mexico in the twenties. It was during the New York period that Frida became friends with him and his wife. Paca refers to Frances Toor and the School is the New Worker's School, where River was painting the 21 panels of Portrait of America.

[29]

LETTER TO ISABEL CAMPOS

New York, November 16th, 1933

Darling Chabela,

It's been a year since I had a word from you or any of you. You can imagine what a year this has been for me; but I don't want to talk about that, because I gain nothing by it, and nothing in the world can console me.

Within a month we'll be in Mexico and I'll be able to see you and tell you lots. I'm writing you this so that you'll answer me and tell me lots of things, for though it seems we have forgotten one another, in my heart I always remember all of you, and I believe you and all the others remember from time to time that I exist, however far away. Tell me how you spend the boring days in Coyoacán, which seem so lovely when one is far away.

Here in Gringolandia I spend my life dreaming of returning to Mexico, but for Diego's work it has been completely necessary for us to stay here. New York is very pretty and I'm much happier than in Detroit, but I still miss Mexico. This time we're going to stay there for almost a year and afterwards, who knows, we may go to Paris, but for the time being I don't want to think of afterwards.

It snowed here for the first time yesterday, and very soon it's going to be as cold as the devil, but there's nothing to do but put on your woolies and endure the snow. At least with my famous long slips the cold gets to me less, but now and then it gets so freezing cold that not even twenty slips resist. I'm still as crazy as ever and I've gotten used to this old-fashioned dress and some of the gringachas even imitate me and want to dress as

"Mexicans", but the poor things look like turnips and the honest truth they just look absolutely dreadful, which doesn't mean I look so good myself, but at least I get by. (Don't laugh.)

Tell me how Mari and Anita are, and Marta and Lolita; I know about Pancho and Chato through Carlitos, who writes me now and again, but I want you to tell me about everyone. The other day a ran into one of the boys, López, I don't remember if it's Heriberto or his brother, but we were talking about all of you with great affection. He's studying in the University of New Jersey and he's happy here.

Cristi writes me seldom, as she's busy with the children, so no one tells me anything about all of you. I don't know if you see Mati from time to time now that she lives in Coyoacán, but she doesn't mention anything. What has happened to the Canets? Chabela must be enormous by now and your sister Lolita as well, I won't recognize them when I see them. Tell me if you're still learning English and if not, when I get back I'll teach you, because now I "bark" a little better than last year.

I would like to tell you *thousands of things* in this letter but it would turn into a newspaper, so I prefer to keep them to myself until I arrive and spill all the beans there.

Tell me what you would like me to bring you from here, for there are such lovely things and so many of them that I don't know what would be best to bring you, but if there's something you especially like, just let me know and I'll bring it for you.

When I arrive you'll have to make me a banquet of squash flower *quesadillas* and *pulque*, just thinking about it makes my mouth water. Don't think I'm making demands and insisting from here that you make me the banquet, I'm just reminding you so that when I get back you don't pretend you don't know.

What news do have of Rubí and all the people we used to be friends with? Tell me some gossip, because here no one tells

me anything and now and then some gossip is pleasant to here.

Give lots of kisses to Uncle Panchito and Lolita and to Aunt Chona as well (since she does love me). For all of you, but especially for you alone, I'm sending tons of kisses for you to hand out and to keep the largest part for yourself.

Don't fail to write me. My address is: Hotel Brevoort, 5^{th} Ave. and 8^{th} Street, N.Y.C. New York.

Your *cuate* who doesn't forget you.

<div align="right">Frieda</div>

Don't forget me.

Letter to Ella and Bertram D. Wolfe

New York, 1933

Bert and Ella, *cuatezones*,

Diego told me to send you this check to help you with the expenses of the invitations, etc., for the New Worker's School.

I'm sending you the money you contributed to the dinner for the Claudes. Don't be angry, darling Ella, but it's not fair that you pay for what Claude ate, since he's got lots of dough and you don't.

Today (Friday) I'll leave you the key at my place so Bert can study.

I'll see you tonight.

Kisses from your skinny *cuate* who loves you with all her heart.

Friedita

The day is coming closer, and I'm very sad, because Diego puts all the blame on me for the trip to blessed Mexico. I was crying for a long time today.

LETTER TO ELLA WOLFE

Mexico, July 11th, 1934

Dear darling Ella:

How do I dare to write you this letter? I prefer not to say any-
thing, nor to offer excuses of any kind. The fact is I haven't
written you, I have behaved like a pig, a wretch, an inconsider-
ate, a riffraff, a scoundrel, etc., etc. and all the bad things you
can think of me are little compared to what I deserve, but
you'll forget all that for the moment, and I'll tell you every-
thing in this letter that I didn't tell you in the others (natural-
ly because I never wrote them).

You asked me in your last letter what Diego and I thought
of the book; I'll tell you, for my own part, that I think it's
magnificent, and Diego liked it very much; he was bothered
somewhat by the incomplete preface, but he understood very
well why it had happened, and he forgot all about it when he
began to read Bert's text, and to see the reproductions, which
we thought were stupendous; the design of the book is gor-
geous, and in general everything came out *very well*; neither
Diego nor I have written to Harry and you'd have to say we are
the most inconsiderate wretches in the world, but I am sure,
or at least I hope, that when we write him he will forgive us and
not be angry anymore; do me the favor of telling Bert as well
that he can curse us, insult us, etc., etc., as he wishes, in
protest that the Riveras have behaved so abominably and that
we didn't even write him two lines about the book and his
marvelous text; but when he tires of insulting us, he should
forgive us, and everything will go on as usual and we'll all be

delighted to take a trip to Water Gap, even if they kick me out of the hotel again for infringing the moral law of the Submitted States by wearing mechanic's overalls in the dining room. No, really, tell Bert not to be angry with us; because he knows of what mettle are made the two friends he has in Mexico called Diego and the Powerful *Chicua*, and he should be indulgent with us this time, and you too naturally, for otherwise everything would be hopeless.

Just imagine, the other day I ran into that wretch Siqueiros in the casa Misrachi, he had the gall to say hello to me, after having written that filthy article in *New Masses*, and all I did was cut him like a dog and not return his greeting, and Diego did worse; Siqueiros said to him: "What's up, Diego?", and so Diego took out his handkerchief, spit in it and put it back in his pocket, and he didn't spit in his face because there were a lot of people and it would have caused a scene, but let me tell you Siqueiros looked just like a crushed flea and went off with his tail between his legs. What did you think of such an article? Well, it's enough to make you curse his progenitor and give a beating to the wretch, don't you think? Diego hasn't decided whether to write an article against him, because it would give too much importance to the idiot, but I'm going to tell him to write it and really put him in his place, because the son of a b..... doesn't deserve to get away with it. What do you think?

Listen darling, it made me enormously happy to know that Jim is coming to Mexico, when I read your letter I could hardly believe it, but when I saw the real one, it made me terribly happy. I'll tell you frankly that it made me sad as well, as I would have liked you and Boit to come with him. I told Paca I would do everything in my power to make you come, but she explained that you had written her you had to work all summer, and I just lost heart altogether, because you can't imagine what I

would give to have you here, at least for a month, and to be able to go about together, and have fun, and... well, we could do everything in Mexico together, but I haven't given up hope that one day we shall see each other again and be as happy as we were in New York.

Diego has been very unwell these last two weeks, he had a nervous fever that lasted more than ten days without leaving him for a moment, his temperature would go up and down and I just didn't know what to do with him. Nacho Millán was looking after him, and as you know Diego has real respect for Nacho as a doctor, he did everything Nacho ordered and in less than two weeks he was quite a bit better. Nacho says that what Diego has is a very intense nervous exhaustion and now he's giving him injections and he has put him on a new diet to make him better; but Diego still looks very weakened and very thin, his skin is rather yellow, and above all, and this is what worries me most, he doesn't seem to feel like working, and he seems sad all the time, as if nothing interested him. At times he gets impatient and he hasn't started to paint anywhere. He has the walls of the Palacio de Medicina ready, but since he doesn't feel well yet he hasn't begun to paint; this makes me as sad as I've ever been, because he doesn't seem happy, I can never be relaxed myself, and his health preoccupies me more than my own. I tell you that if it weren't for not wanting to mortify him still more, I wouldn't be able to endure the great sorrow I feel at seeing him this way; but I know that if I tell him it grieves me to see him this way he will worry still more and that's worse, because he is so sensitive that the least little thing demoralizes and worries him; I really don't know what I will do to encourage him to work with pleasure as before, since he thinks I'm to blame for everything that's happening to him for having made him come to Mexico; but you can't imagine how I suffer knowing that he thinks that he came here for me and that

that's the cause of his being as he is. There are times I would like to talk to you about many things that it's so difficult to write in a letter, and I feel desperate at being so far away from you, but there's nothing to do but wait and wait until he understands that I never had the least intention of doing him such a wrong, because I knew perfectly well what it meant to him to come to Mexico, and I myself made him see that several times in New York. (I don't what's happening to this wretched typewriter.)

You both can testify to the fact that I wasn't *at all happy* to come back, and though there's no help for it now, it's a consolation for me to know that you at least know what I say is true. I don't know if what Diego has is a consequence of having lost so much weight so quickly in Detroit, or if his glands are not functioning properly; the fact is that he's horribly worn out psychologically, and I suffer, if possible, even more than he does from seeing there is no way to make him change his way of thinking, and as much as I would like to offer my life to give him back his health, it's no use. Believe me what I'm telling you is but little in comparison to what I have suffered here these last few months, and though I say nothing to Diego in order not to mortify him, there are times when I'm truly desperate. All of this is naturally reflected in Diego's economic situation as well, for since he's not working, and the enormous expenses he has remain the same, I don't know where he'll end up if he continues in this situation. I do all I can to encourage him and arrange things in the easiest way possible for him, but I haven't achieved anything yet, for you can't imagine how changed he is from the way you saw him in New York; he doesn't feel like doing anything and he's not in the least interested in painting here; I think he's absolutely right because I know the reasons he has for being as he is, with the sort of people there are here, the most unpleasant in the world, and the least understanding you

can possibly imagine, but I don't know how you can change these people without changing what has to be changed in the whole world which is full of these kinds of bastards; so it's not Mexico, or China, or the United States, but rather what you and I and we all know, and naturally I'd like Diego to be interested in expressing himself here in the same way he was interested in expressing himself in New York, but the sad thing is that it rather consists of an interior situation in him, whereby his sickness doesn't let him be as he was, and he blames Mexico, or any exterior situation surrounding him, don't you think? The fact is that I'm in continual anguish seeing this way, and I don't know what the solution is, do you understand?

I don't want him by any means to find out I'm telling you this, since as I just explained the least little thing that he suspects might be said about what's happening to him bothers him immensely; but I would like you to write him intelligently, as if I hadn't told you anything, because he says he doesn't like *anything* of what he's done, that his painting in Mexico and in part that in the United States is horrible, that he has wasted his life miserably, that he desires nothing anymore; in short, it's very difficult to explain to you in a letter the state of mind he's in; but you'll understand from the little I write, and you'll see how painful it is for me to see him this way, since if there's anyone in the world who has worked with all his energy, and all his strength, it's been Diego; so all I can tell you is little in comparison to the sadness I feel to see how downcast and tired he is.

I don't want to tire you telling you only of sorrows, but I don't know why I feel such consolation recounting what happens to me; it must be because you love me somewhat and I take advantage by unloading unto you a little of the weight I feel on top of me; but believe me if it weren't for the fact that I feel truly sad now I wouldn't bother you with such a long and boring letter.

Tell Boit that although I haven't written to him directly, it's the same as if I were doing so when I write to you; tell me I send him many regards, many many, and the same to everyone in the house, to the gang at the School, very especially to Jay who you know how much I love; and if you see the pair of "lovebirds" Lucienne and Dimi, also give them my regards, and to all our friends there, and to Maluchita and Harry and Maluchitititita lots of kisses; don't tell them anything of what I say about Diego since they don't understand any of that, and it would provide material for gossip.

Now you'll understand a little why at times I don't even feel like writing; but neither Paca nor anyone else knows these things, and they'll fill your head up with things against me, and say I'm laziness itself riding a tortoise. But don't believe them, I still love you as much as when I saw you all every day, but you can't put that in letters.

Receive thousands of kisses from me and give some of them, as many as you want, to Boit, and I send lots to your Mommy and Daddy as well.

You have to write me soon so I don't become a sad, disagreeable little girl.

Goodbye darling.

Frieda

I wrote you on this university paper because I ran out of the white and don't have any other. Sorry.

꒛

Bert, or Boit, are both ways of referring to Bertram D. Wolfe. Jay was his son, and Jim was Ella's brother.

Lucienne Bloch, daughter of the composer Ernst Bloch, and Stephen Dimitroff, Rivera's assistants in New York, had gotten married.

The book to which Frida refers is Portrait of America, *by Diego Rivera, with an explanatory text by Bertram D. Wolfe (New York, Covici, Friede Publishers, 1934).*

In the New York magazine New Masses *(May 29, 1934), David Alfaro Siqueiros had published the article "The Counter-Revolutionary Path of Rivera", to which Rivera responded in 1935 with a pamphlet entitled "Defense and Attack Against the Stalinists".*

Maluchita and Harry are Malú Cabrera and her husband Harry Black.

The paper on which the letter is written bears the letterhead of the Universidad Nacional Autónoma de México.

Text on the Letterhead of the
"Pro-Cárdenas" National Students' Party

(1934?)

But no, it can't be, the end is not good. [...] I know the novel, dear reader. That imbecile Raskolnikov, your hero, wasted away in Siberia, he wasted away for ever, and his hope, ready to follow him wherever he went, Sonia, died with him as well.

His destiny was fulfilled, the destiny of the wretched, of the fallen, of the underdog who is condemned to suffer eternally, to die cursed by God and men.

[...] But there is another Raskolnikov, the one who got out of prison to remake his life; that one is a fiction, that one only lives in the conscience of a mediocre man who cannot resign himself to dying and being forgotten.

But reality is different; it is more bestial, more terrible, it is painful, and that is the reality I have recounted to you [...] reader.

THE END

Frida Kahlo

Letter to Alejandro Gómez Arias

October 12th, 1934

Alex.

The light has died away and I have stopped painting little monkeys. I kept thinking of the decoration of the wall separated *by another wall of** wisdom. My head is full of microscopic arachnids and a great quantity of the diminutive predators. I think we'll have to build the wall on a microscopic scale as well, for otherwise it will be difficult to proceed to the mendacious daubing. Moreover, do you think all silent wisdom will fit in such a confined space? And what kind of tomes will contain *such** letters in almost nonexistent pages? *That is the big** problem, and it's your job to resolve it architecturally, for as you say, I cannot order anything within the *big réalité** without going straight to the collision, or I have to hang apparel in the air, or place what is distant in a dangerous and fatal nearness. You will save everything with your rule and compass.

Don't you know that I have never looked at jungles? How am I able to paint a jungle background with predators having some swell fun? Well, I will do what I can and if you don't like it you may proceed to the solid and efficacious demolition of what has been constructed and painted. But it will take so long to finish that we will never have time even to think about the collapse.

I haven't been able to organize the parade of tarantulas and other beings, because I'm thinking that everything will remain sort of stuck to the first of the infinite layers the wall is to have.

I haven't been able to tell you how much good it has done me to see you. I dare to write it now because you're not here,

and because this is a letter written during that eternal winter. I don't know if you'll believe it, but that's how it is, and I can't write you without telling you so.

I'll call you tomorrow, and I would like you to write me one day, even if it's only a few words, I don't know why I ask you this but I need you to write me. Will you?

ॐ

Encouraged by Gómez Arias, on her return from the United States Frida began to consider the possibility of doing a mural painting.

PHOTOGRAPHS

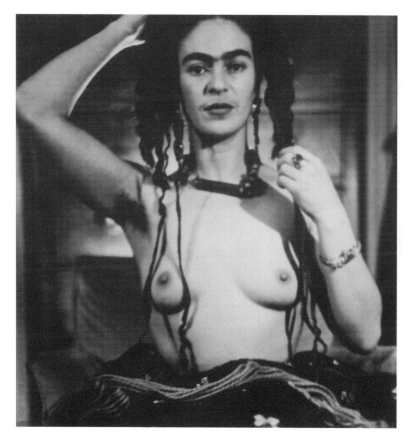

Photograph taken by Julien Levy in 1938, when Frida was in New York for her first individual exhibition at the Julien Levy Gallery.

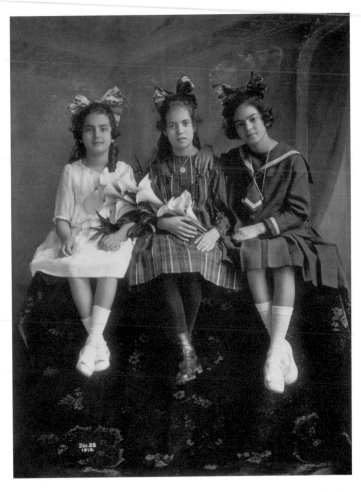

Portrait of Cristina Kahlo, Isabel Campos and Frida Kahlo by Guillermo Kahlo.

The **señoritas** *of Coyoacán in a photograph taken by Guillermo Kahlo at the home of Jacobo Valdés (ca. 1921). Cristina and Frida are the first and fourth, respectively, from right to left. They are accompanied by Lucha Valdés, Consuelo Navarro, the Canet sisters (Etelvina, Monserrat and Lourdes), the Campos sisters (Isabel and Antonieta), Ninfa Garza, Julieta García, Lupe Rubí, Consuelo Robledo and Paz Fariña.*

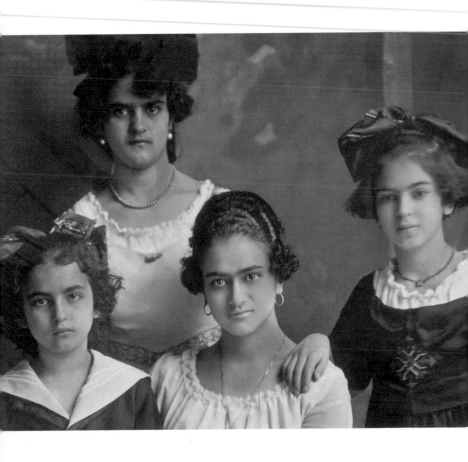

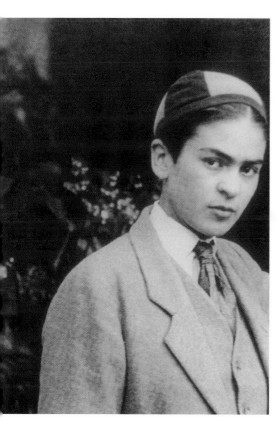

Frida dressed as a boy, ca. *1926.*
ᧄ

Page 4: The Kahlo sisters: Cristina,
Adriana, Matilde and Frida,
photographed by their father.

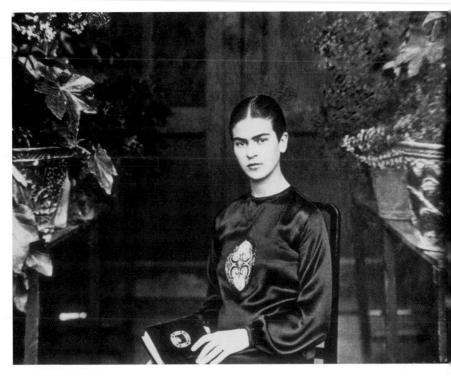

Frida in 1926 (photograph by Guillermo Kahlo).
ॐ

*Page 7: Carlos Beraza (Adriana's stepson),
Alfonso Rué, Frida, Consuelo Navarro and
Cristina Kahlo.*

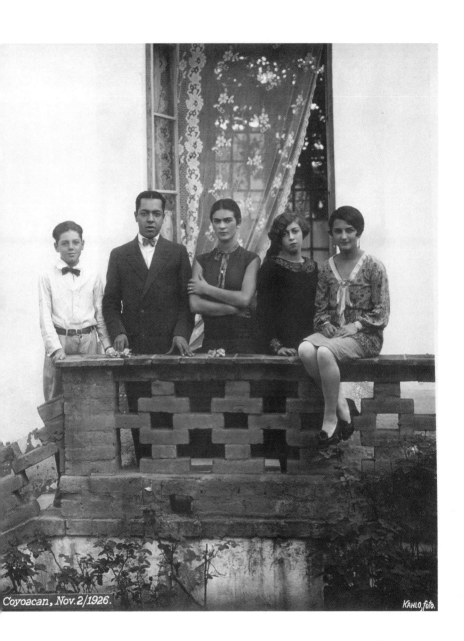

Coyoacan, Nov. 2/1926.

KAHLO, foto.

7

*Part of the garden of
the house in Coyoacán
(photograph by
Guillermo Zamora).*

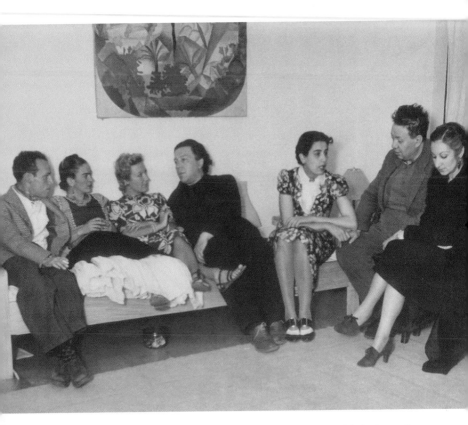

Frida with Jacqueline and André Breton, Lupe Marín, Diego Rivera and Lola Álvarez Bravo in Mexico City in 1938.

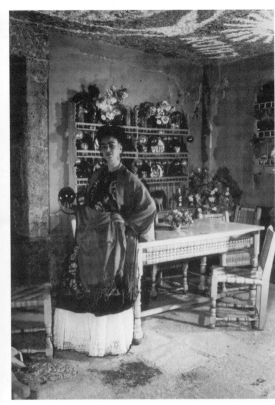

Left: Frida in the dining room of the house in Coyoacán.

ॐ

Below: Frida at the home of her friend Arcady Boytler.

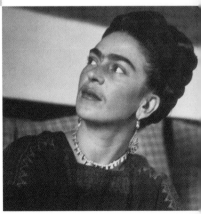

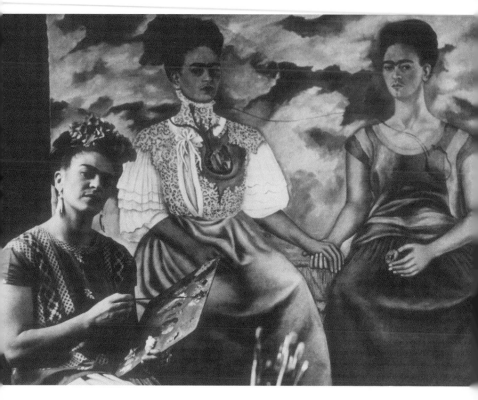

Frida painting The Two Fridas, *1939.*

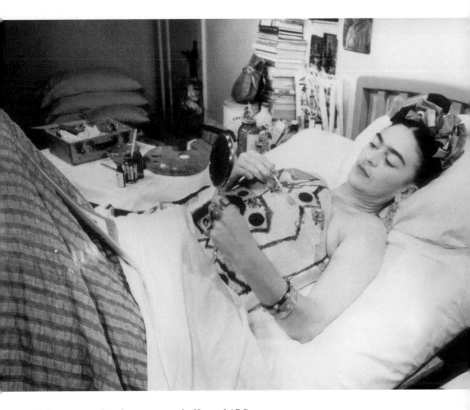

*Frida painting in her plaster corset in the Hospital ABC
in November, 1950 (photograph by Juan Guzmán).*
ᘒ

*Pages 14–15: Letter from New York addressed to
Isabel Campos, November 16, 1933.*

Chato sé por Carlitos que de repente me es
be, pero quiero que tú me platiques de todos.
Me encontré aquí el otro día a uno de los muc-
chos López, no me acuerdo si es Heriberto o su
hermano, pero estuvimos platicando de Uds.
con mucho cariño. El está estudiando en la
Universidad de New Jersey y está contento aquí.

Cristi me escribe poco, pues está ocupada
con los niños así es que nadie me cuenta de U
no sé si verán de vez en cuando a Mati ahora
que vive en Coyoacán, pero ella no me dice
nada. ¿Qué se han hecho las Canet? Chab...
ya debe estar enorme y lo mismo Lolita tu her-
mana, ya ni las conoceré cuando las vea. ¿
Si sigues aprendiendo inglés y si nó, ahora que
llegue, te enseño, pues ya "ladro" un poco
mejor que el año pasado. Te quisiera contar
en esta carta _miles de cosas_ pero se volvería
un periódico, así es que prefiero guardarmel...

Letter from New York addressed to Isabel Campos, November 16, 1933.

Dime qué quieres que te lleve yo de aquí, pues ay cosas tan chulas y tantas que no sé ni que ría bueno llevarles, pero si tu tienes especial gust or algo nada mas me hablas y te lo llevo

Ahora que llegue yo me tienes que hacer un banquete de quezadillas de flor de calabaza y pulquito, pues ya nada más de pensar se me hace agua la boca no creas que me estoy encajando y ya desde aquí te exijo que me des el banquete nada más te lo recuerdo, para que no te hagas de la vista gorda, ahora que llegue

¿Que has sabido de las Rubí, y de toda la gente que antes eran nuestras amigas? Cuéntame algunos chismes, pues aquí nadie me platica y de cuando en cuando los chismes son muy agra- dables al oído. Dales muchos besos a tío Panchito y Lolita y a tía Chona también, (pues a mi si me quiere) para todas Uds. pero especialmente para ti aqui van mil toneladas de besos para que los repartas y te quedes con la mayor parte.

No dejes de escribirme, mi dirección es: Hotel Brevoort 5th Ave. at 8th Street N.Y.C. New York.

Tu Cuate que no te olvida

MEXICO

NO SE OLVIDEN DE MI.

Frieda

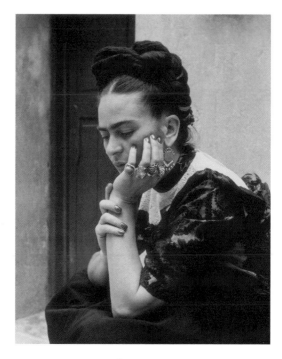

Portrait of Frida by Lola Álvarez Bravo.

[34]

Letter to Ella and Bertram D. Wolfe

Thursday, October 18th, 1934

Ella and Boit,

It's been so long since I wrote you that I don't even know where to begin this letter. But I don't want to give you long and boring pretexts and tell you lengthy stories about why I haven't written for so many months. You know everything that has happened, and I think you will understand my situation, even if I don't give you all the details. I have never suffered so much and never believed I could endure such sorrows. You can't imagine the state I'm in and I know it's going to take me years to free myself from this tangle of things I have in my head. At first I thought there was still a solution because I imagined that what happened would be something that lasted a short time and without importance, but I'm more convinced every day that I was deceiving myself. It is something serious and also has serious consequences, as you must imagine.

In the first place, it's a double sorrow, if I may put it that way. You know better than anyone what Diego means to me in all senses, and then, on the other hand, she was the sister I most loved and that I tried to help as much as I could, so the situation became dreadfully complicated and gets worse every day. I would like to able to tell you everything so you could clearly understand what this has been for me; but I really do think I'm going to bore you with this letter, for I'm not going to speak of anything but myself; just imagine that if I write you the details of the matter you would come running without finishing the letter; and I don't want you to think I'm a gossip and that I like to fill letters

129

with useless gossip; but I've wanted to write you for a long time and tell you what was happening, knowing that you as no one else would understand why I was telling you and why I suffer so.

I love you both very much and trust you enough not to conceal the greatest sorrow of my life and that's why I have decided now to tell you all.

Of course the thing is not just sentimental foolishness on my part, but something that affects my whole life and that's why I feel as if lost, without anything that can help me react in an intelligent way. Here in Mexico I have no one, I had only Diego, and the members of my family, who treat the matter in a Catholic way, and I am so far from the conclusions they draw that I can count on nothing from them. My father is a magnificent person, but he reads Schopenhauer day and night and doesn't help me in the least.

I have been so ill that it was only when I left the hospital that I started to paint a bit, but without enthusiasm, and without the work giving me anything me at all. I don't have any friends here. I'm completely alone. Before I would spend my days sobbing with grief and rage against myself; now I can't even manage to cry because I understood how stupid and useless it was. I trusted that Diego would change, but I see and know that it's impossible and just stubbornness on my part, since I should have understood from the beginning that I'm not the one who will make him live in such or such a way and much less in a matter of this nature. Now that he's working he's the same, and all my hopes were that by working he would forget about everything, but on the contrary, nothing can keep him from what he believes and considers well done.

In the end any attempt on my part is ridiculous and idiotic. He wants his complete freedom. A freedom he always had and would have had now if he had acted sincerely and honestly with

me; but what makes me saddest is that now not even the part of being friends that there used to be between us exists anymore. He's always telling me lies and he conceals every detail of his life from me as if I were his worst enemy.

We're living a life that is false and full of stupidities that I can't bear any longer. He has his work in first place that saves him from many things, after all his affaires that amuse him. People seek him out and *not me*; I know that as always he's full of bothers and worries at work, but nevertheless he lives a complete life without the stupid emptiness of mine. I don't have anything because I don't have him. I never thought he meant everything to me and that apart I was worth just trash. I thought I was helping him to live in so far as I could, and that in any situation I could resolve my life without there being complications of any kind. But now I see I have no more than any girl disappointed in love whose man has left her; I'm worthless, I don't know how to do anything, I'm not sufficient unto myself; my situation seems to me so ridiculous and so idiotic that you cannot imagine how I dislike and hate myself. I've wasted the best time living at the expense of a man without doing anything but what I believed would help him and be useful to him. I never thought of myself, and after six years his response is that fidelity is a bourgeois virtue and only exists to exploit and gain economic advantages.

Believe me I never thought of all this from that point of view, I know I was stupid, as much as you wish, but sincerely stupid. I imagine, or rather I hope, that I'll react little by little, that I'll try to make a new life, becoming interested in something that allows me to free myself of this in the most intelligent way possible. I thought of going to New York and living with you two. From the money Diego gave me to put aside I bought a house cheaply enough in Mexico City, for I

didn't want to go back to San Ángel where I suffered as you can have no idea. Now I live at Insurgentes 432 (write me here). Diego comes occasionally to visit but now we have nothing to say to one another nor is there any connection between us of any kind; he never tells me what he's doing nor is he in the least interested in what I do or think. When things have reached that point it's better to cut them off at the root and I think finally that's going to be the solution for him, since for me it will cost as much suffering or more than what I have had and have, which is already indescribable; but for him I think it will be better, for I won't be a burden as all the others have been, and I won't accept just being a money problem for him. So that's my life for the time being. I don't know what I'll do tomorrow, but I think the only remedy is to separate from Diego, as I see no reason for us to live together with me causing him problems and keeping him from having the complete freedom he demands. Nor do I want to give him the life Lupe gave him with lawsuits, and so I'll let him live, and with all my bourgeois prejudices of fidelity, etc., etc., I'll go with my music to some other place. Don't you think that's best?

I beg you not to say anything to Malú.; if she already knows, as I imagine she does, since it has been public knowledge due to Diego's behavior, let her make any comments alone, I no longer want anyone to know anything and let them imagine what they want.

I don't know what you'll think of me, but everything I have written to you here has been as if I were confiding to you with my heart on my sleeve.

You will neither take Diego's side nor mine, but rather simply understand why I have suffered *so much*, and if you have a moment free you'll write me, won't you? Your letters will be an immense consolation and I'll feel less alone than I am.

I send you a thousand kisses, and don't take me for an annoying sentimentalist and an idiot for you both know how I love Diego and what it means to me to lose him.

<div align="right">Frieda</div>

My address: Insurgentes 432, Mexico City.

<div align="center">ॐ</div>

The cause of Frida's suffering was the intimate relationship between Diego Rivera and Cristina Kahlo.

Letters to Doctor Leo Eloesser

{a}

Mexico City, October 24th, 1934

[...] I have suffered so much during these months that it will be hard to feel entirely well in a short time, but I've done everything in my power to forget what happened between Diego and me and to live again as before.

[...] My foot is still bad, but there's no help for that and one day I'm going to make up my mind to have them cut it off so it doesn't bother me so much. [...]

{b}

November 13th, 1934

[...] I think that by working I will forget my sorrows and I'll be able to be a little happier. [...] I hope the stupid neurasthenia I have soon goes away and my life becomes more normal again but you know that for me it's quite difficult and I'll need a lot of will power to reach the point where painting or doing anything else even makes me enthusiastic. Today was Diego's saint's day and we were happy, let's hope there are many such days in my life. [...]

{c}

Mexico City, November 26th, 1934

[...] I'm in such a state of sadness, boredom, et cetera, et cetera, that I can't even do any drawing. The situation with

Diego gets worse every day. [...] Now, after months of veritable torture for me, I forgave my sister and thought that would change things a little, but it was just the contrary.

LETTER TO DIEGO RIVERA

July 23rd, 1935

[...] a certain letter that I saw by chance in a certain jacket of a certain gentleman, and which came from a certain miss of distant and goddamned Germany, and who I imagine must be the lady Willi Valentiner was kind enough to send here to amuse herself with "scientific", "artistic" and "archaeological" intentions [...] made me very angry and to tell the truth *jealous*. [...]

Why must I be so stubborn and dense as not to understand that the letters, the skirt-chasing, the "English" professors, the gypsy models, the "good will" assistants, the disciples interested in the "art of painting", and the "plenipotentiary envoys from distant parts", only signify amusements and that at bottom you and I love each other very much, and even if we go through countless affaires, splintered doors, insults and international claims, we shall always love each other. I think what it is, is that I'm a little stupid and just a bit of a dissembler, because all these things have happened and happened again for the seven years we've lived together and all of the rages I've gone into have only led me to understand better that I love your more than my own skin, and though you don't love me the same way, in any case you love me somewhat, no? Or if that's not true, I'll always have the hope that it may be, and that's enough for me...

Love me just a little. I adore you

Frieda

[37]

Notes for Alberto Misrachi

{a}

Alberto,
Sorry for the nuisance, but I don't know when Diego will arrive, I implore you to send me 200 *eagles* since I have to pay the taxes on all of the houses.

A thousand thanks and lots of regards.

Frieda

Oct. 28, 1935
I.O.U. $200.00
Frieda Kahlo de Rivera

ॐ

Alberto Misrachi Samanon, born in Monastir when it was under Greek sovereignty, arrived in Mexico at the beginning of the 1920s. Shortly thereafter he established the bookstore Central de Publicaciones at Juárez 18, moving it in 1935 to Juárez 4, where he adapted the cellar for the sale of works of art, especially ones by Diego Rivera. In 1937 Frida painted Misrachi's portrait. She had a good relationship with him and his wife Ana.

{b}

Albertito,
The bearer of this letter is a lady who sold Diego a Tehuana outfit for me. Diego agreed to pay her today, but as he went to Metepec with some gringachos, I didn't remember to ask him for a few centavos early and he left me without cash. In short, it's a matter of paying this woman $100.00 (one hundred

eagles) and putting it on Diego's bill, with this note serving as a receipt.

> Gratefully
>
> Frida

<p style="text-align:center">{c}</p>

I'm going to implore a favor of you, that you give me an advance on next week, since for this one I don't have a cent, after paying you the 50 I owed you, the 50 to Adriana, the 25 that I gave to Diego for the outing on Sunday, and the 50 to Cristi, and I left myself destitute.

I didn't ask Diego for the check because I didn't want to be a nuisance, for I know he's very broke, but since in any case you'll have to give me my money for the week on Saturday, I preferred to ask you, and on Saturday you won't give me any cash, until the following week. Would you? Please deduct the $10.00 I owe Anita from the $200.00, and pay it to her for me, because she lent it to me on Friday in Santa Anita (don't forget to give it to her, because she'll say I'm a *buten* thief if I don't pay her).

Thanks for the favor and many regards.

LETTER AND DEDICATION TO HER SISTER
LUISA KAHLO CALDERÓN

Darling Luisita,
A thousand thanks. I'll leave everything in it's place. I also
leave a thousand kisses all over your little room.
　　Your sister
　　　　　Frida

ॸ

Luisa lent Frida her room near the Cine Metropolitan for surreptitious encounters.

[ON A PHOTOGRAPH]

For Matita and Paco from their sister Frida the goat.
　　It looks like I'm going to start drooling, but no, I was talk-
ing. Don't you believe it?

LETTER TO ELLA WOLFE

Mexico City, March, 1935

Darling Ella,

It was so nice to receive your letter that just for once I'll be a good girl and answer you right away. Martín will have told you everything that's happened to me in these last months so I won't bother you with the details of the adventures, vicissitudes and commotions of the powerful *Chicua* Rivera. My paw, paunch, etc., etc., are almost fine and you don't have to worry about my health. It's only my head that continues functioning awry and there's no help for that because I was born "loco" and loco I shall die, but even so you love me, no?

I read your letter to Diego and he wants me to tell you more or less what he's going to write to Boit in an upcoming letter that he has planned out. I think it's a good idea for me to go ahead and give you his answer, because Boit may get tired of waiting for the letter and it will reach him when the whole world speaks Esperanto and Diego will think that barely a week has passed since the arrival of your letter; so I'll more or less tell you what Diego said you should explain to Bert. As far as the biography is concerned there's not even anything to discuss, as you and all of us know that Bert *must* write it. The letter Diego wrote to the people at the Guggenheim was very good and I think they will respond favorably. Diego says that of course *he will be delighted* if Bert does it. He had a serious disagreement with Harry Block and told him to go to hell, for just imagine he turned out in the end to be a simple bootlicker of Stalin with the idea of doing political work here in favor of the

C.P. by all the stupid and disgusting methods of all the Stalinists; so it turned out to be better that all friendly relations between Harry, Malú and us had ended, since the matter of Siqueiros which you must be well aware of.

Diego thinks that if Covici Friede is to do the book, Bert should first of all find out in detail about the question of price, royalties, etc., since with "Portrait of America" Covici swindled Diego out of some money, and that could be avoided with this book by rectifying all these things in the contracts from the beginning, don't you think?

The most important thing is the following: Diego thinks the frescoes painted in Mexico are not as interesting, plastically, as those he painted in the United States, and that of course the "Portrait of Mexico" should be done taking *more into account* any *political and social* interest the frescoes may have, and using the analysis of them as a pretext for arriving at a clear and open analysis of the current political situation in Mexico, which is extremely interesting, and making the book something useful for the workers and campesinos, avoiding as much as possible an exaggeration of the artistic value of the paintings without reference to their political content; but naturally Diego would perform this analysis, which would be thorough and precise, *in complete accordance with his political line*, which he has always held, and all the more so now after the disgusting stratagems of the C. P. Here in Mexico and all over the world. In this case I don't know what Bert will think, since you know the differences there are between them and I think it's very important that they speak frankly in this sense from the beginning, because Diego would not accept doing the book except in the way I have explained, so I think it would be good if you ask Bert what he thinks of the matter and if he believes Diego and he could come to an agreement, or tell

him to write Diego personally suggesting some way of doing the book without causing conflict between the two of them. Apart from that I don't think anybody could write the book better than Bert, and of course Diego couldn't do it with anyone as well as with him. Tell Bert all this and answer me right away so I can tell Diego what you both have thought.

I want this letter to go off today so I don't have time to tell you a lot of things I'd like to, but I'll soon write you a powerful letter so full of nothing but gossip about myself that it could fill a *New York Times*.

Give my regards to Jay (give him a smacking kiss), to Lucy and to Dimi and all the *cuates*.

For you, darling, millions of kisses divided between you, Boit, your Mom and Dad, brothers and sisters, etc.

Some special ones for you from *la*

<div align="right">Chicua</div>

MISSIVE TO THE COMPOSER CARLOS CHÁVEZ

Mexico City, March 17ᵗʰ, 1936

Mi querido cuatezón	*My dear cuatezón,*
Aquí va la contestada…	*here goes my answer…*
con estilo algo guazón	*in rather jesting style*
pero aprisa y detallada.	*but quickly and in detail.*
Di cuenta de tu misiva	*I gave account of your missive*
a Diego, con gran premura,	*to Diego with great haste,*
y sin ser muy abusiva,	*and without taking advantage*
voy al grano con largura.	*I'll go slowly to the point.*
De los dibujos el precio	*The price of the drawings*
le parece bien planteado,	*seems perfectly fair,*
le va a dar rete que recio	*he'll give all he's got*
para no hacerse de lado.	*not to be left out.*
Sin embargo teme y duda	*But still he fears and doubts*
que Rockefeller la vieja,	*whether old lady Rockefeller,*
siendo necia y testaruda	*being stubborn and pigheaded,*
dé el permiso la… pendeja.	*will give permission… the imbecile!*
Lo que sepas al respecto	*Whatever you find out,*
avísalo por avión	*inform us by airmail*
para que salga perfecto	*so that everything turns out*
el asunto, cuatezón.	*perfectly, cuatezón.*

Que le manden los contratos	*Have them send the contracts*
en carta certificada	*by registered mail*
para terminar los tratos	*to close the deal*
y pa' echarles su firmada.	*and sign on the dotted line.*
Pide de adelanto poco	*Ask for a small advance,*
cincuenta dólares primero,	*fifty dollars up front:*
si esto te parece loco	*if that seems crazy,*
saca más correas al cuero.	*squeeze out what you can.*
Ya con esta me despido,	*With this I close,*
a escribir más ya me niego,	*to write more I refuse:*
aquí termina el corrido	*here ends the corrido*
de Carlos Chávez y Diego.	*of Carlos Chávez and Diego.*

Listen, brother, tell me where I can get a copy of *Antigone* so Diego can take a look at it, and from the verses you know what Diego said about your last letter. If you need more details, tell me.

Of course he has accepted and tell what's his name to send the contracts.

In total Diego will only have to do the drawing of *Antigone*, no? Because the others depend on Mrs. Rockefeller and you'll have to get her permission. I think that's all and at the moment I don't have time to tell you a great deal of gossip, but I send you plenty of regards and the same goes for Diego. Your *cuate*,

Frieda (the Powerful)

Also arrange about the fifty dollars Diego is asking in advance.
Regards to el Chamaco and Rose (Covarrubias).

144

The composer Carlos Chávez had arrived in New York on December 10, 1935. On January 23 he conducted the Columbia Radio Symphony Orchestra in the premiere of his Sinfonía India. *In spite of his own occupations, he found time to perform some errands for his old friend Diego Rivera concerning the possible publication of a book of drawings, which would include the "First of May" series executed in Moscow in 1928. Forty-five of these drawings had been purchased in 1931 by Abby Aldrich, the wife of John D. Rockefeller, Jr. Chávez's reply was also in verse.*

LETTER TO BERTRAM D. WOLFE

Mexico City, March 24th, 1936

Dearest *cuate*, *compañero*, comrade, General and friend Bertrancito:
Your letter arrived yesterday and I'm immediately obeying
your orders by answering you today so that this letter gets to
you on wings and you can without loss of time arrange every-
thing that has to be arranged and come to this beautiful city of
the Palaces. Be good enough to bring Ella, since alone you'll
get lost on the way. If you don't bring her I'll be *very* angry with
you, and it could come to blows when you arrive in the station
and I don't see that girl with you whom you and I love so much
and whose name is Ella.

The news of the Guggenheim was as if the roof fell in for
both Diego and me, for we were sure they would give you the
grant, but you can't expect anything from those honey-tongued
asses of the capitalist sons of.... their newlywed mother. Still,
we're delighted you're coming in spite of them and that you'll
write the book and stick it in their faces.

Diego agrees with what you say in your letter, and we just
want you to hurry up and get here as soon as you can, for that
day we'll celebrate with *mariachis*, *pulque curado*, turkey *mole* and
dances with heel-tapping. Tell Ella not to begin to make
excuses and decide not to come at the last minute because real-
ly I'll fall out with her.

You know *cuate* that my house is here for both of you, wide
open like my heart, and as soon as you arrive you'll see how you
rest a little from the beautiful New Yorks, for both you and Ella
deserve at least to lie on your backs in the sun for an hour a day

and not worry so much nor work like burros all your lives. So arrange things in advance and without backing out come both of you like good little children, to live for a while, a life different from the agitated one in New York City.

What do you say Kid?* Please don't back out and back down, for I'm so looking forward to when you arrive in this populous and never sufficiently appreciated Mexicalán of the prickly pear.

I want this letter to go off on wings, that is by airmail, so it gets to your hands as soon as possible, so I don't have time to tell you any gossip or other things, but I've told you the most important thing and am just waiting for your answer to know if having you here will really come true or if I'm just daydreaming.

Do you know who's in Mexico? The wife of Ernest Born, the one who did the reproductions of the School in *Architectural Forum*. There's a whole flock of people you know here, and it's going to be swell when you two arrive.

Well *cuatezón*, I'll say goodbye in the hopes you'll tell me when you're coming and then you'll make happy

Chicua Rivera and her paunchy beloved

A thousand kisses for Ella.

Regards to all the *cuates* (very specially to Jay).

Diego will write soon.

LETTER TO CARLOS CHÁVEZ

April 29th, 1936

Brother,

I received your poem, I don't need to tell you I liked it a lot. You know well enough. I would like to answer you in verse, but this time I'm just not in the mood, since for two weeks now Diego and I have been in the Hospital Inglés. They operated on my foot again with rather doubtful results, for my hoof just doesn't want to heal. But that is the *least* of my worries. I'm sadder than you can imagine because of Diego's illness, for his eye is very bad. I've spent a few days as never in my life, well, now I'll tell you everything in more detail.

Diego's left eye started to bother him about a month ago; at first we thought it wouldn't be important for as you know he has often had problems with his eyes but without greater consequences. But now it's a serious infection in his tear duct (they did an analysis of the secretions) and it turns out he has streptococci. We have seen *every* oculist in Mexico City. They all say the same thing, that it's dangerous and he even risks losing his eye in the case of the least injury to the conjunctiva, something that could easily happen with any particle of dust or foreign agent that directly injured the eye in the delicate state it's in. The microbes have infiltrated his skin and the tissue of his eyelid, the lower part of his face and his forehead, so he has a terrible swelling that almost closes one of his eyes. There was a moment when we thought everything was lost and you can imagine his situation and my anguish. (I can't even express it to you in words.) It seems the swelling has been going down for

the last three days and there's hope that there will be no more serious consequences, but Doctor Silva says the danger is not past yet and it's a matter of some time yet. He is confined to a darkened room and the poor thing is really desperate (rightly so) and I am helpless and can hardly see him, for I can't walk yet, and even if I could walk, I couldn't solve anything or do anything for him, that's what's driving me crazy with anxiety. We think if he doesn't get better this week the best thing would be to take him to New York to see what the oculists there could do for him, but I don't think it's precisely something local to his eye but rather his general state, and that everything is connected to his thyroid deficiency, also I think a journey in the state he's in would be terrible and a responsibility that afterwards one wouldn't know what to do in the event of something happening because of the journey. So here you have me, desperate, rendered an idiot without even knowing how to resolve this situation. Naturally nothing is gained by stupidities and desperation, and I think the most reasonable thing would be to wait for the injections of "pyophormina" they have given him and the treatment Doctor Silva is giving him to take effect, for it would be worse to do something stupid and wait for a miracle for something that has to take its natural course. But what pains me most is to see him so weakened and the danger that he could develop septicemia from this focus of infection or something that spreads and that he couldn't combat due to his general state. I don't even want to think of it.

I want you to tell me please what you think, what would be the best thing to do, and if you think it would be easier to find a good doctor in New York or is that just one of my prejudices, for there too there are crowds of sweet-talking racketeers who might even do him worse. Nevertheless your opinion would console me, for you have no idea how grieved and sad I am

because of Diego. I don't need to explain any more, for you are fond of him and you know what that means to him.

Forgive me for only talking in this letter about the sorrow I have, but you will understand, you know how much I would like to talk to you about many other things and especially of how happy I am for all you have achieved here. Believe me that it's been a joy to me.

Please write me, you'll help me a lot to feel stronger and to wait for whatever comes with tranquility. Let's hope Diego is a bit better by the time your letter arrives, for that's what we all want and *I more than anybody*.

Say hello to Miguel and Rose (Covarrubias).

Try to come back soon because you are very much missed. I'm waiting for your letter. Diego sends his regards.

Best memories and an embrace from

Frieda

Please try to find out who the best oculist is there and the question of prices in hospitals, etc.

I would also very much appreciate your seeing Dr. Claude (I gave you his telephone number in my last letter but if you've lost it you can always reach him in the mornings at the Rockefeller Institute (Dr. Albert Claude) and more or less explaining Diego's case to him. Here's the complete name of the microbes:

Hemolytic streptococci. They have invaded the entire left tear duct and infiltrated the facial tissue (left side). It would be interesting to know his opinion.

꒰ꙮ꒱

Frida had a long a cordial relationship with the caricaturist, painter and anthropologist Miguel Covarrubias and his wife, the dancer, painter and photographer Rosa Rolando, who lived in the United States in the 1930s and spent short periods in Mexico.

[43]

LETTERS TO DOCTOR LEO ELOESSER

{a}

July 12th, 1936

[...] to go to some little village where there's nothing but Indians, tortillas, beans and lots of flowers, plants and rivers...

I'm finishing my portrait, the one you asked me for in your letter form Russia. [...]

{b}

December 17th, 1936

[...] would be to go to Spain, because I believe now it's the center of what is most interesting that could happen in the world [...] among the most enthusiastic there have been is the welcome all the workers' organizations in Mexico have given to this group of young militia men. Many of them have agreed to vote a day's wages in aid of the Spanish comrades, and you can't imagine how moving it is to see the sincerity and enthusiasm with which the poorest campesino and workers' organizations, making a veritable sacrifice, for you know very well under what miserable conditions people live in the little villages, have given, nevertheless, an entire day of what they have for those now fighting in Spain against the fascist bandits. [...] I have written to New York and other places and I think I'll manage some aid, which, though small, will mean at least food or clothing for some of the children of the workers fighting at the front at this moment. I would beg you to do all you can to make propaganda among our friends in San Francisco...

{c}

January 30th, 1937

[...] the strongest and most energetic hope that fascism be crushed in the world. [...]

[44]

Note for Alberto Misrachi

Albertito,

I received another telegram from Diego and he says he won't arrive until tonight, *late*. I have to bother you for my weekly stipend because yesterday I got Cristi out of the hospital and paid some extra expenses after all. So forgive the nuisance but Diego will give you the cash today or tomorrow.

Many thanks.

June 12th, 1937

Received from Alberto Misrachi the sum of $200.00 (Two hundred pesos) for the week of Saturday the 12[th] of June to Saturday the 19[th].

Frida Kahlo de Rivera

DEDICATION TO LEON TROTSKY
ON A SELF-PORTRAIT

To Leon Trotsky with all my affection I dedicate this painting,
November 7th, 1937.
<div align="center">Frida Kahlo</div>

In San Ángel.
 Mexico

<div align="center">ꙅꙅ</div>

*On that day, the Russian revolutionary Lev Davidovich Bronstein, known as Trotsky, exiled in the
house at Allende and Londres in Coyoacán, turned 58 years of age.*

[46]

LETTER TO LUCIENNE BLOCH

[Originally in English]

February 14th, 1938

Darling Lucy,

When your letter arrived, I was feeling lousy as hell, I been having pains on my damn foot for a week, and probably I will need another operation. I had one four months ago, besides the one they made when Boit was here, so you can imagine how I feel, but your letter came, and believe it or not, gave me courage. Yes Kid, you don't have any bad foot, but you are going to have a baby and you are still *working*, and that is really swell for a young kid like you. You don't know how happy I am with such news, tell Dimi that he is behaving O.K. and for your Kid, all my congratulations. But... please do not forget that I must be the godmother of that baby because, in first place, it will be born the very same month that I came to this damn world, and in second place, I will be damn switched if somebody else would have more right than I to be your "comadre", so keep that in mind.

Please darling take good care of yourself. I know you are strong as a rock, and Dimi healthy as an elephant, but nevertheless you should be very careful and behave as a good girl. I think you shouldn't monkey around too much on the scaffolds, and besides you should eat well and at regular hours, otherwise it is not worthwhile to risk the whole thing. I am talking now as a grandmother, but... you know what I mean O.K.

Now I will tell you some things about myself. I haven't change very much since you saw me last. Only I wear again my

crazy Mexican dress, my hair grew longer again, and I am as skinny as always. My character hasn't change either, I am as lazy as always, without enthusiasm for anything, quite stupid, and damn sentimental. Some times I think that it is because I am sick, but of course that is only a very good pretext. I could paint as long as I wished, I could read or study or do many things in spite of my bad foot and other bad things, but there is the point, I live on the air, accepting things as they come, without the minor effort to change them, and all day long I feel sleepy, tired and desperated. What can I do? Since I came back from New York I have painted about twelve paintings, all small and unimportant, with the same personal subjects that only appeal to myself and nobody else. I sent four of them to a gallery here in Mexico, the University gallery, which is a small and rotten place, but the only one which admits any kind of stuff; so I sent them there without any enthusiasm. Four or five people told me they were swell, the rest think they are too crazy.

To my surprise, Julian Levy wrote me a letter, saying that somebody talked to him about my paintings and that he was very much interested in having an exhibition in his gallery. I answered sending few photographs of my last things, and he send another letter very enthusiast about the photos, and asking me for an exhibition of thirty things on October of this year and he wants to have Diego's exhibition at the same time, so I accepted, and if nothing happens in the meanwhile, I will go to New York in September. I am not quite sure that Diego will have his things ready for then, but perhaps he will come later, and after to London. Such are the projects we have, but you know Diego as well as I do, and... quién sabe lo que pase de aquí a entonces. I must tell you that Diego painted recently a series of landscapes. Two of them, if you trust my own taste, are the best things he ever painted in his whole life. They are

simply gorgeous. I could describe them to you. They are different to anything else he painted before, but I tell you they are magnificent! The color, Kid, is incredible, and the drawing, gee, it's so perfect and strong, that you feel like jumping and crying of joy when you see them. One of them will be very soon at the Brooklyn Museum, so you will see it there. It is a tree on blue background. Please tell me your opinion after you have seen it.

Now that I know that I will have this exhibition on New York, I am working a little bit more to have the thirty damn paintings ready, but I am afraid I will not finish them. We will see.

Reading the *Workers Age* I noticed a great change on your group, but still you have the attitude of a good father trying to *convince* a son that he is wrong but having a great hope that the child will change with your scoldings. I think that this attitude is even worse than the bad behavior of the child. Nevertheless you are admitting little by little many things you thought were all [...] We have many things to talk about this business, but I am not going to bother you now with such stuff after all my opinion in this matter is damn unimportant.

I have many, many interesting things to tell you besides differences of opinion. In September we will talk for hours. Now I only can tell you that his coming to Mexico has been the swellest thing ever happened in my life.

About Diego I am happy to tell you that he feels very well now, his eyes don't bother him any more, he is fat but not too much, and he works as always from morning to night with the same enthusiasm; he still behaves sometimes as a baby, he permits me to scold him once in a while without abusing too much of that privilege naturally; in one word, he is pretty swell guy as ever was, in spite of his weakness for "ladies" (most young Americans who come to Mexico for two or three weeks

and to whom he is always willing to show his murals outside of Mexico City) he is as nice and fine boy as you know.

Well darling, I think this letter is already a magazine for my character. I told you all I could, taking account of my bad humor in this moment having pains on my foot, etc., etc. I will send this letter today, air mail, so you will know a word about this lousy person.

Please give my love to Dimi, and tonight, after you go to bed, make some nice caresses on your belly, thinking I make them myself to my future godchild. I am sure it will be a girl, a little nice beautiful girl made with the best chosen hormones from Lucy and Dimi. In case I fail, and it happens to be a boy, gee! I will be proud of him just the same, anyway, boy or girl I will love it as if it were the child I was going to have in Detroit.

Give my love to Ella and Boit, tell them that in spite of my silence I love them the same old way. Give a kiss to Jay Lovestone, don't pay any attention in case he blushes, just give it in my name.

To Suzy also give my love and my best congratulations for the new little mathematician she will bring to the planet. And... one favor, when ever you happen to pass near Sheridan Square, go to the third floor and give my regards to Jeanne de Lanux, and leave a little paper with one kiss painted with lipstick for Pierre. Will you do it? O.K. Thanks a lot.

Write to me more often. I promise to answer.

What about your father? And your Mommy?

Here goes my love to you dear Lucy; as soon as we know the sex of the baby, I will send a present for the future citizen of the World.

Your murals of which you send photos last year were swell. Diego thought it so also. Send us photos from the last ones. Do not forget. Thank you for your letter, thank you for

remembering me and Diego and for being a nice kid wanting to have babies with such strong clean and wonderful enthusiasm. Diego sends you both his best regards and *un abrazote* de felicitación por el futuro niño.

<div align="center">Frida.</div>

<div align="center">᠅</div>

The University gallery was under the direction of Miguel N. Lira at the time.

The exhibition of 25 paintings in the Julien Levy Gallery opened on November 1, 1938.

[47]

LETTER TO ELLA WOLFE

Wednesday the 13th, 1938

Dear Ella,

It's been ages since I wanted to write you but as always I don't know how I get mixed up and never answer letters or behave like a decent person... Well, girl, let me thank you for your letter and your kindness in asking about Diego's shirts. I'm sorry I can't give you the measurements you ask for, for much as I search around the collar, I can't find even a trace of what could be called a number that indicates the thickness of the neck of Don Diego Rivera y Barrientos, so I think the best thing, if this letter arrives in time, which I *very much** doubt, would be to ask Martin please to buy me six of the biggest shirts in the New Yorks, of those it seems almost incredible they are for a person, that is, one of the big ones on the planet, commonly know as Earth. I think you can get them in the stores for sailors, there on one side of New York, which I... can't remember how to describe to you as I should. And if you can't find them, well... too bad. O.K. In any case, I thank you for your trouble, and Diego thanks Martin for his.

Listen, girl, a few days ago Diego received Boit's letter, he asks you to thank him on his behalf and please to send with Martin the "dough" from Covici and the "dough" from the man who bought the drawing or water color. Diego says that in fact several letters have gone lost and the reason Boit gives in his letter is precisely the true one. So it would be good if anything to do with the powerful and never sufficiently appreciated "dough" be sent special delivery, to keep the others from getting to it first. As you see, my vocabulary gets more flowery every day, and you can understand

the importance of such a cultural acquisition, within my already extensive and most abundant learning. Diego asks that you give his regards to Boit, as well as to Jay and Jim and to all the *cuatezones*.

If you want to know something about my singular person, here goes: since you two left this beautiful country, I have continued to have problems with my hoof, that is, my foot. With the last operation (exactly a month ago), zero and that makes four times they have taken the butcher's knife to me. As you will understand, I feel truly "poifect" and would like to remind the doctors of all their progenitors, starting with our good parents, in general terms, Adam and Eve. But since that wouldn't be enough to console me and for me to rest avenged for so many "evil doings", I abstain from such reminders and such remembrances, and you have me here transformed into a veritable "saint", with patience and whatever else characterizes that very special fauna. You can tell Boit I'm behaving well now, in the sense that I don't drink as many "copious"... tears... of cognac, tequila, et cetera... which I consider another step in the direction of the liberation of the oppressed classes. I drank because I wanted to drown my sorrows, but the scoundrels learned how to swim and now... I'm overwhelmed by decency and good behavior!... Some other more or less unpleasant things have happened to me, which I shall not proceed to recount due to their insignificance. The rest, daily life, et cetera, is exactly as you know it with the exception of all the natural changes due to the lamentable state in which the world now finds itself. What philosophy and what comprehension!

In addition to illnesses, political problems, visits by gringo tourists, lost letters, Riverian discussions, worries of a sentimental nature, et cetera, my life is, as in the poem by López Velarde... the image of its daily mirror. Diego has also been ill, but now he's almost better; he keeps working as always, a lot and well, he's a bit fatter, he talks and eats as much as ever, goes to sleep in the bathtub,

reads the newspaper in the toilet and amuses himself for hours playing with Don Fulang-Chang, for whom we found a consort, but unfortunately it turned out the lady in question was a little hunch-backed, and the gentleman wasn't pleased enough with her to consummate the expected marriage, so there is no offspring yet. Diego still loses most of the letters that come into his hands, leaves papers everywhere... gets very angry when he is called to table, compliments all the pretty girls and at times... makes himself scarce with certain female citizens who arrive unexpectedly, with the pretext of "showing them" his frescoes, he takes them for a day or two... to see different landscapes... for a change, he doesn't fight as much as before with the people who disturb him when he's working; his fountain pens dry up, his watch is always stopping and every fifteen days he has to send it to have it repaired, he keeps wearing those same big miner's shoes (he's worn the same ones for three years now). He gets furious when the car keys get lost, and they generally show up in his own pockets; he does no exercise and never sunbathes; he writes articles for the newspapers that generally cause a swell rumpus; he defends the Fourth International, with tooth and nail, and he's delighted that Trotsky is here. I've told you more or less the main details... As you may have observed, I've painted, which is something after all, since I've spent my life until now loving Diego and deluding myself about work, but now I keep loving Diego and, also, I've started seriously to paint my little figures. Worries of a sentimental and romantic nature... there have been some but they haven't been more than amusements... Cristi was very ill; they operated on her gall bladder and she was in a lot of danger, we thought she was going to die, fortunately she came through the operation well and for now, though she doesn't feel very well, she is much better... She rather lives in the... ether. She still keeps asking... Who is Fuente Ovejuna? And if she sees a movie and doesn't fall asleep, it's a real

miracle, but at the end of the movie she always asks: Fine, but who's the betrayer? Who's the murderer? Who's the girl? In short, she understands neither the beginning nor the end, and in the middle of the movie she generally yields herself to the arms of Morpheus... Her kids are just darling, Toñito (the philosopher) gets smarter every day and builds a lot of things with his "Mecano" set. Isoldita is in third grade now; she's cute as a button and very mischievous. Adriana, my sister, and her husband the *güerito* Veraza (the ones who went to Ixtapalapa with us) always remember you and Boit and send you lots of regards...

Well, darling, I hope with this exceptional letter you'll begin to love me again, at least a little, until you love me as much as before... return my love by writing me a powerful missive that fills with joy the sad heart that beats for you from here with such force as you can hardly imagine, just listen to it: TIC-TOC TIC-TOC TIC-TOC TIC-TOC! Literature is so bad at representing interior sounds and giving them all their volume, so don't blame me if instead of sounding like my heart it sounds like a broken clock, but... *you know what I mean, my children! And let me tell you, it's a pleasure.**

Lots of kisses for both of you, lots of hugs, all my heart, and if anything's left over divide it among Jay, Jim, Lucienne, Dimy and all my soul mates. Give lots and lots of regards to your Mom and Dad and to the little girl who loved me so much.

Your beloved and dunderheaded *chicua*

Friduchín

༄

Martin Temple, *a wealthy merchant and manufacturer, was a benefactor of left wing groups and individuals.*

Fulang-Chang *was the name of Rivera's favorite monkey.*

The Covici, Friede *publishing house in New York published the books* Portrait of America *and* Portrait of Mexico, *produced in collaboration by Rivera and Wolfe.*

Letter to Alejandro Gómez Arias

New York, November 1st, 1938

Alex, on the very day of my exhibition I want to talk to you even just this little bit.

Everything has been arranged absolutely marvelously and I really do have the luck of a scoundrel. The whole gang here is very fond of me and all of them are exceedingly kind. Levy didn't want to translate the preface by A. Breton and that's the only thing that seems iffy to me, since it looks rather pretentious, but there's no help for it now! What do you think about it? The gallery is swell and they arranged the paintings very well. Did you see *Vogue*? There are three reproductions, one in color -the one that seems swellest to me- and something is going to appear in *Life* this week as well.

In a private art collection I saw two marvels, one by Piero della Francesca, which I think is the most wonderful thing in the world, and a little El Greco, the smallest I've ever seen, but the nicest of all. I'll send you the reproductions.

Write to me if you remember me one day. I'll be here for two or three weeks. I love you lots and lots.

Say hello to Mir and Rebe for me. Áurea is here and more acceptable now than of yore.

ॐ

Frida's exhibition in the Julien Levy Gallery, located at 15 East 57th Street, took place from November 1st to 15th, 1938. André Breton presented the catalogue.

[49]

Letter to Diego Rivera

New York, January 9th, 1939

My child,

Yesterday, when I called you by telephone you seemed a little sad and I've felt a little worried about you. I would like your letter to arrive before I go so I can know the details about things in Coyoacán and how the ruckus is going in general. Three articles have appeared here in the *News* about the old man and the Gen., I'm sending them to you so you can see how stupid they are in this goddamned village, they say Lombardo is a raging Trotskyist, etc., etc.

You know I'm going to spend this last week at Mary's house. Last night they came to get me, because David wants me to get lots of rest and to sleep very well before embarking, for the damned flu has put me in the worst possible state and I feel completely sullen and stupid. I miss you so much my darling that there are moments when I feel like going back to Mexico more than anything else, and I was backing out of going to Paris last week, but since you say it may be the last opportunity I have to go, I'm just going to make up my mind and set off. By March I'll be back in Mexico for I don't plan to stay more than a month in Paris.

I don't know why yesterday was such a bad day for me, I cried almost all day and Mary didn't know what to do with me. Eugenia became tiresome and as you already know how stubborn she can be, when she found out I was coming with my [...] some Mexican women, friends of hers. She was getting on my nerves, for though she's very kind, sometimes she becomes very stubborn and you just feel like hanging the wretch.

Mary will help me pack my clothing and everything, for with the wretched illness I wasn't able to finish doing anything. The painting of Mme. Luce was left halfway and I'll finish it in Paris, for I don't have strength for anything because I had a very high fever for five days and I'm exhausted and just a mess. On top of everything I got my period and I really feel like a wreck. Poor Mary has been like a mother to me and David and Anita as well, they scold me now and then to bring the roof down, for you know how disobedient I am with doctors, but at least things weren't complicated by pneumonia because that would have topped everything. Everyone has bronchitis or something, because it's been cold as hell, and they scold me for not wearing a woolen undershirt, but the honest truth is that they prickle a lot and I just can't stand them against my hide.

How glad I was that you liked the portrait I did of Goodyear, he's delighted and when I return he wants one of Katherine Cornell and of his daughter, but it will be in October when you come with me, for I'm not planning on any more time without you. I need you as I need air to breathe and it's a real sacrifice I'm making by going to Europe, because what I want is my child *next to me*.

I don't know what plans the Bretons have for they haven't written me again at all, they didn't even answer the wire I sent them last week. I think they're going to wait for me in Cherbourg or wherever the boat docks, for I don't know what I would get myself into all alone in those lands that I don't even know from pictures.

My life, don't play too much with Fulang for you know what he did to your eye, better just watch him from afar, but don't let him hurt you seriously one day because I'll kill him. And the raccoon? It must be enormous by now. Don't let it hunt too often because that's not good for it.

Have you taken my bicycle up to my bedroom? I don't want the kids to take it on me, and it will be better if you keep it upstairs for me. Is Lupe behaving well? And what happened to Carmelita? Give my regards to all of them and especially to General Trastorno.

Do you ever see Ch. Hidalgo? Tell him I haven't forgotten about his gloves and sweater. My little boy, tell Kitty to darn your clothing, to keep it nice and clean for you and to call the "perruquier" whenever you need him. Don't forget to bathe and to take good, good care of yourself. Don't forget that I love you more than my own life, that I miss you more and more every minute. Behave yourself, *even if you amuse yourself* don't ever stop loving me at least a little bit. I'll write you from Paris as often as I can, but don't you dare to leave me with the pain of not knowing anything about you. Even if they're very little letters or postcards, but let me know how your health is.

The death painting is going very well, the only thing I can't manage is the space between the figures, and the building looks like one of those square chimneys, and it's much to squat. I'm more convinced every day of what a dunce I am at drawing and how stupid I feel when I want to create a bit of distance in a painting. What I would give to see what you are doing now, what you are painting, to be able to be with you and to sleep with you in our little room on the bridge; I so miss your laugh, your voice, your little hands, your eyes, even your tantrums, everything, my child, all of you, you are my life itself, and nothing and no one can change me.

I'm waiting these days for your letter you promised me in the telegram and by telephone. Tell me why you seemed sad, tell me everything, tell me if you want me to go to you and send Paris and everyone to hell.

I send you millions and millions of kisses and all my heart.

Your *chicuita*.

Friduchín

༄

Frida refers to Trotsky, to General Lázaro Cárdenas, to Vicente Lombardo Toledano, to the president of the Museum of Modern Art in New York, A. Conger Goodyear, who purchased Frida's 1938 oil Self-Portrait with Monkey *(40.6 cm x 30.5 cm) for the actress Katherine Cornell.*

The work in progress was The Suicide of Dorothy Hale, *commissioned by Clare Boothe Luce to commemorate her friend the actress and model Dorothy Hale.*

[50]

Letters to Nickolas Muray

[*Originally in English*]

{a}

Paris, February 16th, 1939

My adorable Nick. Mi niño,

I am writing you on my bed in the American Hospital. Yesterday it was the first day I didn't have fever and they allowed me to eat a little, so I feel better. Two weeks ago I was so ill that they brought me here in an ambulance because I couldn't even walk. You know that I don't know why or how I got collibacilus on the kidneys thru the intestines, and I had such an inflammation and pains that I thought I was going to die. They took several X rays of the kidneys and it seems that they are infected with those damn collibacilus. Now I am better and next Monday I will be out of this rotten hospital. I can't go to the hotel, because I would be all alone, so the wife of Marcel Duchamp invited me to stay with her for a week while I recover a little.

Your telegram arrived this morning and I cried very much of happiness, and because I miss you with all my heart and my blood. Your letter, my sweet, came yesterday, it is so beautiful, so tender, that I have no words to tell you what a joy gave me. I adore you my love, believe me, like I never loved anyone -only Diego will be in my heart as close as you- always. I haven't tell Diego a word about all this troubles of being ill because he will worry so much, and I think in few days I will be all right again, so it isn't worthwhile to alarm him. Don't you think so?

Besides this damn sickness I had the lousiest luck since I arrived. In first place the question of the exhibition is all a damn mess. Until I came the paintings were still in the custom house, because the s. of a b. of Breton didn't take the trouble to get them out. The photographs which you sent *ages ago, he never received* –so he says– the gallery was not arranged for the exhibit *at all* and Breton has no gallery of his own long ago. So I had to wait days and days just like an idiot till I met Marcel Duchamp (a marvellous painter) who is the only one who has his feet on the earth, among all this bunch of coocoo lunatic son of bitches of the surrealists. He immediately got my paintings out and tried to find a gallery. Finally there was a gallery called "Pierre Colle" which accepted the damn exhibition. Now Breton wants to exhibit together with my paintings, 14 portraits of the XIX century (Mexican), about 32 photographs of Álvarez Bravo, and lots of popular objects which he bought on the markets of Mexico, *all this junk*, can you beat that? For the 15th of March the gallery suppose to be ready. But the 14 oils of the XIX century must be *restored* and the damn restoration takes a whole month. I had to lend to Breton 200 bucks (Dlls) for the restoration because he doesn't have a penny. (I sent a cable to Diego telling him the situation and telling that I lent to Breton that money. He was furious, but now is *done* and I have nothing to do about it.) I still have money to stay here till the beginning of March, so I don't have to worry so much.

Well, after things were more or less settled as I told you, few days ago Breton told me that the associated of Pierre Colle, an old bastard and son of a bitch, saw my paintings and found that only *two* were possible to be shown, because the rest are too "shocking" for the public!! I could of kill that guy and eat it afterwards, but I am so sick and tired of the *whole affair* that I have decided to send everything to hell, and scram from this rotten

Paris before I get nuts myself. You have no idea the kind of bitches these people are. They make me vomit. They are so damn "intellectual" and rotten that I can't stand them any more. It is really too much for my character. I rather sit on the floor in the market of Toluca and sell tortillas, than to have anything to do with those "artistic" bitches of Paris. They sit for hours on the "cafés" warming their precious behinds, and talk without stopping about "culture" "art" "revolution" and so on and so forth, thinking themselves the gods of the world, dreaming the most fantastic nonsenses, and poisoning the air with theories and theories that never come true.

Next morning they don't have anything to eat in their houses because *none of them work* and they live as parasites of the bunch of rich bitches who admire their "genius" of "artists". *Shit* and only *shit* is what they are. I never seen Diego or you wasting their time on stupid gossip and "intellectual" discussions, that is why you are real *men* and not lousy "artists". Gee wez! It was worthwhile to come here only to see why Europe is rottening, why all this people -good for nothing- are the cause of all the Hitlers and Mussolinis. I bet you my life I will hate this place and its people as long as I live. There is something so false and unreal about them that they drive me nuts.

I am just hoping to get well soon and scram from here.

My ticket will last for a long time but I already have accommodations for the "Isle de France" on the 8 of March. I hope I can take this boat. In any case I won't stay here longer than the 15th of March. To hell with the exhibition in London. To hell with everything concerning Breton and all this lousy place. I want to go back *to you*. I miss every moment of your being, your voice, your eyes, your hands, your beautiful mouth, your laugh so clear and honest, *YOU*. I love you my Nick. I am so happy to think I love you -to think you wait for me- you love me.

171

My darling give many kisses to Mam on my name. I never forget her. Kiss also Aria and Lea. For you, my heart full of tenderness and caresses, one special kiss on your neck, your

Xochitl

Give my love to Mary Sklar if you see her and to Ruzzy.

꒰ꕤ꒱

Aria and Lea were Muray's daughters, while Mam seems to have worked as his assistant.

{b}

Paris, February 27th, 1939

My adorable Nick,

This morning after so many days of waiting, your letter arrived. I felt so happy that before starting to read it I began to weep. My child, I really shouldn't complain about anything happens to me in life, as long as you love me and I love you. It is so real and beautiful, that makes me forget all pains and troubles, makes me forget even distance. Your words made me feel so close to you that I can feel near me -your eyes- your hands, your lips. I can hear your voice and your laugh, that laugh so clean and honest that only *you* have. I am just counting the days to go back. A month more! And we will be together again.

Darling, I made a terrible mistake. I was sure that your birthday was the 16th *January*. If I knew it was the 16th of February I would never send that cable that caused you unhappiness and trouble. Please forgive me.

Five days ago I left the hospital, I am feeling much better and I hope I will be entirely well in a few days. I didn't go back to the damn hotel because I couldn't stay all alone. *Mary Reynolds*, a marvellous American woman who lives with *Marcel*

172

Duchamp, invited me to stay at her house and I accepted gladly because she is really a nice person and doesn't have anything to do with the stinking "artists" of the group of Breton. She is very kind to me and takes care of me wonderfully. I feel rather weak after so many days of fever because the damn infection of collibacili makes you feel rotten. The doctor tells me I must of *eaten* something which wasn't well cleaned (salad or raw fruits). I bet you my boots, that in Breton's house was where I got the lousy collibacili. *You* don't have any idea of the *dirt* those people live in, and the kind of food they eat. It's something incredible. I never seen anything like it before in my damn life. For a *reason* that I *ignore*, the infection went from the *intestines* to the *bladder* and the kidneys, so for two days I couldn't make pipi and I felt like if I were going to explode any minute. Fortunately everything is *OK now*, and the only thing I must do is to rest and to have a special *diet*. I am sending you here some of the reports from the hospital. I want you to be so sweet to give them to *Mary* Sklar and she will show them to David *Glusker*, so he can have an idea of what is the matter and *send* me indications of what I should *eat*. (Tell her please that for the three last days the *urine tests* show that it is *acid* and *before* it was *alkaline*.) The fever disappeared completely. I still have pain when I make pipi and a slight *inflammation* on the *bladder*, *I feel tired all the time (specially on the back)*. Thank you, my love, for making me this favor, and tell Mary that I miss her a lot and that I love her.

The question of the exhibition finally is settled. Marcel Duchamp has helped me a lot and he is the only one among this rotten people who is a real guy. The show will open the *10th of March* in a gallery called "Pierre Colle". They say it's one of the best here. That guy Colle is the dealer of Dalí and some other big shots of the surrealism. It will last two weeks -but I already made arrangements to take my paintings on the 23rd in order to

have time to pack them and take them with me on the 25th. The catalogues are already in the printing shop, so it seems that everything is going on all right. I wanted to leave on the "Isle de France" the 8th of March, but I cabled Diego and he wants me to wait till my things are shown, because he doesn't trust any of this guys to ship them back. He is right in a way because after all I came here *only* for the damn exhibition and would be stupid to leave two days before it opens. Don't you think so? In any case, I don't care if the show will be successful one or not. I am sick and tired of the whole affair in Paris, and I decided that the same thing would be in London. So *I am not* going to make any exhibit in London. People in general are scared to death of the war and all the exhibitions have been a failure, because the rich bitches don't want to buy anything. So what is the use of making any effort to go to London to waste time only?

My darling, I must tell you, that you are a bad boy. Why did you send me that check of 400 bucks? Your friend "Smith" is an imaginary one, very sweet indeed, but tell *him* that I will keep *his check untouched* until I come back to New York, and there we will talk things over. My Nick, you are the sweetest person I have ever known. But listen darling, I don't really need that money now. I got some from Mexico, and I am a real rich bitch, you know? I have enough to stay here a month more. I have my return ticket. *Everything is under control* so really, my love, it is not fair that you should spend anything extra. You have plenty of troubles already to cause you a new one. I have money even to go to the "thieves market" and buy lots of junk, which is one of the things I like best. I don't have to buy dresses or stuff like that because being a "tehuana" I don't even wear pants, nor stockings either. The only things I bought here were two old fashioned dolls, very beautiful ones. One is blond with blue eyes, the most wonderful eyes that you can imagine. She is dressed as

a bride. Her dress was full of dust and dirt, but I washed it, and now it looks much better. Her head is not very well adjusted to her body because the elastic which holds it, is already very old, but you and me will fix it in New York. The other one is less beautiful, but very charming. Has blond hair and very black eyes, I haven't washed her dress yet and is dirty as hell. She only have one shoe, the other one she lost in the market. Both are lovely, even with their heads a little bit loose. Perhaps that it is which gives them so much tenderness and charm. For years I wanted to have a doll like that, because somebody broke one that I had when I was a child, and I couldn't find it again. So I am very happy having two now. I have a little bed in Mexico, which will be marvellous for the bigger one. Think of two nice Hungarian names to baptize them. The two of them cost me about two dollars and a half. So you can see my darling, that my expenses are not very important. I don't have to pay hotel because Mary Reynolds doesn't allow me to go back to the hotel all by myself. The hospital is already payed. So I don't think I will need very much money to live here. Anyway, you cannot imagine how much I appreciated your desire of helping me. I have no words to tell you what joy it gives me to think that you were willing to make me happy and to know how good hearted and adorable you are. -My lover, my sweetest, mi Nick -mi vida- mi niño, te adoro.

I got thinner with the illness, so when I will be with you, you will only blow and... up she goes! the five flours of the La Salle Hotel. Listen Kid, do you touch every day the fire "whachamay-callit" which hangs on the corridor of our staircase?

Don't forget to do it every day. Don't forget either to sleep on your tiny cushion, because I love it. Don't kiss anybody else while reading the signs and names on the streets. Don't take anybody else for a ride to our Central Park. It belongs only to

Nick and Xochitl. -Don't kiss anybody on the couch of your office. Only Blanche Heys can give you a massage on your neck. You can only kiss as much as you want, Mam. Don't make love with anybody, if you can help it. Only if you find a real F.W. but *don't love her*. Play with your electric train once in while if you don't come home very tired. How is Joe Jinks? How is the man who massages you twice a week? I hate him a little, because he took *you* away from me many hours. Have you fenced a lot? How is Georgio?

Why do you way that your trip to Hollywood was only half successful? Tell me about it. My darling, don't work so hard if you can help it. Because you get tired on your neck and on your back. Tell Mam to take care of yourself, and to make you rest when you feel tired. Tell her that I am much more in love with you, that you are my darling and my lover, and that while I am away she must love you more than ever to make you happy.

Does your neck bother you very much? I am sending you here millions of kisses for your beautiful neck to make it feel better. All my tenderness and all my caresses to your body, from your head to your feet. Every inch of it I kiss from the distance.

Play very often Maxine Sullivan's disc on the gramophone. I will be *there with you* listening to her voice. I can see you lying on the blue couch with your white cape. I see you shooting at the sculpture near the fire place, I see clearly, the spring jumping on the air, and I can hear you laugh -just like a child's laugh, when you got it right. Oh my darling Nick I adore you so much. I need you so, that my heart hurts.

I imagine Blanche will be here the first week of March. I will be so happy to see her because she is a real person, sweet and sincere, and she is to me like a part of yourself.

How are Aria and Lea? Please give my love to them. Also give my love to the Ruzzie, tell him that he is swell guy.

My darling, do you need anything from Paris?, please tell me, I will be so happy to get you anything you may need.

If Eugenia phones you, please tell her that I lost her address and that is why I didn't write. How is that wench?

If you see Rosemary give her lots of kisses. She is OK? To Mary Sklar lots of love, I miss her very much.

To you, my loveliest Nick, all my heart, blood and all my being. I adore you.

<div style="text-align:center">Frida</div>

The photographs you sent finally arrived.

<div style="text-align:center">ॐ</div>

Blanche Heys and Joe Links were friends of Muray's.

The initials F.W. stand for "fucking wonder".

LETTER TO ELLA AND BERTRAM D. WOLFE

Paris, March 17th, 1939

Darling Ella and Boitito, *my true cuates*:

After two months I write you, I know you're going to say the same as always: that "chicua" is a *mula*! But this time believe me it wasn't so much *mulez*, but rather cursed bad luck. Here go the powerful explanations: ever since I got here it's been a f...rigging mess... for my exhibition wasn't arranged. My paintings were waiting for me nice and quiet at customs, because Breton hadn't even come to pick them up. You can't have even the faintest idea of what kind of old cockroach Breton is, like almost all the others in the surrealist group. In a word, they're a bunch of perfect sons of... their mothers. I'll tell you in detail the whole story of the exhibition in question when we're face to face again, for it's long and sad. But in summarized synthesis it took a month and a half before... et cetera, et cetera, the goddamned exhibition. All this took place to the accompaniment of arguments, gossip, rages and problems of the "woist" kind. Finally, Marcel Duchamp (the only one of the painters and artists over here who has his feet on the ground and his brains in place) managed to arrange the exhibition with Breton. It opened on the 10th of this month in the *Pierre Colle* gallery, which from what they tell me is one of the best here. There were lots of people the day of the *opening**, great congratulations for the "chicua", including a big hug from Joan Miró and great praises from Kandinsky for my painting, congratulations from Picasso and Tanguy, from Paalen and from other "big shits" of the surrealist movement. In short, I can say it was a success and taking into

account the quality of the crop (that is, of the flock of congratulations), I think the thing turned out rather well...

I had my belly full of anarchists and every one of them must have put a bomb in some corner of my poor guts. I felt at that moment that my credit had run out, for I was sure the grim reaper was going to take me away. Between the pains in my belly and the sadness of being alone in this goddamned Paris, which I like about as much as a kick in the navel, I can assure you I would have preferred to kick the bucket right then and there. But when I found myself in the American Hospital, where I could "bark" in English and explain my situation, I began to feel a little better. At least I could say: "*Pardon me I burped!*"* (which wasn't the case of course, since burping was precisely what I couldn't for the life of me do.) It was only on the fourth day that I had the pleasure of letting out the first "burp"* and since that happy day until now I have felt better. The reason for the anarchist uprising in my belly was that it was full of coli bacilli and those wretches wanted to trespass the decent limits of the their activity and had the idea of going on a spree through my bladder and kidneys, and frankly they began to burn, because they were kicking up a hell of ruckus in my kidneys and carrying me off to the funeral parlor. In short I was just counting the days for my fever to break so I could grab a boat and flee to the *United States**, since here they didn't understand my situation and no one gave a damn about me... and little by little, I began to recover...

If you only knew the state of the poor people who have managed to escape from the concentration camps. It would break your heart. Manolo Martínez, Rebull's friend, is here. He tells me Rebull was the only one who had to stay on the other side, because he couldn't leave his dying wife, maybe now as I'm writing you they'll already have put the poor thing

in front of a firing squad. These contemptible French have behaved like pigs with all the refugees; they're just bastards, of the worst sort I've ever known. I'm disgusted with all these rotten people in Europe, these goddamned "democracies" aren't worth a dime...

We'll talk about all that at length. Meanwhile I want to tell you: that I've missed you terribly; that I love you more and more; that I've behaved well; that I haven't had any affaires or amusements, or lovers, or anything like that; that I love Mexico as never before; that I adore Diego more than my own life; that I also miss Nick a lot now and them; that I'm becoming a serious person, and that in short until I see you again I want to send you both lots and lots of kisses, divide some of them fairly among Jay, Mack, Sheila and all the *cuates*. And if you have a bit of time go and see Nick and give him a kiss as well and another to Mary Sklar.

Your *chicua* who never forgets you

Frida

Boitito: How is the book going, Brother? Are you working a lot? Another piece of gossip. Diego has quarreled with the IVth and seriously sent "Vandyke" Trotsky to hell. I'll tell you the whole wrangle in detail.

Diego is completely right.

ॐ

Manuel Rebull was a Spaniard Frida had met in Mexico.

Frida's friend Mary Sklar (née Schapiro) was married to Solomon Sklar.

LETTER TO NICKOLAS MURAY

[*Originally in English*]

Coyoacán, June 13th, 1939

Nick darling,

I got my wonderful picture you sent to me. I find it even more beautiful than in New York. Diego says that it is as marvellous as Piero della Francesca. To me is more than that, it is a treasure, and besides, it will always remind me that morning we had breakfast together in the Barbizon Plaza Drugstore, and afterwards we went to your shop to take photos. *This one* was one of them. And now I have it near me. You will always be inside the magenta *rebozo* (on the left side). Thanks million times for sending it.

When I received your letter, few days ago, I didn't know what to do. I must tell you that I couldn't help weeping. I felt that something was in my throat, just if I had swallowed the whole world, I don't know yet if I was sad, jealous or angry, but the sensation I felt was in first place of a great despair. I have read your letter many times, too many I think, and now I realize things that I couldn't see at first. Now, I understand everything perfectly clearly, and the only thing I want, is to tell you with my best words, that you deserve in life the best, the very best, because you are one of the few people in this lousy world who are honest to themselves, and that is the only thing that really counts. I don't know why I could feel hurt one minute because you are happy, it is so silly the way Mexican wenches (like myself) see life sometimes! But you know that, and I am sure you will forgive me for behaving so stupidly. Nevertheless you have to understand that no

matter what happens to us in life, you will always be, for myself, the same Nick I met one morning in New York in 18 E. 48th St.

I told Diego that you were going to marry soon. He said that to Rose and Miguel, the other day when they came to visit us, so I had to tell them that it was true. I am terribly sorry to have said it before asking you if it was O.K., but now it's done, and I beg you to forgive my indiscretion.

I want to ask from you a great favor, please, send by mail the little *cushion*, I don't want anybody else to have it. I promise to make another one for you, but I want that one you have now on the couch downstairs, near the window. Another favor: Don't let "her" touch the fire signals on the stairs (you know which ones). If you can, and isn't too much trouble, don't go to Coney Island, specially to the *Half Moon*, with her. Take down the photo of myself which was on the fire place, and put it in Mam's room in the shop, I am sure she still likes me as much as she did before. Besides it is not so nice for the other lady to see my portrait in your house. I wish I could tell you many things but I think it is no use to bother you, I hope you will understand without words all my wishes.

Darling, are you sure it is not too much bother for you to arrange for me the question of the painting of Mrs. Luce? Everything is ready to send it, but I wish you could get for me only one detail that I need very badly. I don't remember the *date* when Dorothy Hale committed suicide, and it is necessary to write it down on the painting, so if you could find out, by phone, somewhere, I would be very happy. Not to bother you so much, please write down in a piece of paper the exact date and mail it to me. About the painting, you just leave it in your office (it is a small one) and as soon as you think that Mrs. Luce is in New York, just call her up and let her know that the damn picture is there. She will send for it, I am sure.

About my letters to you, if they are in the way, just give them to Mam and she will mail them back to me. I don't want to be a trouble in your life in any case.

Please forgive me for acting just like an old fashion sweetheart asking you to give me back my letters, it is ridiculous on my part, but I do it for you, not for me, because I imagine that you don't have any interest in having those papers with you.

While I was writing this letter Rose telephoned and told me that you got married already. I have nothing to say about what I felt. I hope you will be happy, very happy.

If you find time once in a while, please write to me just a few words telling me how you are, will you do it?

Give my love to Mam and to Ruzzy.

I imagine you must be very busy now and will not have time to get for me the date when Dorothy Hale killed herself, please be so sweet to ask Mam to make for me that favor. I can't send the picture till I know that damn date. And it is urgent that this wench of Claire Luce has the painting in order to get from her the bucks.

Another thing, if you write to Blanche Hays, tell her that I send all my love to her. The same, and very specially, to the Sklars.

Thanks for the magnificent photo, again and again. Thanks for your last letter, and for all the treasures you gave me.

Love
 Frida

Please forgive me for having phoned to you that evening. I won't do it any more.

~

The painting to which Frida refers is The Suicide of Dorothy Hale (*oil on canvas, 60.4 cm x 48.6 cm*), *painted between 1938 and 1939. The actress and model Dorothy Hale committed suicide on October 21, 1938 by throwing herself from one of the upper floors of the Hampshire House in New York.*

Letter to Carlos Chávez

[October, 1939]

Carlitos:

Here's the information, I implore you, you translate it, because if I do it would just be a mess.

I started to paint twelve years ago. During my convalescence from an automobile accident that obliged me to stay in bed for almost a year. I worked during all those years always from the spontaneous impulse of my feeling. I have never followed any school or anyone's influence, I didn't expect anything more from my work than the satisfaction it could give me from the very fact of painting and saying what I was unable to say in any other form.

I have done portraits, figure compositions, also subjects in which landscape and still life take on the greatest importance. I managed to discover, without being forced to do so by any prejudice, a personal expression in painting. My work for ten years consisted of eliminating everything that did not come from the internal lyric motives that impelled me to paint.

Since my subjects have always been my sensations, my moods and the profound reactions that life has produced within me, I have frequently objectified all this in figures of myself that were as sincere and as real as I could make them for the expression of what I felt for myself and before myself.

I did not exhibit until last year (1938) in the Julien Levy gallery in New York. I took twenty-four pictures. Twelve went to the private collections of the following persons:

Conger Goodyear. N.Y.

Mrs. Sam Lewison. N.Y.

Mrs. Clare Luce. N.Y.

Mrs. Salomon Sklar. N.Y.

Mr. Edward G. Robinson. Los Angeles (Hollywood)

Walter Pach. N.Y.

Mr. Edgar Kaufmann (Pittsburgh)

Mr. Nickolas Muray. N.Y.

Dr. Roose. N.Y.

And two other persons whose names I don't remember but which Julien Levy can supply. The date of the exhibition was from November 1st to 15th, 1938.

Later I held an exhibition in Paris, organized by André Breton in the Renou et Colle gallery, from March 1st to 15th, 1939. (The only exhibitions I have had in my life.) My work interested the critics in Paris and the artists. The Louvre (Jeu de Paume) acquired one of the my paintings.

As references I can give the names of the following people:

Diego Rivera. Palma at Altavista. Villa Obregón, Mexico City.

Pablo Picasso. Rue de la Botie, Paris.

Carlos Chávez.

Mr. Sam Lewison. (I don't remember his address.)

Marcel Duchamp. 14 Rue Hallé. Près du Parc Montsouris.

André Breton. 42 Rue Fontaine. 9ème, Paris.

Dr. William Valentiner. Director Museum Detroit.

Conger Goodyear. Museum of Modern Art.

My intention is to hold an exhibition in the United States. I am working on large paintings that required a lot of work. I need tranquility in order to work, and I don't have enough "dough". That is why I am applying for a Guggenheim fellowship.

A thousand thanks, if you need any other details just call me. Many regards and a hug from

Frida

⤳

On November 23, 1939, Carlos Chávez sent Frida's application for a Guggenheim fellowship to Mr. Henry Allen Moe. In the attached letter he wrote: "Frida, as you undoubtedly know, is an extraordinary artist. She has always painted, since she was a child. When she married Diego Rivera, she became known and more admired, but only in the small circle of Diego's friends. We were all astonished by her incredible sensibility and refinement. Moreover, her skill in the craft is that of a master. [...]

As Diego Rivera's wife she never had to worry about any kind of financial consideration. Now, however, the circumstances are completely different. She has just divorced Diego Rivera and as a result has had to consider her work from more than just an artistic viewpoint.

I suggested to Frida that she apply for a Guggenheim fellowship. Frankly, I know of no clearer case of an artist who needs and deserves to be stimulated by the Foundation."

In spite of the numerous recommendations, Frida did not receive the fellowship.

[54]

Letter to Nickolas Muray

[Originally in English]

Coyoacán, October 13th, 1939

Nick darling,

I couldn't write to you before, since you left, my situation with Diego was worse and worse, till came to an end. Two weeks ago we began the divorce. I love Diego, you must understand that this troubles will never end in my life, but after the last fight I had with him (by phone) because it is almost a month that I don't see him, I understood that for him it is much better to leave me. He told me the worst things you can imagine and the dirtiest insults I ever expected from him. I can't tell you here all the details because it is impossible, but one day, when you will be in Mexico, I can explain to you the whole thing. Now I feel so rotten and lonely that it seems to me that nobody in the world has suffer the way I do, but of course it will be different I hope in a few months.

Darling, I must tell you that I am not sending the painting with Miguel. Last week I had to sell it to somebody thru Misrachi because I needed the money to see a lawyer. Since I came back from New York I don't accept a damn cent from Diego, the reasons you must understand. I will never accept money from any man till I die. I want to beg you for forgiving that with a painting that was done for you. But I will keep my promise and paint another one as soon as I feel better. It is a cinch.

I haven't seen the Covarrubias, so the photos you sent to them are still with me. I love all the photographs you were so sweet to send, they are really swell. Thanks a lot for them. I send Diego your check.

Has he thank you for it? He didn't see the photos because I don't think he will be very much interested in seeing my face near his.

So I kept them all for me.

Listen baby, please don't think badly about me because I haven't seen Juan O'Gorman about your house. It is only because I don't want to see anybody that is near Diego, and I hope you will understand. Please write to Juan directly. His address is: Calle Jardín No. 10, Villa Obregón, D.F., México. I am sure he will be very happy in doing what you wish.

I am so glad to hear that Arija is well and will be with you soon. I think you will bring her along to Mexico next time, won't you? I am sure she will enjoy it very much.

How about your own troubles? It is all set with the girl? In your last letter you sound happier and less preoccupated, and I am glad as hell for that. Have you heard from Mary Sklar? Whenever you see her tell her in spite my negligence to write I do love her just the same as ever.

Tell Mam that I will send with Miguel the presents I promised her, and thank her for the sweet letter she sent me. Tell her that I love her with all my heart.

Thanks Nickolasito for all your kindness, for the dreams about me, for your sweet thoughts, for everything. Please forgive me for not writing as soon as I received your letters, but let me tell you kid, that this time has been the worst in my whole life and I am surprised that one can live thru it.

My sister and the babies send their love to you.

Don't forget me and be a good boy. I love you.

Frida

༄

The self-portrait Frida painted for Muray is the very elaborate one with the hummingbird hanging from a necklace of thorns.

LETTER TO EDSEL B. FORD

[Originally in English]

Coyoacán, December 6th, 1939

[...] I am sure you must receive thousands of bothering letters. I feel really ashamed to send you one more, but I beg you to forgive me, because it is the first time I do so, and because I hope that what I will ask you, won't cause you too much trouble.

It is only to explain to you the special case of a very dear friend of mine, who was for many years a Ford's dealer in Gerona, Cataluña, and who for the circumstances of the recent war in Spain came to Mexico. His name is *Ricardo Arias Viñas*, he is now thirtyfour years old. He worked for Ford Motor Co. for almost 10 years, he has a letter given by the European Central (Essex) which guarantees his actuation as a Ford worker, this letter is addressed to your plant in Buenos Aires. Also Mr. Ubach, the subdirector of your plant in Barcelona could give any kind of information about Mr. Arias. During the war, taking advantage of his charge as chief of transportation of Cataluña, he could get back to your factories several hundred units which were stolen at the beginning of the movement.

His problem is this, he couldn't go directly to Buenos Aires on account of economical difficulties, so he would like to stay here in Mexico and work in your plant. I am sure that Mr. Lajous your manager here, would give him a job knowing all about his experience and good acceptance as a Ford worker, but in order to avoid any difficulties I would appreciate very much if you were so kind just to send me a note which Mr. Arias

could present to Mr. Lajous as a recommendation directly from you. That would facilitate enormously his entrance in the plant. He doesn't belong to any political party, so I imagine there is no difficulty for him to get this job and work honestly.

I really would appreciate of you this big favor and hope there won't be much trouble for you in accepting my petition.

Let me thank you in advance for anything you can so kindly do in this case.

Ricardo Arias Viñas was a Spanish refugee with whom Frida had a close romantic involvement. After the assault on Trotsky's house perpetrated by Siqueiros and a group of others on May 24, 1940, Arias, his wife, Frida and Cristina Kahlo were detained and interrogated, and Frida's house searched.

[56]

Letters to Nickolas Muray

[*Originally in English*]

{a}

Coyoacán, December 18th, 1939

Nick darling,

You will say that I am a complete bastard and a s. of a b.! I asked you money and didn't even thank you for it. That is really the limit kid! Please forgive me. I was sick two weeks. My foot again and grippe. Now I thank you a million times for your kind favor and about the paying back I want you to be so sweet to wait till January. The Arensberg from Los Angeles will buy a picture. I am sure I will have the bucks next year and immediately I will send you back your hundred bucks. Is it OK with you? In case you need them before I could arrange something else. In any case I want to tell you that it was really sweet of you to lend me that money. I needed it so much.

I had to give up the idea of renting my house to tourists, because to fix the house would of cost a lot of money which I didn't have and Misrachi didn't lend me, and in second place because my sister wasn't exactly the person indicated to run such a business. She doesn't speak a damn word of English and would of been impossible for her to get along well. So now I am hoping only in my own work. I been working quite a lot. In January I will send to Julien two or three things. I will expose four paintings in the surrealist show which Paalen will have in Ines Amor Gallery. I think that little by little I'll be able to solve my problems and survive!!

How is your sinus? How long were you in the hospital and how it worked? Tell me something about yourself. Your last letter was only about myself but not a word about how do you feel, your work, your plans, etc. I received a letter from Mary. She told me the magnificent news that she will have a baby. I am more than happy about it, because Sol and herself will be just crazy of joy with a kid. Tell me about Mam. Kiss her one hundred times for me. Beginning in her eyes and finishing wherever is more convenient for both. Also kiss Ruzzy in the cheek. What is Miguelito and Rose doing? Are you coming with them to Mexico? I imagine you have already some other plans because you don't say a damn word about it in your letters. Is there another wench in your life? What nationality?

Give my love to Lea and to your baby. Were they happy in France?

Kid, don't forget about me. Write once in a while. If you don't have very much time take a piece of toilet paper and in… those moments… write your name in it. That will be enough to know that you still remember this wench.

All my love to you.

Frida

{b}

January, 1940

Nick darling,

I received the hundred bucks of this month, I don't know how to thank you. I couldn't write before because I had an infection in the hand which didn't let me work or write or anything. Now I am better, and I am working like hell. I have to finish a big painting and start small things to send to Julien this month. The 17th it will be a show of surrealist paintings and everybody in

Mexico has become a surrealist because all are going to take part on it. This world is completely cock-eyed, kid!!

Mary wrote to me and said that she hasn't seen your for a long time. What are you doing? It seems to me that you treat me now only as a friend. You are helping, but *nothing more*. You never tell me about yourself, and not even about your work. I saw *Coronet* and my photo is the best of all. The other wenches are OK too but one of myself is a real F.W. (Do you still remember the translation? "fucking wonder".)

I think Julien will sell for me this month or next a painting to the Arensberg (Los Angeles). If he does, I told him to pay back to you the money you already sent me, because it is easier to pay little by little than to wait till the end of the year. Don't you think so? You can't have *any idea* of the strange feeling I have owing you money. I wish you would understand. How is Arija? And Lea? Please tell me things of yourself!!! Are you better of your sinus trouble?

I feel lousy. Everyday worse and worse. Anyway I am working. But even that I don't know how and why. Do you know who came to Mexico? That awful wench of Ione Robinson. I imagine she thinks that the road is clash now!... I don't see anybody. I am almost all day in my house. Diego came the other day to try to *convince* me that nobody in the world is like *me*! Lots of crap kid. I can't forgive him, and that is all.

Your Mexican wench

Frida

My love to Mam.

How is this new year for you? How is Joe Jings? How is New York? How is the La Salle? And the woman who you always shooted?

～

Frida participated in the International Surrealism Exhibition, held in January–February of 1940 at the Mexican Art gallery, with two oils: The Two Fridas *(1939) and* The Wounded Table *(1940).*

{c}

Coyoacán, February 6th, 1940

Nick darling,

I got the bucks, thanks again for your kindness. Miguel will take one big painting for the show on the Modern Museum. The other big one I will send to Julien. He proposed me to have a show next November so I am working hard. Besides I applied for the Guggenheim, and Carlos Chávez is helping me on that, if it works I can go to New York in October–November for my show. I haven't sent small paintings to Julien because it's better to send three or four than one by one.

What about you? Not a single word I know about what the hell are you doing. I imagine all your plans about Mexico were given up. Why? Do you have another wench? A swell one? Please kid tell me something. At least tell me how happy you are or what on earth are you thinking to do this year or next.

How is little Mam? Give her my love.

I have to give you a bad news: I cut my hair, and looks just like a ferry. Well, it will grow again, I hope!

How is Arija? And Lea? Have you seen Mary and Sol?

Write to me, please, one evening instead of reading Joe Jings, remember that I exist in this planet.

Yours

Frida

Letter to Sigmund Firestone

[*Originally in English*]

February 15th, 1940

[...] Diego is happier now than when you saw him. He eats well and sleeps well and works with great energy. I see him very often but he doesn't want to live in the same house with me anymore because he likes to be alone and he says I always want to have his papers and other things in order, and he likes them in disorder. Well anyway I take care of him the best I can from the distance, and I will love him all my life even if he wouldn't want me to. [...]

๛

Sigmund Firestone was a Rochester art collector.

[58]

Telegram and Letter to Dolores del Río

Coyoacán, June 13th, 1939

Sra. Dolores del Río
757 Kingman Rd.
Santa Monica, Calif.

Mexico City, Mex., 27 (February, 1940)

DOLORES DARLING BEG YOU TO FORGIVE THIS NUI-
SANCE COULD YOU LEND ME TWO HUNDRED FIFTY
DOLLARS NEED IT TO RESOLVE EMERGENCY WILL
PAY YOU IN TWO MONTHS STOP IF SO KIND BEG
YOU TO WIRE IT TO LONDRES 127 COYOACÁN DF
MILLION THANKS LETTER FOLLOWS EXPLAINING
REASONS FOR THIS IMPERTINENCE STOP KISSES.

FRIDA RIVERA

Frida enjoyed a long friendship with the actress Dolores del Río (1902–1983), who began her movie career in Hollywood in 1925.

Coyoacán. March, 1940

Darling Dolores,
I feel terrible that I haven't been able to send you the 250 bucks
you so kindly lent me. You know I requested a Guggenheim fel-
lowship, and I hope it comes through by June, I wanted to ask

you please to wait until then, as I would you 100 *macanas* every month and that way I could pay you back the bucks. You'll say I'm taking advantage, but you have to understand darling that after the divorce from Diego it has been very difficult for me to meet my expenses because I didn't want to accept *even a penny* from him though he offered. By the end of this year maybe the difficulties will change because I'll have an exhibition in New York in November in the Julien Levy Gallery, and so I should be able to make some "dough". So I beg you not to think for a moment that I am taking advantage by not paying you back your money.

If you have a spare moment write me, don't be a bad girl. I'm glad you liked the little painting of the naked girls, I also felt terribly bad about that painting because I promised it to you a long time ago.

Tell me how you are darling, and if you're thinking of coming to Mexico soon. We all miss you *a lot*. Diego calls me on the telephone from time to time and we see each other seldom. He has made me suffer so much that I can't easily forgive him, but I still love him more than my life, he knows that well enough and that's why he asks so much, you know what an ill-bred child he is.

Write me sweetheart and here I send you a thousand kisses and all my affection as ever.

<div align="center">Frida</div>

Give my regards as well to your Mommy and to Carmen Figueroa.

<div align="center">ॐ</div>

"The little painting of the naked girls" is the small oil on metal (25 cm x 30.5 cm) of 1939 that has appeared under various different names in books and exhibitions: Two Nudes in a Forest, The Earth Herself *and* My Wet Nurse and I. *It has been taken as conclusive proof of Frida's lesbian practices.*

Notes for Alberto Misrachi

{a}

March 4th, 1940

Albertito,

Here are the last tax vouchers. On Insurgentes I owe the first two months of '40. On Coyoacán the last two months of '39 and the first two of '40.

For Insurgentes	47.30
Coyoacán	74.00
	121.30

If you can have Insurgentes paid it would be better to just send me the 74.00 in cash to pay for Coyoacán.

I owed you	325.00
plus	121.00
	446.00

Please send me the difference so that I owe you exactly 500 macanas.

Many thanks.

Frida

June 8th, 1940

Albertito,

Be kind enough to hand over to Sr. Veraza the sum of $200.00 (two hundred pesos) to complete payment on the moving of Diego's idols.

Let this serve as voucher and receipt for said sum.

A thousand thanks.

Frida Kahlo

Letter-Report to Diego Rivera

Diego my darling child,

Yesterday I received your letter and I wanted to write you, but as I have so many things to tell you and got back very tired from San Ángel, I fell asleep like a log, and waited to write you today with more calm. Your letter made me very happy, for it's the only thing that's happened to me for days and days, receiving your letters. I couldn't describe to you the joy it gives me to know you are alright, finally outside of all that shitty commotion. As soon as they found out you were on the "other side" things immediately looked different as you can imagine. Precisely today el Ch. told me the president had spoken personally to people telling them not to be sticking their noses into the matter of l-d, because they would pay dearly for it and their attitude was seriously compromising the country. He said all this in front of G. Bueyes in response to some things Chente said, completely stupid as usual and pissing to one side of the chamber pot. I'll send you the newspaper clippings about all these things. Today's newspapers say the matter has been clarified and within three days we'll know who caused all the uproar and how, splattering two important figures in the process. El Ch. wants you to know that he spoke long and hard and in complete detail with *el chaparro*, and that his conversation and the result were completely favorable. He'll write you later on.

My darling, Montezuma's treasure is almost securely in my possession. I myself packed the figures one by one in person,

counting them and separating them according to where they came from. There were 57 big wooden crates just for the clay things, we moved the stone separately. I left the most precious and fragile things aside, and within a few days I'll send you the exact list of the quantity you have. I think the best thing would be to leave them packed as they are until you send new orders, for it's much safer and more transportable given the circumstances. The only ones I left at your house were the stone ones in the garden, counted, and in Mary Eaton's care. I brought your drawings, photographs, all kinds of papyri, etc., everything's at my place. In San Ángel I just left the bare furniture, the house cleaned and swept, the garden tidied up, etc. So I think on that count you can be completely at ease. Even if they try to kill me I won't let them steal your things. Every single thing of yours makes me think of you and I suffer horribly, especially the things you most love, the treasure, the thick-lipped mask, and many others, but there's nothing to do now but make myself stronger. I'm happy to have been able to help you as much as my strength permitted, though I didn't have the honor of having done *as much* for you as Miss Irene Bohus and Mrs. Goddard! According to your statements to the press they were the heroines and the only ones deserving of all your gratitude. Don't think I'm telling you this out of personal jealousy or desire for glory, but I just want to remind you that there is someone else who also deserves your gratitude, above all for not expecting any reward, whether journalistic or of any other kind... and that is Arturo Arámburo. Although he's not the husband of any world-famous "star", nor does he possess "artistic genius", but he does have his balls in the right place and he's done more than can be said to help you, especially you, and Cristina and me who were absolutely alone; I think he deserves every consideration. People like him always remain

in the shadows, but at least I know they're worth more than all the disgusting stars and parvenus in the world, and all the young women painters of supernatural talents, that talent that is always in direct proportion to the temperature in their rear ends. You understand me. And now I understand better than before your statements and the "insistence" of Miss (?) Bohus on meeting me. Nothing gives me more pleasure than having told her to go to hell. According to a very amiable letter of yours to Goodyear you are inviting her to be your assistant in San Francisco. I think it must already be arranged, let's hope she learns fresco in her spare time, after riding horseback in the mornings, and dedicating herself to the "sport" of taming droolers. To Mrs. Goddard give my most repeated thanks for her timely and magnificent cooperation, and above all for her punctuality and "coincidence" at the moment of taking the airplane. She must be clairvoyant, because el Ch. assures me that she didn't go with you and knew nothing of your departure. If I was *distrusted* to the last moment before being told certain things, she enjoyed the privilege of absolute trust, she must have had her reasons. Unfortunately I was completely unaware of my being catalogued among the *cowards and suspects*. Now, all too late, I realize certain things. That's how it is in this life!

In any case, I have tried to carry out exactly what was entrusted to me:

Money:
Of the first two thousand *lócodos* you sent me with el Ch.

Moving, material, packaging, etc. of the treasure$400.00
To the secretary Leah Brenner300.00
To "Pulques" with receipt500.00
To restless Manuel, for scramming, with receipt210.00

To Liborio ... 210.00
To Cruz Salazar ...174.00
To Sixto Navarro (month of May) 180.00
To Raúl, last week in the clink 45.00
To Sixto's wife, during the uproar 25.00
To Manuel, in the clink17.50
To Manuel's wife and mother 25.00
According to Cruz, you owed him back pay50.00
Last week of newspapers in San Ángel14.50
Gasoline for two weeks 59.00
Electricity — Telephone - taxes 130.00
 Total 2350.00
Note. (Misrachi took the $350.00 left over.)
At Misrachi's you had a balance of $6998.00

First voucher for moving the treasure $150.00
Second voucher for " " " 200.00
Third voucher, for a telegram I sent you15.00
Fourth voucher, which Sr. Zaragoza cashed........ 1000.00
Fifth voucher, four months' salary for Raúl handed
over personally to el Ch. 720.00
 2085.00
The water colors you left were paid for 2500.00
 Total 4585.00

So there's a balance of $2413.00 *macanas*. And still owing, four
months' salary to Sixto, and five hundred pesos for Señor
Ramos Idolero, who hasn't yet appeared.

Sr. Zaragoza brought another shipment which I let him leave
until I could ask you what you decided. I'll send you photo-
graphs of the things so you can see what they are. In my opin-

ion, all of the pieces he brought are worthwhile. There are 33 pieces in all, most of them from Nayarit, two very large and magnificent ones, the rest medium-sized but very nice. And the most important thing is an axe about half a meter long, complete, of obsidian painted black and brown, marvelous. He's asking 500 *eagles* for the axe, and for the rest around 800 *lócodos*. Think it over and tell me what I should do. Sr. Zaragoza will come back for your decision in two months.

In order not to enter into long explanations of why I had to let go of Liborio, Cruz and Manuel, I'll tell you that the first two had been putting their foot all the time into what you can imagine; when I got to the house to give orders, they became extremely difficult, and asked Arámburo what right I had to be in charge, saying you were their boss and I was just worth shit to you and to them. Manuel, with a hand on each ball, didn't want to work or take care of the house, after he'd been paid. Mary Eaton and her mother, who are a couple of fucking self-centered idiots as no others, didn't want to stay without Manuel, so I had to ask him again if he would accept working for them at the same salary. Yesterday it turned out that Mary can't stand him because he never shows up and he does whatever he feels like and asked me to fire him again. I told her to go to hell because now it's them who have to screw themselves getting rid of that good-for-nothing. Meanwhile Arámburo has found me a certain Don Rafaelito, a trusted companion to be with them until they fire Manuel and find someone else who suits them. Those filthy gringas got pissed off at me for taking away the idols and during those days of so many complications and sorrows Mary wanted to start sketching them!! They're a couple of dried-up old cows, like all the others you used to put up there in your house who left nothing but piles of filth and shit and when it came down to it just made off with the palms of glory in their hands. It burns me up! What people! I

did my part by leaving the house completely clean, the garden in order, the patio tidied up without any work or junk lying around, in short, I did what I could before falling into bed with a swollen back; now they're on their own, and if they don't like it they can scram; Arámburo and I will find someone to leave there. After all there's nothing left but the bare furniture.

The only thing left is to arrange the question of Sixto. I think the best thing would be for him to weigh anchor as well, since after paying him the fourth months you ordered him to stay, three more will have to be given to him for nothing, and better give it to him now, because I'm not going to be able to maintain him. I had the telephone in the big house cut off, and tell me if the arrangement with Mary was that she is to pay the electricity, telephone and water of the small house, and if I should pay the taxes. So far they're completely up to date with all the payments.

The picture of la Maja with its box and all is in Alberto junior's house; let's hope the slacker gets a move on and sends it soon, for you can't imagine what kind of son of a b… Alberto is. He treats Cristina and me as if we were his goddamned beggars. I'm tempted to take out the rest of the dough just so I don't have to be asking for leftovers from that bastard, he thinks he's the cock of the walk riding an airplane.

The Sahagún will be sent to you as soon as possible as well as the photographs of Detroit, factories and frescoes; just give me a day to look for them, since I barely got out of bed today for I fell asleep with a pain in my backbone that made me blind and Federico kept me in bed a whole day. I'm better now and I'll do what I can to have the things reach you in time.

Your little animals are fine. The teeny-weeny little dog, the little parrot and the raccoon are with me, Arámburo has the dachshunds and the burro at his house, I had left the monkey in San Ángel but Mary doesn't want her if Manuel doesn't stay,

so I'll have her brought here.

Except for Arámburo and el Ch., all the rest treat me like trash now that I don't have the honor of belonging to the elite of famous artists, and above all now that I'm not your wife. But as Lupe Rivas Cacho says, everything changes, some go up and others go down and that's how the *regolution* is... The faggots of Carlos Orozco Romero and his gang, all the "decent people" of Mexico City, and all the ladies that volunteer at the Red Cross, prancing like the most brazen whores down the street, without clean bills of health, meet me on the street and don't deign to speak to me, for which I'm very grateful and content. I don't see anyone and above all I'll never again see those filthy, snobbish ass-kissers and sons of bitches. The situation is rapidly changing, now the two men elected by "the people" to govern... are convinced anti-fascists and anti-Stalinists. One day they'll have to admit that the only one who dared to speak the pure and naked truth, right in everyone's mug, was you. In any case my warmest congratulations for the thrashing the above-mentioned will be given thanks to your clean and solid work.

I also wanted to talk to you about how you left or plan to leave the matter of the payments to Guadalupe Marín. As you know she's capable of coming and seizing your houses or something so that you'll have no choice but to pay her. Settle things once and for all in such as way that she doesn't try to screw you, because if her dirty little business in New York didn't work out she's going to come back with plenty of poison on her arrows. Though it wouldn't surprise me at all if she goes to visit you at the West to settle verbally various things that interest her, and that you, naturally, stricken by fear, accept her proposals, threats, etc. Now is the time of the small and great betrayals. You know better than anyone what an abject bitch Guadalupe is, as if Mussolini himself had given birth to her. So I'm warning you in advance, let's

see if this time you listen to me a little.

Now I'll tell you about myself as you asked me to do in your letter. I don't think it's necessary to tell you much, because you know well enough. I have suffered unspeakably and much more now that you have gone. In these past days, that is, weeks naturally, I haven't painted and I think as many more will pass before I feel better and begin again. Since the months are passing quickly, I don't think I'll be able to do the exhibition in New York in January. I wrote to Levy but he hasn't answered me, I don't even know what might have happened to my painting of *The Wounded Table* that Miguel took to deliver to Levy. I don't have the slightest news of the exhibition. I know that what you say in your letter is very kind on your part but rather doubtful, for unfortunately I don't believe my work has interested anyone. There's no reason why they should be interested and much less that I should believe they are.

I was hoping the Guggenheim thing would fix me up for this month, but not even the ghost of a response, not even the ghost of more hopes. When I found out that you had in your possession the first self-portrait I painted this year, or last, I don't remember, and which I candidly took to Misrachi's for him to send to the purchaser... Misrachi and you having deceived me, with a sweet and charitable deception, and when I saw that it wasn't even unwrapped, something that might have excused in part the deception, for according to what you said you exchanged it for one of your paintings in order to have a portrait of me, I realized many things. The portrait of the hair, the one of the butterflies and that one, and your marvelous painting of the sleeping girl that I wanted so much, and that you sold to Kaufmann so he would give me the money, has been all that has maintained me last year and this. That is to say, your money. I've continued living off of you, creating illusions for

myself of other things. The conclusion I've drawn is that all I've done is fail. When I was a little girl I wanted to be a doctor and a bus squashed me. I live with you for ten years without doing anything in short but causing you problems and annoying you, I began to paint and my painting is useless but for me and for you to buy it, knowing that no one else will. Now that I would have given my life to help you, it turns out other women are the real "saviors". Maybe I'm thinking all this now that I find myself fucked up and alone, and above all worn out from interior exhaustion. I don't believe any sun, anything I'm supposed to swallow or any medicine will cure me; but I'll wait longer to see what this mood depends on; the bad thing is that I think I already know and there's no remedy. New York no longer interests me, and all the less now with the Irenes, etc., there. I don't have the slightest desire to work with the ambition I would like to have. I'll continue painting only so that you'll see my things. I don't want exhibitions or anything. I'll pay what I owe with my painting, and even if I have to eat shit, I'll do exactly what I feel like doing when I feel like doing it. The only thing left to me is to have your things close to me, and the hope of seeing you again is enough to keep living.

The only thing I ask of you is that you do not deceive me, there's no reason anymore, write me whenever you can, try not to work too hard now that the cool weather is beginning, take very good care of your eyes, don't live alone so there will be someone to take care of you, and whatever you do, whatever happens, I will always adore you.

<div align="center">Your Frida</div>

Tell me everything you need from here so I can send it to you.

The children and Cristi say hello.

I'll send you the receipts and the clippings.

I beg you not to leave this letter lying around because all my other ones were put with many others accompanied by notes from Irene and other whores.

Give my regards to Ralph and to Ginette and to Doctor Eloesser and to all the good friends in San Francisco.

‍⁂

Frida and Diego had divorced on November 6, 1939. On May 24, 1940, David Alfaro Siqueiros and a group attacked Trotsky's house without succeeding in eliminating him. On June 3, 1940, Rivera sent a formal letter to Sra. Frida Kahlo saying: "I attach a letter of proxy duly signed and sealed by which you are authorized to take from my house whatever objects you consider necessary and to deposit them where you think most advisable".

Chente is Vicente Lombardo Toledano, the president, Lázaro Cárdenas, l-d, Lev Davidovich Bronstein, "Trotsky".

Mary (Marjorie) Eaton was an artist Frida and Diego had met in New York in 1933 when she was living with Louise Nevelson; they saw each other again in Mexico in 1934.

The Hungarian painter Irene Bohus was first Diego's assistant in Mexico and San Francisco and later a close friend of Frida's.

Rivera first did a portrait of the movie actress Paulette Goddard in Mexico in 1939 and a year later in a mural in San Francisco, in which Frida was also portrayed.

The art collector Conger Goodyear had purchased one of Frida's paintings in the 1938 exhibition in New York.

Federico is Doctor Federico Marín, Lupe's brother.

The sculptor Ralph Stackpole and his wife Ginette had been friends of Frida's and Diego's since 1930.

LETTER TO EMMY LOU PACKARD

[*Originally in English*]

Miss Emmy Lou Packard
c/o Stendahl Galleries
3006 Wiltshire Boulevard
Los Angeles, Ca.
U.S.A.
Registered

New York, October 24th, 1940

Emmy Lou my darling,

Please forgive for writing you in pencil, I can't find any foun-
tain pen or ink in this house. I am terribly worried about
Diego's eyes. Please tell me the exact truth about it. If he is
not feeling better I will scram from here at once. Some doc-
tor here told me that the sulphanilamid sometimes is danger-
ous. Please darling ask Dr. Eloesser about it. Tell him all the
symptoms Diego has after taking those pills. He will know
because he knows about Diego's condition in general. I am so
happy he is near you. I can't tell you how much I love you for
being so good to him and being so kind to me. I am not
happy at all when I am away from him and if you were not
there I wouldn't leave San Francisco. I am just waiting to fin-
ish one or two paintings and I'll be back. Please darling, make
any effort you can to make him work less.

That affair with Guadalupe is something that makes me
vomit. She is absolutely a son of a bitch. She is furious because I

will marry Diego again, but everything she does is so low and dirty that sometimes I feel like going back to Mexico and kill her. I don't care if I pass my last days in prison. It is disgusting to feel that a woman can sell every bit of her convictions or feelings just for the desire of money and scandal. I can't stand her anymore. She divorced me from Diego just in the same dirty way she is trying to get some dough from Knoff and Wolfe. She really doesn't care what she does as long as she is in a front page of the papers. Sometimes I wonder why Diego should stand that type of wench for seven years. He says it was only because she cooked well. Perhaps it was true, but my god, what kind of an excuse is that? I don't know. Maybe I am getting cooko. But the fact is that I can't stand any more the funny life those people live. I would like to go to the end of the world and never come back to anything which means publicity or lousy gossip. That Guadalupe in the worst louse I ever met, and even the damn law helps her to get away with her rotten tricks. This world is "some thin" kid!

The letter Donald wrote is beautiful. I am sorry, didn't see the spitting business between Philip and him. Tell him I would of done the same thing in his case. His "charro" dress will be ready soon and Cristina will send it to you.

Darling, Julien Levy liked very much your drawings but he can't give you an exhibition because he says he only shows surrealist paintings. I will talk to Pierre Matisse about it and I am sure I can arrange something here for you next year. I still like the first one you made of me better than the others.

Give my love to Donald and to your mother and father. Kiss Diego for me and tell him I love him more than my own life.

Here is a kiss to you and one for Diego and one for Donald.

Please write to me when ever you have time about Diego's eyes.

Mi cariño,

Frida.

꒰꒱

The painter Emmy Lou Packard (born 1914) was Rivera's assistant both in his workshop in Mexico City and on his murals painted in the United States.

Frida refers to Guadalupe Marín, Rivera's wife from 1922 to 1929.

[62]

LETTER TO SIGMUND FIRESTONE

[Originally in English]

New York, November 1ˢᵗ, 1940

Dear Sigy,

It is three weeks ago that I received your kind letter and your check of 150.00 dlls, when I was at the hospital in San Francisco. I should of answered you immediately but I was so ill that I didn't have the strength to do anything. Please forgive me. I have no words to tell you how happy I was to hear from you and how glad to know that you like the selfportrait. I am terribly sorry Diego didn't write to you explaining about the paintings. I am sure he will apologize to you as soon as he is able to finish the fresco he is painting at the fair in San Francisco. I beg you to forgive him. You don't have any idea of the way he is working in that fresco. Sometimes he hardly has time for sleep. He works twenty hours a day and sometimes more. Before he came to San Francisco he had a terrible time in Mexico and finally had to leave the country in very difficult circumstances (all due to political troubles there). So I really hope you will be so sweet to understand and try to forgive him.

I came to New York few days ago. I had to arrange my exhibition for next year. Everyday I wanted to write to you and for one reason or another I couldn't. I am staying here at a house of some friends of mine, Mr. and Mrs. Sklar, who very kindly invited me to be with them for a while, and I hope very much to have a chance to see Alberta, and if possible you and Mrs. Firestone. I heard that Natalie is in Hollywood. I think I will be here two weeks more.

Before I came to the States, a month and a half ago, I was very ill in Mexico. Three months I was lying in bed with a plaster corset and an awful apparatus on my chin which made me suffer like hell. All the doctors in Mexico thought I had to be operated on my spine. They all agreed that I had tuberculosis on the bones due to the old fracture I suffered years ago in an automobile accident. I spend all the money I could afford to see every specialist on bones there, and all told me the same story. I got so scared that I was sure I was going to die. Besides, I felt so worried for Diego, because before he left Mexico I didn't even know where he was for ten days, shortly after he could finally leave, Trotsky's first attempt of assassination took place, and after, killed him. So the whole situation for me, physically and morally was something I cannot describe to you. In three months I lost 15 pounds of weight and felt lousy all together.

Finally I decided to come to the States and not to pay any attention to Mexican doctors. So I came to San Francisco. There I was in the hospital for more than a month. They made every possible examination and found *no* tuberculosis, and *no* need for an operation. You can imagine how happy I was, and how relieved. Besides, I saw Diego, and that helped more than anything else. I wish you could see and understand that it is not really my fault if I didn't behave with you as I should. Writing you on time, and explaining you all about the painting. It was more than anything else my whole situation which prevented me to think and to act as I should of done it.

They found that I have an infection in the kidney which causes the tremendous irritation of the nerves which go through the right leg and a strong anemia. My explanation doesn't sound very scientific, but that is what I gathered from what the doctors told me. Anyhow I feel a little better and I am painting a little bit. I will go back to San Francisco and marry

Diego again. (He wants me to do so because he says he loves me more than any other girl.) I am very happy.

Sigy, I would like to ask you a favor. I don't know if it is too much trouble for you. ¿Could you send me the one hundred dollars balance of my painting here because I need them badly, and I promise you that as soon as I go to San Francisco I will make Diego send to you his selfportrait. I am sure he will do it with great pleasure, it is only a question of time, as soon as he finishes the fresco he will have more time and paint for you that portrait. *We will be together again, and you will have us together in your home*. Please forgive him and forgive myself for being the way we are. We really don't mean to hurt anyone.

Will you be so kind to do so? Please tell me where can I reach Alberta. My address is *88 Central Park West*. C/o Mrs. Mary Sklar.

Thank you for all your kindness and for be so good to me. Give my love to the girls and to Mrs. Firestone. Besos to all of you from your Mexican friend

<div align="center">Frida</div>

<div align="center">৵</div>

At the beginning of 1940 the engineer Sigmund Firestone, of Rochester, commissioned self-portraits from Diego and Frida for the total sum of 500 dollars. Frida finished her painting (oil on masonite, 59.7 cm x 40 cm) the same year, while Diego delivered his a year later. Frida dedicated the portrait to Firestone and to his daughters Natalia and Alberta.

Note for Diego Rivera

San Francisco, November [?], 1940

Diego, my love,
Don't forget that as soon as you finish the fresco we shall be together forever, without quarrels or anything, only to love each other very much.

Don't misbehave and do everything Emmy Lou tells you to.

I adore you more than ever. Your child

Frida

(Write me)

[64]

Letter to Sigmund Firestone

[*Originally in English*]

San Francisco, December 9th, 1940

Dear Sigy,

Your letter and your telegram were the nicest wedding presents I had. You cannot imagine how grateful I am with all your kindness, and so is Diego. He sends to you million thanks and his best wishes. Having the right measures of the painting he will start very soon his self-portrait and we will be together on your wall, as a symbol of our remarriage. I am very happy and proud because you like my portrait, it is not beautiful, but I made it with a great pleasure for you.

I am very glad, Sigy, that Alberta is with you. You will not feel lonesome and I am sure she is very happy being home again. If by any chance I go to Los Angeles I will see Natalie, send to me her address if you [...] like a nightmare. I had to do many things and rush all the time, but tell her that I will never forget the day we had lunch together. Tell her she is a swell girl, besides being very beautiful.

Our plans now are not very precise. Diego has to finish a portrait of a lady here, and after, two more in Santa Barbara. I probably will go back to Mexico because I want to be *sure* about the situation there before risking to let Diego go back. He would like to stay here as long as possible, but his permit expires soon so we have to figure out what to do in case he couldn't stay in this country longer. Perhaps it's only a question of crossing the border and coming back again. But everything depends on

the work he has here and on the political circumstances. Besides I left everything in Mexico in a kind of a mess, so I must go and arrange definitely how Diego's things are going to be placed, etc. Above all his collection of Mexican sculpture and his drawings.

How I wish you could of seen the fresco Diego just finished here. It is in my opinion the best painting he ever did. The opening was a great success. More than 20,000 people saw it and Diego was so happy! Just like a little boy, he was shy and very happy at the same time. If I can get a photograph of it I will send it to you.

Wherever I will be I will write to you from time to time. Where are you going to be for Christmas? I wish to arrive in Mexico before the "piñatas". (Do you remember last year in my house?) I am sure my sister's kids will enjoy again this month in my house in Coyoacán. Sometimes I miss them a lot. I miss also my father and my sisters (the two fat ones and the one you met). My heart is always divided between my family and Diego, but of course Diego takes the bigger part and now I hope to be in his heart.

Sigy dear, give my love to Alberta and to Mrs. Firestone.

To you all the *cariño* from this Mexican bride who likes you so much.

Frida

A kiss for you, one for Alberta.

[65]

LETTER TO EMMY LOU PACKARD

Coyoacán, December, 1940

Darling Emilucha,

I received your two letters; many thanks, *compañera*. I'm looking forward to you both finishing all the work so you can come to Mexicalpán of the Prickly Pears. What I wouldn't give to be just around the corner and be able to visit you today, but there's nothing for it, I'll have to wait it out, sister.

I miss both of you very much... Don't forget me. I entrust the great child (Diego) to you with all my heart, and you can't know how grateful I am for your being so worried about him and taking care of him for me. Tell him not to throw so many tantrums and to behave himself.

I do nothing but count the hours and the days to go before having you both here... Make sure Diego sees an oculist in Los Angeles, and that he doesn't eat too much spaghetti so he doesn't get too fat.

Goodbye, darling girl, I send you lots of kisses.

Your *cuate*, Frida. How is Pandy? Her two husbands are anxiously awaiting her here.

༄

After having remarried Rivera on December 8, 1940 in San Francisco, Frida returned to Mexico to spend the Christmas and New Year holidays with her family, while Diego stayed behind to finish, in public view, ten fresco panels on the cultural unity of the Americas, a commission from the architect Timothy Pflueger for the Golden Gate International Exposition. Rivera's closest collaborator was the painter Emmy Lou Packard.

Letters to Doctor Leo Eloesser

{a}

Coyoacán, March 15th, 1941

Dearest Doctorcito,

You're right to think I'm a wretch for not even writing you when we got to Mexicalpán of the Prickly Pears, but you mustn't imagine it was just laziness on my part, because when I arrived I had a pile of things to arrange in Diego's house, which was absolutely filthy and in a mess, and when Diego arrived, you must know how he has to be looked after and how he takes up one's time, for as always when he gets back to Mexico he's in a hellishly bad mood the first days until he gets used to the rhythm of this country of "locos". This time his bad mood lasted more than two weeks, until they brought him some marvelous idols from Nayarit and when he saw them he began to like Mexico again. Also, the other day he ate a really nice turkey *mole*, and that helped him still more to regain a taste for life. He stuffed himself with so much turkey *mole* that I thought he was going to get indigestion, but you know how foolproof his resistance is. After these two events, the idols from Nayarit and the turkey *mole*, he decided to go out and paint some watercolors in Xochimilco, and little by little his mood has been getting better. In general I understand why he becomes so exasperated with Mexico, and he's right, because to live here you have to be constantly on your guard against being screwed around by others; the nervous exhaustion that comes of defending yourself from all the bastards here is much greater that what one experiences in Gringolandia, for the simple reason that there people are more

stupid and malleable, and here everyone goes around picking fights and wanting to screw and kick the crap out of their neighbors. Also, in Diego's work people always respond by screwing and cheating you, and that's what most exasperates him, for as soon as he arrives the newspapers start to harass him; they envy him so much they would like to make him disappear by magic. In Gringolandia, on the other hand, it's been different, even in the case of the Rockefellers one could struggle against them without back-stabbing. In California everyone has treated him very well, and they respect a person's work there; here he barely finishes a fresco and by the following week it's already been scratched and spat on. That would disillusion anyone, as you can well understand. Especially someone who works as Diego does, expending all the effort and energy he's capable of, without taking into account the "sacredness" of art and all that string of stupidities, but on the contrary wearing himself out like any laborer. On the other hand, and this is my personal opinion, although I understand the advantages of the United States for any work or activity, I still prefer Mexico, I can't stand the gringos for all their qualities and defects, which they also have plenty of, I detest their ways, their hypocrisy and their disgusting Puritanism, their Protestant homilies, their boundless pretension, the fact that one has to be "very decent"* and "very proper"* for everything... I know that here they're all crooks, sons of bitches, bastards etc., etc., but I don't know why even the dirtiest tricks are performed with a bit of a sense of humor, while the gringos are just disagreeable from birth, though terribly respectful and decent (?). And then I can't bear their way of life, those ghastly parties, where after ingesting their fill of cocktails (they don't even know how to get drunk with good taste) they settle everything from the sale of a picture to a declaration of war, always providing the seller of the picture or the declarer of war is

an "important" personality, otherwise they don't pay the slightest attention to you, there only the "important people" *matter*, even if they're just sons of their mothers*, and in the same English I could give you a few more opinions of the kind. You might tell me you can also live there without cocktails and without *parties**, but then you'll never be more than second-rate, and I feel the most important thing for everyone in the Gringolandia is to be "somebody", and frankly I don't have the slightest ambition to be anybody, I don't give a damn about "airs" and I'm not in any sense interested in being a "big shit".

I've told you too much about other things and nothing about what is most important at the moment. It's about Jean. When we got to Mexico, and as you and I had planned, the thing was to get her a job so later she could make her way more easily in the United States. I thought at first it would be easy to find her something at Misrachi's or at the American Legation, but now the situation is completely different and I'm going to explain why. She has complicated her situation by a stupidity, instead of keeping her mouth shut and not sticking her nose into what she doesn't know anything about, from the beginning she made a show of her political opinions, which according to her (who does nothing but repeat what she has heard Clifford and Cristina Hastings say) are of *open sympathy with Mister Stalin*. So you can imagine the effect that had on Diego, and as is entirely natural, when Diego realized exactly how things stood, he told her he couldn't allow her into the house in San Ángel, which is what we had been planning at first, to live with Emmy Lou and help her receive people coming to buy paintings, so she came to live with me in the house in Coyoacán, and Emmy Lou stayed in San Ángel. Everything was going more or less fine until yesterday, though Diego wasn't as free to speak of certain things in front of her as he is in front of Emmy Lou or me, and that created an atmosphere of reserve and

tension at the lunchtime table. Jean noticed it perfectly well, but instead of being sincere with Diego and openly clarifying her situation, since she no longer has, as she says, any active interest within the Stalinist camp, she would always keep her mouth shut when the subject came up, or say things that sunk her more and more, reinforcing the certainty that she's an out-and-out Stalinist. The incident yesterday was the last straw. We were talking at lunch about the rumor circulating that the Stalinists had attacked Julián Gorkín (a member of the POUM) for the third time. Jean is friendly with an intimate friend of Gorkín who lives in the same house where Gorkín lives, the rumor was that they had gone to attack him at his own house, and recalling the case of old Trotsky, Diego commented that "someone" must have opened the doors of Gorkín's room to the Stalinists, and then addressing Jean he said: Might not your friend know something about that? Instead of defending her friend or frankly clarifying the matter, Jean went that very afternoon and tattled to the friend of Gorkín in question that Diego was saying that *it was he who had attacked Gorkín.* The gossip started to go the rounds like wildfire, and I told Jean the only thing she should do before Diego found out from a third party what a stupid thing she'd done, was to talk to Diego and confess to him that she herself had gone with the gossip to Julián's house. After a lot of talking, she made up her mind and talked to Diego, telling him the truth. You can imagine how furious Diego got, with a perfect right, since the situation is delicate enough without compromising it still more by Jean's stupidities and blunders. So Diego told her quite frankly, as she had her return ticket to California, to be good enough to leave, since he could no longer trust her to be in the house, knowing she would repeat (interpreting incorrectly) everything that was said or commented on at the table or anywhere else in the house. As you can understand, Diego is perfectly right, and though I'm very

sorry Jean has to leave in her present circumstances, there's no help for it. I spoke at length with her about how best to solve the problem, I spoke to Misrachi to see if he could give her a job, but it doesn't look good, for she doesn't speak Spanish and it's not possible to employ her speaking only English, moreover she would have to obtain the formula fourteen that allows foreigners to work in Mexico, something which is very difficult before having been in the country for six months. The most reasonable thing would be to go back to California and have Emily Joseph recommend her to Magnit so she could start to work there and make a living. But she doesn't want to go immediately because the Josephs are here. Sidney is coming as well, and she thinks that if she arrives in California without work it will be very difficult, on the other hand if she waits for the Josephs to return she will have a firmer guarantee of finding something in San Francisco. So, brother, I don't see any other solution but if you can help her with a hundred dollars, send it to her, so she can rent a modest apartment until such time as she can arrange something more permanent. She has the enormous defect of believing eternally that she's seriously ill, she doesn't do anything but talk about diseases and vitamins, but she makes no effort to study anything or work in whatever, like millions of people who in spite of being much more fucked than she is have no choice but to work. She doesn't have the energy to work but she does to go about and do other things I can't talk to you about here; I'm very disappointed in her, because at first I thought she would make an effort at least to help me with the housework, but she was born lazy and is as selfish as they come; she doesn't want to do anything, I mean anything at all. It's not that I want to boast, but if she's ill, I'm even worse, and nevertheless, dragging my hoof about as I can, I do something, or try to fulfill my obligations as best I can in tending to Diego, painting my little figures, or at least keeping the house

in order, knowing that that means lessening Diego's difficulties and making life easier for him, since he works like a horse to put food on the table. This Jean doesn't have anything but stupidities in her head, how to make herself a new dress, how to make up her mug, how to comb her hair so she'll look better, and she's forever talking of "fashions" and stupidities that don't lead anywhere, and not only that but she does it with a pretentiousness that leaves you cold. I don't think you can interpret what I'm telling you as washerwomen's gossip, since you know me, and you know I always tell things as they are, and I haven't the slightest interest in annoying Jean, especially because it's my responsibility that she came here after you judged it best. Since I have the greatest trust in you, I think I can speak to you with complete sincerity about this matter. With the absolute certainty that what I write you will not reach Jean's ears, in order to avoid useless gossip. I told her I would write you so that you would know Diego's political situation, which is already delicate in itself, and would be much more complicated by his admitting an openly declared Stalinist into his house. I promised her (a promise I am not keeping) not to tell you anything of the details of the incident, but I don't keep my promise because I understand that it's my duty to tell you exactly what Diego's attitude consists of, for otherwise she might tell you something else, making herself the victim, and wishing to wrap a situation that is delicate because it involves politics in sentimental romantic gossip or any other stupidities she may be used to using in order to make everything appear owed to her bad luck... of which she speaks continually, without considering that she herself creates this series of troubles by the way she is and because she doesn't give the slightest importance to the only thing that should concern her, working, in order to earn a living like anyone else. I really don't know what she thinks she'll be able to do when she's old and ugly and there's no one to pay attention to her sexually,

which is her only weapon for the moment. And you know very well the sexual attraction of women ends in no time at all, and afterwards they have nothing left but what is in their heads to defend themselves in this goddamned filthy life. Now I think that if you write to her and tell her exactly how things stand, making it *very clear* that the hundred dollars you are sending her are the last you can send, not because you don't have more, but in order to make her understand that *she has to start working* in whatever she can find, for her own good, she'll see that not all that glitters is gold, and here or there she'll find a way to get a *job**, whatever it may be, so that she has a sense of responsibility, and forgets for a moment the imaginary illnesses that so torment her. You as a doctor and a friend should tell her that she is not so ill as to be unable to work, and above all that she keep in mind that although there was something more than friendship between the two of you, that does not mean that you will be eternally responsible for maintaining her. In this case I would have come to her defense, if I saw that she really had a point, but on the contrary I see that, if the first time she causes such a nuisance I had taken her side, she would be capable of compromising Diego much more seriously, and that's something I will by no means permit. Because I can quarrel with Diego millions of time about whatever passes through my ovaries, but always taking into account that I am first of all his friend, and it won't be me who betrays him on the political terrain even if they kill me. I'll do whatever I can to make him see when he's mistaken, the things that seem clearer to me, but there's no way I want to become a blind for someone I know is his enemy, and much less for a person like Jean who doesn't even know where her nose is, and proudly boasts of belonging to a group of indecent bandits like the Stalinists. I want all I'm telling you to remain completely between you and me, and for you to write her that you received a letter from me with a concrete explanation of how

226

Diego's situation does not permit him to have her in his house, since it's no longer a question of a difference of opinion on political matters, but rather simply of his personal safety which would be seriously compromised before public opinion if it came to be known that he allowed a Stalinist to live in his house. Which is completely true. If you want to send her money, tell her frankly to use it until she finds a job, since you know that Emily Joseph is very gladly willing to get her work in San Francisco. You can't imagine how sorry I am for bothering you with this nuisance, but I see no other solution, and I unfortunately don't have sufficient "dough" to say, Here's five hundred pesos, Jean, go and find a house. Diego is so angry with her that I don't dare suggest that he lend her money until she finds work, for he's sure that if she wants to she can find it herself. I want to ask you to consider this matter from a completely impartial point of view, without passion, and without taking into account whatever romantic relationship may exist between you and Jean, because that comes second in this case, and above all it would be harmful for her to find very broad support from you, because that is precisely her weak point. You understand me. She'll be able to find plenty of lovers as long as she performs the pantomime that she's gravely ill, but I think it will be very difficult for her to find friends like you, so make her see the situation very clearly and very sincerely so she realizes she can't be telling you tall tales. I think a hundred dollars will be more than enough for her to be able to live two or three months here until she returns to San Panchito and the Josephs find her a job, or maybe in the mean time she'll find some gentleman who takes her to live with him, I think that would be the best solution for her, and that way you wouldn't have any responsibility anymore. Give some thought to how you're lending her those bucks so they'll be the last. I'm waiting for your answer to know what to expect. In another letter I'll tell you about

227

my hoof, my backbone, etc., for the moment I'm a little better because I don't drink alcohol anymore, and because I made up my mind that even if I limp, it's better not to give too much attention to illnesses because in any case even a slip on a fucking banana peel can put an end to your days. Tell me what you're doing, try not to work so very many hours, have more fun, since the way the world's going, very soon it's going to be lousy for all of us, and what's the use of passing from this world without having taken a bit of pleasure in life. I wasn't so sorry about the death of Alfred Bender because I detest Art Collectors*, I don't know why, but art in general does less for me every day, and especially those people that exploit the fact of being "art connoisseurs" to brag about being "God's elect"; often I feel more sympathy for carpenters, shoemakers, etc., than all that herd of stupid so-called civilized windbags known as "cultivated people".

Goodbye brother, I promise to write you a long letter telling you about my hoof, if that happens to interest you, and other tittle-tattle related to Mexico and its inhabitants. I send you lots of affectionate regards and hope your health is good and that you're happy.

La Malinche. Frida

ॐ

In 1939 Diego Rivera first distanced himself from, and then broke with, the IVth International; he was then supporting the candidacy of General Almazán in the Mexican presidential elections, a rather adventurous step that was surely intended to conceal his still close relations with the Stalinists.

Albert Bender, an insurance agent and patron of the arts, met Rivera in the 1920s in Mexico and purchased some of his work. In 1930 he obtained permission for the painter to enter the United States.

Emily Joseph, the wife of the painter Sidney Joseph, was the arts columnist for the San Francisco Chronicle and had served as interpreter at the lectures Rivera delivered in French in California in 1930.

Coyoacán, July 18th, 1941

Dearest Doctorcito:

What will you think of me? -that I'm an absolute wretch. I didn't even thank you for your letters, nor for the *child* that gave me such joy- not a single word in months and months. You're absolutely right to *remind* me of the... family. But you know that I remember you no less for not writing you. You know I have the enormous defect of being lazy as no one else when it comes to writing. But believe me I've thought of you very often and always with the same affection.

I see Jean very little. The poor thing has not been able to find steady work and she is making plaster mold copies of toys for a factory —they pay badly and above all I don't think it's something that can resolve her life. I have tried to make her see that the best thing would be to fly the coop back to the Californias but she doesn't for the life of her want to. She's very skinny and very nervous because she doesn't take vitamins. They cost a fortune here so it's too bad, but she can't buy them. She says it's difficult for you to send them from there because of customs or some such problem. But if someone were coming soon and you could send some, it would do her a lot of good, because as I say, she's very unwell and hard up.

My hoof, or paw, or foot, is doing better. But my general state is pretty fu... nny. I think it's because I don't eat enough and I smoke a lot. And strange to say, I no longer drink any cocktails, large or small. I feel something in my belly that hurts and constantly makes me feel like burping (*Pardon me, burp!!**). My digestion is a damned mess. My mood are terrible, I'm getting more ill-tempered every day, [...] that is, very *ornery*. If medicine offers some remedy that takes people like me down a

peg, go ahead and prescribe it to me so I can swallow it immediately and see what effect it has. I'm still working at my painting. I paint little but I feel I'm learning something and I'm not as inept as before. They want me to paint some portraits in the dining room of the Palacio Nacional (5 of them): The five most distinguished Mexican women in the history of this nation. So now I'm trying to find out just what kind of beasts these heroines were, what sort of mugs they had, and what kind of psychology they were loaded with, so that when it comes to seeing them daubed in paint, people will be able to distinguish them from the vulgar and common wenches of Mexico, though I can tell you that for my money there are among the latter more interesting and important ones than the ladies in question. If among your curiosities you find some weighty tome that speaks of Doña Josefa Ortiz de Domínguez, of Doña Leona Vicario, of..., of Sor Juana Inés de la Cruz, be ever so kind enough to send me some information or photographs, engravings, etc. of the period and of their most worthy effigies. With this work I'm going to earn some "bucks" which I will use to purchase some "wares" that are pleasing to my sight -smell and touch- and to buy some really swell flower pots I espied in the market the other day.

The re-marriage is working well. Few quarrels, greater mutual understanding, and on my part, less bothersome inquiring into the question of other women who suddenly occupy a preponderant place in his heart. So you can understand that I finally realized that life is *like that* and the rest is just window dressing. If I my health were better I would be able to say I'm happy, but feeling such a mess from head to toe sometimes muddles my brains and makes me go through some bitter moments. Hey, aren't you going to come to the International Medical Congress to be held in this beautiful city -so they say- of

the Palaces? Come on, grab a steel bird and Zócalo, Mexico City. How about it, yes or yes?

Bring me lots of Lucky and Chesterfield cigarettes because here they're a luxury, comrade, and I can't afford to spend a buck a day on nothing but smoke.

Tell me about your life. Something that shows me you're always thinking that in this land of Indians and gringo tourists there is a girl who is your tried and true friend.

Ricardo got a tiny bit jealous of you because he says I address you as "tú". But I explained everything that could be explained to him. I love him terribly and I tell him you know that.

I'll close now because I have to go to Mexico City to buy brushes and colors for tomorrow and it's gotten terribly late on me.

Let's see when you'll write a long, long letter. Say hello to Stack and Ginette for me, and to the nurses at Saint Luke. Especially to the one who was so kind to me -you know which one-, I can't remember her name at the moment. It begins with M. Goodbye darling doctorcito. Don't forget me.

Lots of regards and kisses from

Frida

The death of my father has been something horrible for me. I think that's why I declined so much and lost quite a bit of weight again. Do you remember how sweet and good he was?

༃

As a "legal convenience", in Diego Rivera's words, he and Frida had divorced at the end of 1939 in a Coyoacán court. In the course of their separation, their relations remained very close.

The "child" to which Frida refers was a fetus given to her as a present by Dr. Eloesser.

The Spanish refugee Ricardo Arias Viñas was Frida's lover at the time.

Voucher for the Central de Publicaciones

September 23rd, 1941

Voucher to the "Central de Publicaciones" in the sum of $1000.00 -one thousand pesos- corresponding to household expenses for the month of *October* 1941, to be charged to the account of Sr. Diego Rivera.

Frida Kahlo

Notes for Alberto Misrachi

{a}

Nov. 17th, 1941

Albertito.
Back to bother you with the same favor as in other months.

Could you advance me the $500.00 from December? I haven't been able to send the portrait they commissioned in New York and I've gotten short of bucks again. *Don't squeal to Diego* and keep this note as a receipt. So on December 1st I'll only have 500 barefoot eagles coming to me.

A million thanks from you *cuate*

Frida

{b}

Coyoacán, Dec. 10th, 1941

Albertito.
I'm going to bother you again for an advance of $500.00 out of what is due to me in January. I can't get through the month on what I have. Because from the painting Paulette bought I paid nothing but the "IOUs" I had.

A million thanks.

Frida

Here is the official receipt.

Received from Mr. Alberto Misrachi the sum of $500.00 (five hundred pesos) as an advance on the monthly stipend corresponding to me for January 1942, leaving only $500.00 to be

paid me on January 1ˢᵗ.

<div align="center">Frida Kahlo</div>

<div align="center">࿔</div>

Paulette Goddard had purchased The Flower Basket *(oil on canvas, 64.5 cm in diameter).*

Dedication to the Daughters of the Venezuelan Ambassador, Sr. Zawadsky

December 1ˢᵗ, 1941

For Clarita, Gloria and Mireya, three girls I love very much and who came to bring more light to Mexico.

Your *cuatezona* with the long petticoats.

Don't forget me.

Frida

Letter and Telegram to Emmy Lou Packard

Coyoacán, December 15th, 1941

Darling Emmylucha,
Here I am still stretched out in bed with a fucking flu that just won't say goodbye. I've been feeling so shi... ftless and that's why I haven't written you darling.

I was terribly glad you finally managed to have your exhibition, and the only thing I'm sorry about is not having "cast a third eye" on the very day of the *opening**. We would have "tied on" one of those that are remembered even in times of *war*. Since you left I've felt like a dirty skunk, I don't know what the hell exactly is wrong with me, but frankly *compañera*, I don't feel well. All I want to do is sleep all day, and I look like a piece of masticated chewing gum, down in the dumps and all fu... nny.

Guess what, the little parrot "Bonito" died. I gave him a little burial and all, and cried my eyes out because he was marvelous, remember? Diego also took it terribly hard. The monkey "El Caimito" got pneumonia and he almost popped off as well, but the "sulphamidyl" put him right. Your little parrot is just fine, he's here with me now. How is Pandy #2?

Tell me darling, how has the harvest of paintings gone, and how did you find the public in Los Angeles, very nasty or not?

Tell me how Donald was, and your parents and your sister and the *chilpayates*.

About the Arensbergs, I want you to tell them that Kaufmann has the "Birth" painting. I would like them to buy "Me Sucking", because that would really set me up. Especially now that I'm so extremely "hard up". If you get the chance, do

make an effort, but as if it were coming from you. Tell them it's a picture I painted at the same time as "Birth" and that you and Diego both love it. You know which one it is, right? Where I'm with my wet nurse, sucking purest mother's milk! Remember? I hope you can convince them to take it off my hands, because you can't imagine how I need the bucks just now. (Tell them it's worth 250 dollars). I'm sending you a photograph so you can sing its praises and play the go-between to interest them in this "work of art", eh young lady? Also tell them about the "the bed" one that's in New York, could be they're interested, it's the one with the skull at the top, remember? That one's worth 300 greenbacks. *Won't you give me a little boost darling, because I really do need the bucks.*

Diego is working terribly hard on Paulette's painting. On Thursday I met Paulette and she seemed better than I expected.

When are you coming back? You're missed a great deal around the Coyoacanes. Write me now and then.

A million kisses for Donald and your parents from me. Give *buten* regards to the Homolkas and tell'em they should come down here. Don't forget me darling and tell me if there's anything I can send you from here.

Did you look pretty at the opening*? Tell me all the gossip. And don't forget about the Arensbergs.

Diego sends you kisses and I my heart entire. Yours

Frida

Coyoacán, December 17th, 1941

[*Originally in English*]

EMMY LUCHA LETTER LEFT THIS MORNING AFRAID
ARRIVE LATE WOULD LIKE ASK YOU ENORMOUS

FAVOR TELL ARENSBERG PAINTING BIRTH BELONGS KAUFMANN STOP WISH YOU COULD CONVINCE THEM TO BUY INSTEAD "I WITH MY NURSE" SAME SIZE SAME PRICE 300 BECAUSE NEED BUCKS VERY URGENTLY BEFORE FIRST JANUARY PLEASE MAKE ALL EFFORTS AS POSSIBLE STOP SENDING PHOTO LET ME KNOW RESULTS MILLION THANKS LOVE.

FRIDA KAHLO

300 BUCKS.

⌇

Walter G. Arensberg was a Los Angeles collector; Edgar J. Kaufmann, a manufacturer and collector from Pennsylvania.

Frida refers to her paintings, in order, My Birth (1932), My Wet Nurse and I (1937) and The Dream (1940).

LETTER TO MARTE R. GÓMEZ

Coyoacán, March 15th, 1943

Dear *compañero*,

For a long time I have wanted to talk with you about something that is very important for me personally, but which I also think has a general interest. I'm writing you because it's easier for me to express concretely what I want to say than if I explained the matter to you in person, and especially because this way I think I will take up less of your time. It's a question of asking you for some advice as a friend. I dare to speak of this to you before anyone else, because I think you are one of the few real friends Diego has in Mexico, and I think you will give me your frank and sincere opinion.

For a long time now I have been truly worried about Diego, firstly about his health, he's constantly having problems with his eyes and moreover his general state is not what it used to be. You must have noticed that even with the fresco work he's doing in the Palacio he has gone much more slowly, because he keeps having the nuisance of the conjunctivitis which doesn't allow him to work and to produce as much as a few years ago. Also, the economic difficulties that everyone is going through now as a result of the war have been much harsher in Diego's personal situation than I could have imagined. It grieves me a lot that this crisis has come precisely at the moment when I would have wanted him to be secure and tranquil in order to be able to paint without serious worries, because a man who has worked like Diego deserves to have a few years of security to do what he feels like. What worries me is not so much the immediate problem of earning

enough money to live on, for that can be more or less solved by the two of us working. My principal worry is much more important for Diego and I feel utterly incapable of resolving it.

As you know, what most interests Diego in life, after painting, are *his idols*. For more than fifteen years, spending the greater part of what he has earned by working incessantly, he has been assembling a magnificent collection of archaeological pieces. I don't believe there is a more important private collection in Mexico. His idea has always been to build a "house of idols", and a year ago he found the place that really deserved this house of idols in the Pedregal de Coyoacán, in a little village called San Pablo Tepetlapa. He began to build it with the stone of the Pedregal itself, saving an enormous amount of material that way; he himself drew up the plans with a love I can hardly describe to you, working all night at times after arriving tired from painting all day. Believe me I have never seen him put such joy and such enthusiasm into building something. I don't want to describe the plan to you because I would like so much for him to show it to you personally.

The situation is that, as I told you before, under the present circumstances he doesn't have enough money to continue construction. I can't express to you what that means to Diego, because nothing has made him so sad since I have known him. I would like to help him in the best way not to become discouraged nor to lose hope completely of solving this problem that is so important to him, and I thought, after turning all the possibilities around in my head, that maybe the only feasible one would be for the Mexican government to interest itself in the matter, not as personal aid for Diego nor anything of the sort, but by reaching a sort of *agreement for the establishment of an Archaeological Museum with Diego's collection.* That is, *a sort of exchange: the government would construct the building,* following Diego's idea of course, and *he would donate his entire*

collection to the country after his death, thus resolving two important things: that Diego would be able to enjoy his collection as long as he lives, and that afterwards a collection of *such* importance would not be broken up nor dispersed, for you know what it would mean to leave in the hands of the family things of incalculable value which, as always happens, end up in La Lagunilla.

I don't know if my idea is silly or preposterous, or even what Diego himself would think of it, because I haven't dared to say a word to him of this suggestion of mine, because I don't want him to think that it's just my desire to help him in a sentimental way that moves me to speak of this; but believe me, Marte, that it is something that really worries me, because I know the value this matter holds in his life. I would like to ask you just to orient me, to tell me I whether what I'm thinking could be a serious possibility or not, whether you think it advisable that I speak to him about it. If you think my idea is good, then imposing on your kindness in coming to have lunch or dinner with us one of these days, you and I could discuss this as a suggestion and see what his reaction is, if not, I beg you never to tell him I spoke to you about this, for maybe he'll think I'm meddling without any right in his problems.

Forgive me for bothering you with this matter which after all is nothing but a personal problem; but knowing that you appreciate Diego and feeling sure that you will understand that the only reason that moves me to bother you with this letter is the immense affection I have for Diego, and my interest in all of his things; I feel more tranquil. Naturally everything I'm saying is just an idea I've been turning around in my head, I don't even know whether the way I'm formulating it is correct, for I imagine that if it were possible to do it, it would be much more complicated, which is why it would be a matter of you and Diego discussing everything in detail. But as a general idea, I want you

to tell me with complete frankness what you think. I wouldn't want to see Diego suffer from not having something he so deserves, because what he is asking is really nothing compared to what he has given. I also think it would be really marvelous for Mexico to have a museum of this kind.

You can't know, Marte, how grateful I would be for your opinion. This week I'm going to arrange with Hilda the lunch we talked about by telephone; that's why I wanted you to receive this letter first, so that when we see each other you can tell me what you think of what I've said.

A thousand thanks for all your kindness, give my warmest regards to Hilda and the children and your mother, and accept the affectionate greetings of

<div align="right">Frida</div>

It was the agronomist Marte R. Gómez (1896-1973) who in 1923 invited Diego Rivera to paint the murals in the National Agriculture School in Chapingo. When Frida wrote this letter to him he was Secretary of Agriculture in the administration of Manuel Ávila Camacho (1940-1946). In 1944 Marte R. Gómez commission a portrait from Frida for the rectors' gallery of the school in Chapingo. She executed two identical copies in oil on masonite (32.5 cm x 26.5 cm), one for the school and one for the agronomist's private collection, the latter at the request of Eduardo Morillo Safa.

LETTER TO FLORENCE ARQUIN

[*Originally in English*]

Coyoacán, November 30th, 1943

Florence darling,

Please forgive my laziness! You know what kind of "son of a gun" I am for writing. But *in my heart you are all the time*, and in spite my apparent forgetfulness, I am the same Frida as ever.

Darling, Diego was very happy with the beautiful color-photo you sent to him. It is right in front of his bed and every morning I see you there. *We miss you a lot.*

My life is the same. Sometimes OK, sometimes damn boring. I can't say the same for Diego. He is never bored. He works like the devil, and he is always constructing something. His pyramid on the Pedregal is getting every day more magnificent and the painting he is doing at the Institute of Cardiology is gorgeous.

Since you left I finished *three* paintings (small ones). I sold one, and the other two are on Verlullaire's Gallery. But I think I will take them away from there because that damn gallery is every day lousier. About my painting of the 4 monkeys you took to the States, I haven't heard a word from Julien. I am a little bit afraid something happened to it. What do you think? Did you write to Julien about it? Shall I write to him? Or what can I do? I am sorry to bother you with that, but I am afraid he hasn't got it, and I don't have any papers here to arrange anything.

Listen baby, if you think it is only a question of the circumstances now, the cause of the delay we leave the thing as it is, but I

imagine the people of the border had plenty of time already to have sent it to N. York. Don't you think so? Anyway tell me what to do. Maybe everything is under control.

How is your health now? I was so worried when you left. How is your husband and your mother. Please give my love to both, and tell them *how much I love you*.

Forgive my English and handwriting. It is lousy!!!! But if I make the letter again I will never send it, so it's better you will forgive such awful letter.

Darling baby, I want you to tell me all kind of details about you. I will write you again soon. It's a cinch!!!

All my love and Diego's too for our kid Florence.

<div align="right">Frida</div>

Happy Christmas to you all.
Come to Mexico very soon!

<div align="center">ॐ</div>

The American painter, photographer, educator and critic Florence Arquin (1900-1974) was in Mexico in 1943 and exhibited her work at the Benjamin Franklin Institute in Mexico City. She traveled through Latin America giving lectures on art and doing field research.

Frida is worried about the oil Self-Portrait with Monkeys *(1943, 81.5 cm x 63.0 cm), purchased by Jacques and Natasha Gelman.*

LETTER TO MARTE R. GÓMEZ

Coyoacán, March 7th, 1944

Compañero Marte,

Herewith I'm sending you an invitation in case you have "half a minute" to come and see the paintings that the students of my class in the Painting and Sculpture School of the Secretariat of Education have done at some *washbasins* in Coyoacán. The Ing. Morillo has already seen them, he can give you his impression and I'm sure you'll feel like coming. If you don't like the idea of the *official* party at 10 in the morning, you can arrive a little later or come at whatever time you are able to, but I beg you not to forget all about it.

To get there easily do the following: when you reach the "El Carmen" tramway stop (across from the orphanage), turn right and continue until you reach "La Concepción" square, where there's a marvelous Colonial church; at the last corner of the little square turn left and continue for a block, the washbasins are across from a big factory you'll see right away.

A thousand thanks for coming and putting up with the nuisance of this letter.

Many regards from

Frida

❧

In 1943 Frida began to given beginners' painting classes to a numerous group of students in a desolate space in the Painting and Sculpture School. The tyrannical demands of her lacerated body obliged her to continue the classes at her home. The management of the School supported the move by subsidizing the fares of the students who traveled to Coyoacán from Monday to

Friday. The group that began the pilgrimage was fairly numerous, but soon there were only four left: Fanny Rabel, Arturo Estrada, Guillermo Monroy and Arturo García Bustos, for whose mural painting practice Frida managed to obtain the walls of some public washbasins erected through the efforts of a group of poor washerwomen. The place was dubbed the "Josefa Ortiz de Domínguez House of Women".

Letter to Bertram and Ella Wolfe

Coyoacán, 1944, Mexico

Dearest Boitito and Ella,

You'll think when you receive this singular missive that I have *resuscitated* to this treacherous world, or that I was simply pretending not to hear, and I hadn't even tossed you a "line" since we saw one another in the New Yores three years ago. Think whatever you like; even if I don't throw you a scrap of writing, you are always present in my thoughts.

And I want to wish for both of you that the year of 1944 (though I detest its numeration) will be the happiest and most pleasant that you have ever lived or ever will live. [...]

Well children, now the drilling's going to start. How is your health? What kind of life are you leading? What kind of "folks" are you seeing and who do you talk to now and then?

Do you still recall that in the Coyoacanes there exists a well-born lady, cherished of all, who the Grim Reaper hasn't yet carried away... and who is ever hopeful of seeing again your dear faces, one day, in this beloved land called Tenochtitlán. If this should happen to you, *please** write with haste, telling me *all your** details, that my heart may proceed to its delusive joy.

Since the re-nuptials, a second episode in my life which you well know, I will tell you, not in great detail, but rather "summarily" (that last word is worth a 100 pesos) how I am:

Health: —Regular patch, my backbone will still resist a few blows more.

Love: —Better than ever because there is mutual understanding between the spouses, without impair-

ment of the just freedom in such cases for each one of the consorts; total elimination of jealousy, violent arguments and misunderstandings. Great quantity of *dialectic* based on past experience. I have said!

"Dough": —Minute quantity, almost zero, but enough to cover most urgent needs: eatables, attire, taxes, cigarettes, the occasional bottle of aged "Cuervo" tequila whose cost is $350 (per liter).

Work: —Too much for my impetus because now I am a teacher in a painting school (higher station, reduced strength). I start at 8 a.m. I leave at II a.m., it takes me I/2 hour to cover the distance between the school and my place = at 12 a.m. I organize in part whatever is necessary to live more or less "decently", see that there's food, clean towels, soap, the table set, etc. etc. = 2 p.m. I proceed to the swallowing, then to the cleansing of the gauntlets and hinges (that is, teeth and mouth).

I have the afternoon left over to dedicate myself to the fine arts, I'm always doing pictures, for I barely finish one before I have to sell it to have enough dough for monthly expenses. (Each spouse contributes to the upkeep of the mansion.) In the nocturnal night I go to the movies or to a goddamned theater, and return to sleep like a log. (Sometimes insomnia overwhelms me and then I'm really f... ixed up!!!)

Liquor: —I have succeeded in exerting my *iron* will power to help me *curtail* the quantity of imbibable liquor, reducing it to two "cop...ious tears" by day*. Only on rare occasions does the volume imbibed

increase, and is magically transformed into a "drunk" with its respective morning "hangover"; but these cases are neither frequent nor efficacious.

Of other

things that tend

to happen to everybody... After 19 years, Don Diego's paternal love has been reborn, bringing as a consequence that Lupita junior, *so-called** Picos, has been living with us for two years, because the permanent bomb of her *mother* was going to explode, *Lupe grande, against Lupe chica**, and these events made an adoptive "mammy*" of me with her adoptive *child**. I can't complain because the kid is as good as Michelangelo, and more or less adapted to the character of her pappy, but in any case the situation of my life is not particularly... flattering, let's say. Because since 1929 to the present 1944, I can't remember a single time during which the Rivera couple has not had *at least one* female companion living at their home. *Home, sweet home!** What has changed is the quality of the company; before they were closer to worldly love, now they're getting closer to filial love. You understand.

Well, comrade, I have to go, I've told you more or less my current life; I hope to receive -not a chance!- the answer that this singular, abrupt, heterogeneous and almost surrealistoid letter deserves.

Your loyal and obedient servant

Doña *Frida*, the luckless

NOTE WITH GIFT FOR ALEJANDRO GÓMEZ ARIAS

April 24th, 1944

This is the present of the biggest loco there is in the world. Do not proceed to laugh and laugh. Accept it with pleasure and rejoicing in remembrance of all the years and years I have loved you for ever and ever.

F.

(The letter is originally in English with several Spanish words and phrases thrown in. TN)

LETTER TO DOCTOR LEO ELOESSER

June 24th, 1944

[…] I'm worse every day. […] At the beginning it was very hard for me to get used to, because it's a fucking nuisance to put up with this sort of apparatus, but you can't imagine how bad I felt before putting it on. I literally could not work, for every movement, however insignificant, tired me out. I improved a little with the corset, but now I feel just as bad again and I'm desperate, for I see that nothing improves the condition of my spine. The doctors tell me my meninges are inflamed, but I just don't understand how things are, because if the reason for immobilizing the spine is to avoid irritation of the nerves, how is it that with the corset and all I still feel the same pains and the same annoyances?

Listen, darling, this time when you come, for the sake of what you most love in life, tell me what the fuck I have and if there's some remedy or if the grim reaper is going to take me in any case. Some of the doctors have insisted I need another operation, but I wouldn't let myself be operated on unless *you* performed it, if it were necessary.

჻

At the time, Doctor Alejandro Zimbrón ordered absolute bed rest and made Frida wear a steel corset.

Note and Postcard for Diego Rivera

{a}

Apple of my eye,
Cuquita invited me to have lunch in the country, I waited until
12 o'clock but you didn't even call me on the telephone.

I'll be back around six o'clock in the afternoon more or less.

El Güerito tells me you invited Milagros to have lunch. Please
tell her I'm very sorry I didn't see her but if she has nothing to
do we'll see each other when I'm back (at six o'clock).

Please leave me the "dough" in the first drawer of your
dresser under the shirts or in an envelope with Manolo or *el
Güerito*, thanks a lot and I hope I see you when I get back. I'll
see you later tonight in any case, no?

I leave you, as always, my heart and my life.

Your *chicuita*
Frida

{b}

November 13ᵗʰ, 1944, Coyoacán

Apple of my eye,
you know how I adore you and how I would like this day, like
all days, to be the best.

Drink a glass of wine to my health.

Your little girl
Fisita

Letter to Ruth Rivera Marín

June 17th, 1945

Darling Ruth,
Here for your day are some golden earrings for your beautiful little ears. Whenever you put them on, remember that in the distant Coyoacanes there is someone who loves you very much, for three reasons: first, for being yourself; second, for being the daughter of Don Pelelico; and third, for being so pretty. You're not to blame for any of the three, nor I for loving you so much.

 Your

 Frida

༄

Ruth (1927–1969) was the youngest daughter of Guadalupe Marín and Diego Rivera (Don Pelelico). *Frida had a special predilection for her.*

Presentation for Fanny Rabel

Fanny Rabinovich paints as she lives, with an enormous worth, keen intelligence and sensibility, with all the love and joy of her twenty years. But what I judge to be most interesting in her painting is the profound root that links it with the tradition and strength of her people. It is not personalist, but rather social painting. She is fundamentally concerned with problems of class, and has observed, with exceptional maturity, the character and style of her models, always lending them a vivid emotion. All this, without pretensions, and full of a femininity and a refinement that make it so complete.

࿇

Fanny Rabel was born on August 27, 1922 in Poland. She began to go to school in France in 1929. She arrived in Mexico in 1938 and entered the Painting and Sculpture School ("La Esmeralda"). Among her teachers were Frida Kahlo, José Chávez Morado and Feliciano Peña. This first exhibition of 24 oils, 13 drawings and 8 engravings was held in the Liga Popular Israelita in August of 1945.

Speaking of One of My Paintings, of How, Starting from a Suggestion by José D. Lavín and a Text by Freud, I Made a Picture of Moses.

BY FRIDA KAHLO
Exclusive for ASÍ

The public frequently explains and wants to know what certain paintings mean, particularly modern ones. Reluctant to give explanations, Picasso responded to a certain lady who claimed not to understand his work:

—Do you like oysters?

—Very much! -replied the lady.

—And do you understand them?

On another occasion, the same artist affirmed: "Everyone wants to understand art. Why don't they try to understand the song of a bird?"

Orozco also said one day: "The public refuses to see painting… it wants to hear painting".

Less from aesthetic convictions than for other reasons, Frida Kahlo has never "explained" her paintings.

But a few days ago, at the request of a group of friends who gathered at the home of the well-known manufacturer José Domingo Lavín to admire a painting he had purchased from the famous painter, she agreed to talk about the work.

Ironically, with the good humor, simplicity and lack of pretension typical of her, Frida Kahlo explained the meaning of the symbols and the figures that make up the painting, whose central subject is Moses.

As being of some interest to our readers, we give a photographic reproduction of the painting and an approximate summary, taken down by one of our staff writers, of the painter's explanation.

Frida Kahlo naturally did not "explain" that her painting is a work of great

255

plastic richness and lofty conception, which confirms the talent of this extraordinary artist who has won a definitive place among Mexico's greatest painters.

We offer in the following pages the gist of the explanation given by Frida Kahlo of the painting in question:

Since this is the first time in my life that I have tried to "explain" one of my paintings, to a group of more than three people, you will have to forgive me if I feel rather inhibited and get a bit "tangled up".

Two or so years ago, José Domingo told me one day that he would like me to read Freud's *Moses*, and to paint, however I wished, my interpretation of the book.

This painting is the result of that short conversation between José Domingo Lavín and me.

I read the book only once and began to paint the picture from the impression it had left on me. Yesterday I reread it, and I have to confess that I find the painting very incomplete and quite different from what should be the interpretation of what Freud analyzes so marvelously in his *Moses*. But now, there's nothing to be done, I can't add or take away, so I will tell you what I painted just as it stands, and which all of you can see here in the picture.

Of course the specific subject is *Moses* or *The Birth of the Hero*. But I generalized in my own way (a very confused way!) the facts or images that made the greatest impression on me when reading the book. With regard to what I have to "own up to" myself, you can tell me whether I've put my foot in it or not.

What I wanted to express most intensely and most clearly was that the reason people invent or imagine heroes and gods is merely *fear*. Fear of life and fear of death. I began by painting the figure of Moses as a child. (In Hebrew, Moses means the one taken from the waters, and in Egyptian "mose" means

child.) I painted him as many legends describe him, abandoned in a basket and floating on the waters of a river. In plastic terms, I tried to make the basket, covered by the skin of an animal, recall a womb as much as possible, because according to Freud the basket is the exposed womb and the water signifies the maternal source in the birth of a child. In order to centralize this fact I painted the human fetus in its last stage within the placenta. The Fallopian tubes, which resemble hands, are extended toward the world.

To either side of the created child I placed the elements of his creation, the fertilized egg and the division of cells.

Freud analyzes in a clear but, to my mind, complicated manner the important fact that Moses was not Jewish but Egyptian, but in my picture I did not find the way to paint him as either Egyptian or Jew, and I just painted a *chamaco* who would in general represent both Moses and any other of those who in legend had such a beginning, later becoming important figures, leaders of their peoples, that is, *Heroes*. (More astute than the rest, which is why I gave him a "third eye".) In this category are Sargon, Cyrus, Romulus, Paris, etc.

The other very interesting conclusion reached by Freud is that Moses, not being Jewish, gave to the people chosen by him to be guided and saved a religion that was not Jewish either, but rather Egyptian: Amenhotep IV or Akhenaton revived that of Aten, that is, that of the Sun, taking as its roots the extremely ancient religion of On (Heliopolis).

So I painted the Sun as the center of all religions, as the *first god* and as the creator and reproducer of *life*.

There always have been and will be a great quantity of "grandees" like Moses, transformers of religions and of human society. One might say they are a sort of messenger between the people they govern and the "gods" invented by them in order to be

able to govern them.

There's a "whole batch" of these "gods", as you know. Naturally, I couldn't fit them all in and I arranged, on either side of the Sun, those that, like it or not, have a direct connection with the Sun. To the right the Western ones and to the left the Eastern ones.

The winged Assyrian bull, Amen, Zeus, Osiris, Horus, Jehovah, Apollo, the Moon, the Virgin Mary, Divine Providence, the Holy Trinity, Venus and... the devil.

To the left, Lightning, the Thunderbolt and the traces of Lightning, that is, Hurricane, Cuculcán and Gukumatz, Tláloc, the magnificent Coatlicue, mother of all the gods, Quetzalcóatl, Tezcatlipoca, the Centéotl, the Chinese Dragon god and the Hindu Brahma. I'm missing an African god, but I couldn't find one anywhere, but space could still be made for one.

I can't tell you something about each one of them, because ignorance of their origin, importance, etc., overwhelms me.

After having painted all the gods that would fit, in their respective heavens, I wanted to divide the celestial world of the imagination and of poetry from the terrestrial world of the fear of death, and I painted the skeletons, human and animal, that you see here. The earth cups its hands to protect them. Between death and the group of "heroes" there is no division at all, since they also die and the earth receives them generously and without distinctions.

On the same earth, but painted with larger heads to distinguish them from the "mass", the "heroes" are portrayed (very few of them, but a select company), the transformers of religions, the inventors or creators thereof, the conquerors, the rebels... that is, the real "big wigs".

To the right (and I should have painted this figure with much more prominence than any other) is Amenhotep IV, later called Akhenaton, a young Pharaoh of the 18th Egyptian

dynasty (1370-1350 B.C.), who imposed on his subjects a religion contrary to tradition, in conflict with polytheism, strictly monotheistic, with distant echoes in the cult of On (Heliopolis), the religion of Aten, that is, the Sun. They not only worshipped the Sun with a material cult, but also as the creator and preserver of all living beings, within and without Egypt, whose energy was manifested in its thunderbolts, anticipating the most modern scientific knowledge about solar power. Breasted calls Amenhotep IV "the first individual in human history".

Next Moses, who according to Freud gave his adopted people the same religion of Akhenaton, transformed a little in accordance with the interests and circumstances of his time.

Freud reaches this conclusion after a thorough study in which he discovers the intimate connection between the religion of Aten and that of Moses, both monotheistic. (I was unable to transmit this very important part of the book in plastic terms.)

There follow Christ, Zoroaster, Alexander the Great, Caesar, Mohammed, Tamerlane, Napoleon and "the lost child"... Hitler. To the left, the marvelous Nefertiti, the wife of Akhenaton; I imagine that in addition to being extraordinarily beautiful, she must have been a "hidden treasure" and an extremely intelligent collaborator of her husband. Buddha, Marx, Freud, Paracelsus, Epicurus, Genghis Khan, Gandhi, Lenin and Stalin. (The order is muffed, but I painted them in accordance with my historical knowledge, which also is.)

Between them and the "mass", I painted a sea of blood by which I signify war, inevitable and fecund.

And lastly, the powerful and "never sufficiently valued" human mass, made up of all sorts of... animals: warriors, peacemakers, scientists and ignorant people, monument-builders, rebels, flag-bearers, medal-wearers, talkers, the crazy

and the sane, the merry and the sad, the healthy and the sick, poets and fools, and whoever else you would like to exist in this powerful commotion.

Only those at the front are clearly seen, of the rest, "with all the noise... we didn't know".

On the left side, in the foreground is Man, the builder, in four colors (the four races).

On the right side, the Mother, the creator, with her child in her arms. Behind her is the Monkey.

The two trees that form a Noachian ark/arch of Triumph are the new life that always sprouts from the trunk of old age. In the center, below, the most important thing for Freud, and for many others... Love, which is represented by the scallop shell and the conch, the two sexes, wrapped in ever-new and ever-living roots.

That is what I can tell you about my painting. But all kinds of questions and comments are permitted. I won't get angry.

Thank you.

Congratulations for Diego Rivera

December 8th, 1945

Diego, my child, my love,
You know what gifts I would give you, not only today but all my
life, but this year I had the bad luck of not being able to give
you anything made by my hands, nor of buying you anything
you would really like. I offer you all that is mine and I have, as
always, my affection, which is born and lives at every moment,
only because you exist and receive it.

 Your little girl

 Fisita

 (your ancient concealer)

Letter to Ella and Bertram D. Wolfe

<div align="right">February 14th, 1946</div>

Darling Ella and dear Boit,

The comet appears again! Doña Frida Kahlo, believe it or not!! I'm writing you from bed, because for the last four months I've been a wreck with my crooked spine, and after having seen countless doctors in this country, I've taken the decision to go to the New Yores to see one they say is the "daddy" of them all... all the ones here, the "bonesetters" or orthopedists think I should have an operation that I believe is very dangerous, for I'm skinny, exhausted and in a f... rigging mess and in this state I don't want to let myself be operated on without first getting the opinion of some "big shot" doctor in Gringolandia. So I want to ask you a huge favor, which consists of the following:

I am attaching a copy of my clinical history that will serve to give you an idea of everything I've suffered in this goddamned life, but I would also like you, if it were possible, to show it to Doctor Wilson, who is the one I'm going to consult there. He's a bone specialist, whose complete name is Philip Wilson, 321 East 42nd Street, N.Y.C.

What interests me is to know the following points:

1) I could go to the United States more or less at the beginning of April. Would Doctor Wilson be in New York at that time? And if not, when could I find him there?

2) After he more or less knows my case through the clinical history you could show him, would he be willing to receive me for a serious examination and give me an opinion?

3) If he accepts, does he think I would need to go directly to *a hospital* or could I live somewhere else and just go to his office several times?

(All of this is extremely important for me to know as I have to calculate the "bucks", which I'm very short of just now.) *You know what I mean kids?***

4) You can give him the following information to make things quite clear: I have been in bed for *four* months and I'm very weak and tired. I would travel by airplane to avoid any further disturbance. They will put a corset on me to help me put up with the irritations. (An orthopedic or plaster corset.) How long does he think he will need to make a diagnosis, taking into account that I have x-rays, analyses and all sorts of "stuff" of that kind? 25 x-rays from 1945 of my spinal column, and 25 x-rays from January 1946 of my spine, leg and hoof. (If they need to take new ones there, I'm ready and willing... for anything!

5) Try to explain to him that I'm not a "millionaire" or anything like that, but rather that the "dough" happens to be in short supply.

6) VERY IMPORTANT

That I'm placing myself in his magnificent hands because, apart from being aware of his great reputation through my doctors, he was recommended to me personally in Mexico by a gentleman who was his client, by the name of Arcady Boytler, who admires him and adores him because he cured him of something about his dorsal column. Tell him that Boytler and his wife spoke marvels of him and that I'm absolutely delighted to be going to see him, for I know the Boytlers adore him and think highly enough of me to send me to him.

7) If any other practical things occur to you (remembering what kind of dunce I am), I would be grateful to you with all my heart, beloved children.

8) I'll send you whatever dough you say for the appointment with Doctor Wilson.

9) You can explain to him more or less what kind of uncivilized beast your *cuate* peg-leg Frida Kahlo is. I give you complete freedom to give him any kind of explanation and even to describe me (if necessary, ask Nick for a photo, so he sees what kind of mug I have).

10) If he wants more information, proceed to write me in all haste, so everything's ready to put my foot into (skinny or fat).

11) Tell him that, as a patient, I can put up with quite a lot, but that he's getting me a bit strained, because in this s.o.b. of a life you suffer, but you learn, and also the pile... of years has made me more pen... sive.**

Now some other information for you, not for Doctorcito Wilson:

1º You going to find me somewhat changed. My gray hair is overwhelming me. My thinness as well and I'm rather darkened by so much suffering.

The 2nd conjugal life is going very well. Everything changes and now I take everything with more calm and deliberation.

I still love you tons and hope you love me the same. Am I wrong?

Until I hear words from your mouths, a big hug. Please write me quickly about this matter which is urgent. I send you lots and lots of kisses and all the gratitude of your *cuatacha*

Frida

Regards to all our friends.

〜

(** *Frida is playing with the slightly off-color word* pendejo *"stupid, moronic". See also letters 88 and 103. TN*)

Corrido for A and L

<div align="right">May, 1946</div>

Solito andaba el Venado	*Lonely wandered the Deer*
rete triste y muy herido	*very sad and sorely wounded*
hasta que en Arcady y Lina	*until with Arcady and Lina*
encontró calor y nido	*she found warmth and shelter.*
Cuando el Venado regrese	*When the Deer returns*
fuerte, alegre y aliviado	*strong, joyful and healed*
las heridas que ahora lleva	*the wounds she now bears*
todas se le habrán borrado	*will all be effaced.*
Gracias niños de mi vida	*Thank you children of my life*
gracias por tanto consuelo	*thank you for so much consolation*
en el bosque del Venado	*in the forest of the Deer*
ya se está aclarando el cielo	*the sky is beginning to clear.*

<div align="right">Coyoacán, Friday May 3rd, 1946</div>

Ahí les dejo mi retrato	*Here I leave you my portrait*
pa' que me tengan presente,	*so that you'll remember me*
todos los días y las noches,	*every day and every night*
que de ustedes yo me ausente.	*that I am far from you.*
La tristeza se retrata	*Sadness is depicted*
en todita mi pintura,	*in every part of my picture*
pero así es mi condición,	*but that is my condition:*
ya no tengo compostura.	*I have no remedy.*

Sin embargo, la alegría	*Nevertheless, I bear*
la llevo en mi corazón,	*joy in my heart*
sabiendo que Arcady y Lina	*knowing that Arcady and Lina*
me quieren tal como soy.	*love me as I am.*

Acepten este cuadrito	*Accept this little picture*
pintado con mi ternura,	*painted with tenderness*
a cambio de su cariño	*in exchange for your affection*
y de su inmensa dulzura.	*and your measureless sweetness.*

Frida

✤

In April of 1946 Frida painted The Wounded Deer, *a small oil on masonite (22.4 cm x 30.0 cm), and on May 3 she delivered it to Lina and Arcady Boytler, accompanied by the above verses, a copy of which was given to me in 1981 by Ana María Monteo de Sánchez, who worked with Lina Boytler.*

[84]

Telegram for Ella Wolfe

[Originally in English]

May 10th, 1946

ELLA WOLFE 68 MONTAGUE ST BROOKLYN NY

DARLING DR WILSON WIRED ME HE CAN RECEIVE ME
23 MAY I WILL ARRIVE NEW YORK 21 BY PLANE
THANKS A LOT FOR ALL YOUR WONDERFUL KIND-
NESS PROBABLY WILL STAY FIRST DAYS AT 399 PARK
AVENUE MISS SONJA SEKULA
 LOVE TO BOTH
 FRIDA

Letter to Alejandro Gómez Arias

June 30th, 1946. New York

Alex *darling**,

They don't let me write much, but this is only to tell you I swallowed *the big** operation. Three *weeks** ago they proceeded to the cut-cut of bonesetters. And this medicine is so marvelous and my *body** so full of vitality, that today they proceeded to get me up on my *pauper feet** for two short minutes but I myself *no lo belivo**. The *first** two weeks were all suffering and tears, for I wouldn't wish the pains on *anybody**; they're *buten* piercing and dreadful, but this week the howling died down and with the help of the little pills I've more or less survived. I have two whopping scars on my back in *this** shape. From there they proceeded to yanking out a scrap of my pelvis to graft it onto my column, which is where the scar is least hair-raising and straightest. Five vertebras were damaged and now they're going to remain like a repeating rifle. But *the** nuisance is that it takes a long time for the bone to grow and readjust itself and I still have six weeks left in bed until they release me and I can flee this horrible city for my beloved Coyoacán. How are you? *Please** write me and send me some little book; *please don't forget me**. How is your Mommy? Alex, don't leave me all alone, alone in this foul hospital and write me. Cristi is bored out of her mind and we're roasting in the heat. There's a terrible lot of heat and we don't know what to do. What's new in Mexico? What's happening with everybody there?

Tell me about everyone and above all, about yourself.

Your F.

I send you *buten* affection and lots of kisses. I got your letter, it cheered me up a lot! Don't forget me.

Letter to José Bartolí

Bartolí — last night I felt as if many wings were caressing me all over, as if there were mouths in your fingertips kissing my skin.

The atoms of my body are yours and vibrate together for us to love one another. I want to live and be strong to love you with all the tenderness you deserve, to offer you all that is good in me, and for you to feel you are not alone. Near or far, I want you to feel accompanied by me, to live intensely with me, but never for my love to encumber you in your work or in your plans, I want to form such an intimate part of your life, that I become your very self, that if I care for you, it will never be by demanding anything of you, but by letting you live freely, because all your actions will always have my complete approval. I love you as you are, your voice makes me love you, everything you say, everything you do, everything you project. I feel I have always loved you, since you were born, and before, when you were conceived. And I feel at times you gave birth to me. I would like all things and all people to care for you and love you and be proud, as I am, to have you. You are so fine and so good that you do not deserve to be wounded by life.

I could write you for hours and hours, I will learn stories to tell you, I will invent new words to tell you in all of them that I love you as I love no one else.

<div align="right">Mara</div>

August 29 (1946)
Our first afternoon alone together.

✌

Frida disguises herself in this letter under the pseudonym Mara, which she would use again in November 1947 in another surreptitious love letter to the poet Carlos Pellicer. Frida sent some twenty letters to José Bartolí (1910-1995), a Catalan painter, caricaturist and political cartoonist who had founded and was president of the Draftsmen's Syndicate of Catalonia (1936). He fought on the Republican side during the Spanish Civil War and at the end of the conflict was interned in concentration camps in France and Germany. He went into exile in Mexico in 1942. In 1946 he went to the United States, but the McCarthy persecution led him to return to Mexico in the 1950s. He lived for several years in France and after 1978 divided his time between Spain and the United States. His widow, Dr. Berenice Bromberg, has put up for auction some of the objects with amorous dedications given to him by Frida.

[87]

LETTER TO ELLA WOLFE

Coyoacán, October 23rd, 1946

Darling Ella of my heart,

It will surprise you that this lazy, shameless girl is writing you, but you know that in any case, with or without letters, I love you lots and lots. There's nothing new of importance here. I'm still much better, I'm painting (an absolutely foul picture), but something is something, and better than nothing. Diego is working as always —a double amount—. Since the argument with Boitito there hasn't been another heated discussion in this house, and he's not angry anymore, and I think it allowed both of them to get some things off their chests.

How is Boit? And Sylvia? (I had written the "i"s upside down.) Give lots of kisses for me to Boit, to Jimmy, to Sylvia, to Rosita and to all the friends who remember Me... ndelssohn.

I want to ask you a favor the size of the pyramid at Teotihuacán. Will you do it for me? I'm going to write to *Bartolí* at your address, so that you can forward the letters to him wherever he is, or keep them to deliver into his own hands when he passes through New York. For the sake of what you most love in this life, don't let them pass out of your hands, except *directly into his. —You know what I mean Kid!—* I wouldn't even want Boitito to know anything if you can avoid it, for it's better that only you keep the secret, do you understand? Here *no one* knows anything; only Cristi, Enrique... *you* and I and the boy in question know what it's about. If you want to ask me something in your letters, ask me in the name of SONJA, got it? I beg you to tell me how he is, what he's doing, if he's happy, if he's taking care of himself, etc.

Not even Sylvia knows any of the details, so don't "tittle-tattle" with *anyone* about this matter, please.

To you I can say that I truly love him and he's the *only* reason that makes me feel like living again. Speak well of me to him, so that he leaves happy, and knows that if I'm not a good person, at least I'm an O.K. one...

I beg you to *tear up* this missive as soon as you have found out everything you think you can tell me about this marvelous boy.

I send you millions of kisses and all my affection.

<div align="right">Frida</div>

Don't forget to tear up this letter, in case of future misunderstandings. Promise?

Letter to Eduardo Morillo Safa

Coyoacán, October 11th, 1946

Dear *Ingeniero*,

I received your letter today. Thank you for being so kind to me, as always, and for your congratulations for the prize (which I haven't received yet). Let them try to wriggle out of it, brother, you know what s... of b... they are. Together with your letter, that is, at the same time, I got one from Dr. Wilson, who was the one who operated on me and left me like a repeating rifle. He says I can now paint for *two hours* a day. Before receiving his orders I had already begun to paint and endured up to *three* hours dedicated to painting and painting. I have almost finished your first picture, which of course is no less than the result of the damned operation. I'm there -seated at the edge of a precipice- with the steel corset in my hand. Behind I'm lying on a hospital stretcher bed facing the land-scape, with a bit of my back revealed where you can see the scar from the slashes given me by the surgeons, "sons of... their newlywed mothers". The landscape is day and night, and there's a skeleton (or death) fleeing in fright from *my will to live*. You imagine it, more or less, for the description is really awful. You can see that I don't possess Cervantes' tongue, nor poetic or descriptive talent or genius, but you're an "ace" at understanding my rather "colorful" language.

I loved your letter, but I still feel you're rather *alone* and disconnected among those people living in such a f... unny, ancient milieu. Still, it will allow you to cast a "third eye" at South America in general and later write the pure and naked

truth, making a comparison with what Mexico has achieved in spite of it all.

It would interest me very much to know something about the painters there. Can you send me photos or magazines with reproductions? Are there any Indian painters? Or just mestizos?

Listen young man, I'll paint the miniature of Doña Rosita with all my affection. I'll have photos taken of the pictures, and from a photograph of the big portrait I can paint the little one, what do you think? I'll also paint the altar with Our Lady of the Sorrows, and the little dishes of green wheat, barley, etc., because my mother used to set up one of those altars every year and it was marvelous. I've already sown the *chía* and the rest, and as soon as I finish the first picture, which as I say is almost ready, I'll start yours. It also seems like a nice idea to paint the "pelado" with his woman wrapped in a rebozo. I'll do what I can so the pictures in question come out just "swell". I'll deliver them to your house, as you say, to your Aunt Julia, and send you a photo of each one as I finish it. You can imagine the color, *compañero*, it's not hard for you to guess since you already have a pile of Fridas.

You know I always get somewhat tired from daubing away, especially when I get interested and continue for more than three hours, but I hope to be in less of a mess within two months. You suffer a lot in this goddamned life, brother, and even if you learn, you really feel it in the long run, and for all I do to give myself strength, there are times when I'd like just to kick the bucket, like a real man!

Listen, I don't like you to sound so sad, you know there are people in this world, like me, who are worse off than you, and they keep tugging the same, so no getting down in the dumps. As soon as you can, return to Mexicalpán of the maguey juice, and you know life here is hard but delectable, and you deserve

275

lots of good things, because the simple truth is that you have what it takes and more, *compañero*. You know it's your true soul *cuate* that tells you so from her heart.

For now I can't tell you any gossip from around here, because I spend my life cloistered in this foul mansion of oblivion, supposedly devoted to recovering my health and painting in my spare time. I don't see any people at all, neither big shots nor proletarians, I don't do the circle of "literary-musical" gatherings. At most I listen to the hateful radio, a punishment worse than being purged. I read the *newspapers* (each one more pen… sive than the last). I'm reading a bit fat book by Tolstoy called *War and Peace*, which I think is "swell". Novels of "love and despair" just don't do it for me anymore, and it's only now and then I get my hands on a good detective novel. I like the poems of Carlos Pellicer more and more and the odd other true poet like Walt Whitman, but apart from that I don't have much to do with literature. I want you to tell me what you like to read so I can send it to you.

You must have heard of the death of the Doña Estercita Gómez, Marte's mother. I didn't see him personally, but I sent him a letter with Diego. Diego tells me he took it hard and he's very sad. Write to him.

Thanks, honey, for what you offer to send me from there. Anything you give me will be a souvenir I shall keep with lots of affection.

I received a letter from Marianita and it gave me a lot of pleasure. I'll answer her. Give my warm regards to Licha and all the kids.

To you, as you know, I send a kiss and the sincere affection of your *cuate*

Frida

Thanks for sending me the dough, I rather need it. *La chaparri-ta* sends her regards, as do Diego and the kids.

જી

The engineer, diplomat and art collector Eduardo Morillo Safa, at that time ambassador to Venezuela, had come to an agreement with Frida for a certain number of works, which he spon-sored economically. He would eventually purchase 35 pieces.

The painting described in the letter is The Tree of Hope *(1946, oil on masonite, 55.9 cm x 40.6 cm).*

The miniature Frida planned to paint based on the portrait of Sra. Rosita Safa de Morillo (1944, oil on canvas, 76.0 cm x 60.5 cm) is not known to exist.

Doña Estercita was the mother if Marte R. Gómez; Licha (Alicia), Eduardo Morillo's wife; la chaparrita *("Shorty") and the kids are Frida's sister Cristina and her children Isolda and Antonio.*

The prize Frida refers to was awarded to her by the Secretariat of Education for having been a finalist in the open competition for the Premio Nacional de las Artes, won by José Clemente Orozco on that occasion. Ten architects, 23 engravers, 192 painters (49 of them hors con-cours*) and 18 sculptors submitted work, a total of 500 pieces by 245 artists. The exhibition opened in the Palacio de Bellas Artes on June 22, 1946. Frida presented* Moses *or* Solar Nucleus *(1945, oil on masonite, 61.0 cm x 75.6 cm).*

Letter and Corrido for Mariana Morillo Safa

Coyoacán, October 23rd, 1946

Cachita, *changa maranga*,
Today I'm sending you some little rhymes so you won't say I've forgotten about you. Tell me how things are there in Caracas. What school do you go to? Where have you visited?

I'm here, in a bit of mess with the operation they did on my spine.

What are Lupita and Yito doing? And your Mommy and Dad? Say hello to them all for me and don't fail to write.

[...]

I send you lots of kisses and the great, great affection of your *cuatezona*

Frida

{b}

Desde Coyoacán, muy triste,	*From Coyoacán, with great sadness,*
ay, Cachita de mi vida,	*ay, Cachita of my life,*
te manda estos versos "gachos"	*I send you these foul verses,*
tu mera cuate, la Frida.	*your true cuate, la Frida.*
No pienses que me hago "rosca"	*Don't think I'm backing out*
y no te escribo cantando,	*and don't write you in song,*
pues con todo mi cariño	*for with all my affection*
este corrido te mando.	*I'm sending you this corrido.*

Te fuiste para Caracas
en un poderoso avión,
y yo desde aquí te extraño
con todo mi corazón.

Venezuela me robó
a mi Cachita la hermosa,
y Frida aquí se quedó
rete triste y pesarosa.

Venezolanos malvados,
jijos del siete de espadas,
regrésenme a mi Cachita
o se las quito a... trompadas!

Que no me tiren de a "lucas"
los chamacos Lupe y Yito,
pues ya ni la tronchan verde,
¡¡no me echan ya ni un lacito!!

A tus papás les das besos
que les mando de a montón!
Diles que me manden uno
pa' que me dé yo un quemón!

A pesar de las distancia
los llevo en mi corazón
y espero su regresada
pa' echar harto vacilón.

You went off to Caracas
in a powerful airplane,
and from here I miss you
with all my heart.

Venezuela stole from me
my beautiful Cachita
and Frida remained here
in great sadness and sorrow.

Venezuelan scoundrels,
sons of the seven of spades,
send me back my Cachita
or I'll take her from you... by blows!

Don't let them think I'm crazy,
the chamacos Lupe and Yito,
for now they're taking no chances:
they don't even lend me a hand!

Give kisses to your parents,
I'm sending them a bunch!
Tell them to send me one
to give me a big surprise.

In spite of the distance
I carry you all in my heart
and await your return
to have lots and lots of fun.

Un pájaro de ojos negros	*A black-eyed bird*
dijo que estás re bonita	*told me you're very pretty,*
ese pájaro chismoso	*how well that gossipy bird*
conoce bien a Cachita!	*knows my Cachita!*
Otro pájaro me dijo	*Another bird told me*
que en la escuela eres un "hacha",	*that you're an "ace" at school.*
yo les contesté orgullosa:	*I proudly replied:*
¡es muy lista mi muchacha!	*She's very clever, my girl!*
Cachita Morillo Safa,	*Cachita Morillo Safa,*
dueña de la simpatía,	*object of my affection,*
no me olvides, niña linda,	*don't forget me, darling girl,*
ya nos veremos un día.	*we'll see each other one day.*
El día que tú regreses	*The day that you return*
te haré una fiesta re "piocha"	*I'll throw you a real "swell" party*
con piñatas y hartos cohetes	*with piñatas and lots of fireworks*
que salgan "hechos la mocha".	*that take off like railway trains.*
Hasta el cielo subirán	*They'll go up to the sky*
a bajarte las estrellas	*and bring you down the stars*
y mientras estés ausente	*and for as long as you're away,*
¡que guarden sus luces bellas!	*may they preserve their lovely light!*
No te olvides de tu México	*Don't forget your Mexico,*
que es la raíz de tu vida	*which is the root of your life,*
y ten presente que "acantos"	*and don't forget that here*
te espera tu cuate Frida.	*your cuate Frida is waiting for you.*

FIN

Frida had done a portrait of Mariana Morillo Safa, the daughter of Eduardo Morillo Safa, in 1944 (oil on canvas, 36.0 cm x 26.0 cm). Lupita and Yito (Eduardo) were Mariana's sister and brother. Frida did a portrait of Lupita (oil on masonite, 58.7 cm x 53.3 cm) in the same year. And it was probably also in 1944, the year of the cycle of family portraits, that she painted Eduardo beside his mother, Alicia de Morillo Safa (oil on canvas, 56.0 cm x 88.5 cm).

DECLARATION SOLICITED BY THE
INSTITUTO NACIONAL DE BELLAS ARTES

I began to paint... out of pure boredom at being bedridden for a year, after suffering an accident in which I fractured my dorsal spine, one of my feet and some other bones. I was seventeen years old at the time and enthusiastic about studying to become a doctor. All that was thwarted by the collision of a Coyoacán bus with a Tlalpán tram... Since I was young, this misfortune did not take on a tragic cast at that time: I felt I had energy enough to do anything instead of studying to be a doctor. Without much realizing what I was doing, I began to paint.

I really don't know if my paintings are surrealist or not, but I do know they are the frankest expression of myself, without ever taking into account the judgements or prejudices of anyone else. I have painted little, without the slightest desire for glory or ambition, in the hope, first of all, of giving myself pleasure, and then of being able to earn a living through my craft. From my travels, seeing and observing all I could, magnificent painting and very bad painting as well, I have drawn two positive things: to try to be myself as far as possible, and the bitter realization that many lives would still be insufficient to paint as I would like and all I would like.

In 1945 the Instituto Nacional de Bellas Artes presented on its premises an exhibition of 45 self-portraits by Mexican painters from the XVIIIth to the XXth century. Beside each self-portrait (Frida's contribution was Diego in My Thoughts, *1943) there was a statement by the artist, written at the request of Fernando Gamboa, the head of the Department of Visual Arts and the organizer of the showing. The biographical notice gave Frida's date of birth as 1910, an error*

sanctioned by Frida herself since long before. The correct date –July 6, 1907– was revealed by chance in 1981: two German television professionals, screenwriter Gislind Nabakowsky and cameraman Peter Nicolay, came to Mexico to do a half-hour documentary on the Mexican painter. Wishing to offer something new for the program, I asked the writer Marco Antonio Campos to take the two German filmmakers to meet his godmother Isabel Campos. In the course of the interview, Isabel Campos commented that Frida had not been born in 1910, since she was a year younger than herself, born in 1906. The verification of Frida's birth certificate was enough to prove Isabel right. The correction of three years still needs to be emphasized, since not a little of the literature on Frida continues to record the erroneous date.

LETTER TO CARLOS CHÁVEZ

Coyoacán, February 18th, 1947

Dear Carlitos:

In place of me, here's a letter, brought to you with my affectionate regards by three young painters, [Arturo García] Bustos, [Guillermo] Monroy and [Arturo] Estrada, who were in my class at the Esmeralda School. I would have liked to accompany them to see you, but unfortunately I was taken by an "influation" and I'm laid out in bed.

Diego and I spoke to you of them on one occasion, and in our opinion they are the best among the younger painters in Mexico today. In addition to talent they have an enormous desire to work, but as always, in these cases, they don't have any "bucks". Their greatest dream is to take a trip to Yucatán, and thereafter to hold an exhibition here. All they would really need would be the cost of the passage and enough "dough" to live *very modestly* for the time they would be working there (they will tell you how much time they are planning on). If it were possible for you to *commission them officially*, even just providing them with the strictly indispensable, it would be an immense help and give them the opportunity to work as they want to, with room and board ensured if only for a short time. If it's possible for you to fix something up for them, it would give me a great deal of pleasure, for I know what these boys *are worth* and I'm sure they will perform their work very scrupulously, because I've known them for four years, during which time they have worked continually with enormous zeal and make constant progress without the least pedantry or pretension. I hope, Carlitos, that you can

do something for them. I thank you in advance, for I'm sure you'll do whatever you can. At the same time I beg you to take them into account when you start acquiring work by painters for the museum you're planning. Forgive any nuisance my request may cause you, and accept my warmest regards, as always

<div align="right">Frida</div>

<div align="center">ॐ</div>

At the time of the letter, Carlos Chávez was director of the Instituto Nacional de Bellas Artes, an institution established by decree of President Miguel Alemán, who had taken office on December 1, 1946.

Letter to Antonio Ruiz, "El Corcito"

Coyoacán, February 20ᵗʰ, 1947

Dearest Corcito, *cuate* of my heart,

First of all I want to make you my deepest bow, and then share several pieces of news with you: first, I no longer reside where I used to reside, that is, I proceeded to the falacious change of mansion, for I'm planning to rent the powerful house at Allende 59 Coyoacán, because you see the situation is a f... lipping mess, for any being who lives in the Mexican highlands, so here you have me living in the home of *la chaparrita* Cristi, at Aguayo number 22 of the very noble and ancient villa of Coyoacán, a house that has a *so called** ericsson "telefunken" whose number is "the following"*: 19-58-19. My stay in this mansion is of course temporary, for in the first patio of the house I left, I plan to build "in the future"*, "*avec*" the rent income, a diminutive dwelling that won't be too difficult for me to keep up, and which can be swiftly cleaned. "*You know what I mean, don't you Kid?*" Well then, here I am bringing you up to date on my existence at the above-mentioned street and number so that: when you feel like it, and have a great deal or regular amount of "time", you may proceed to arrive for a visit, something which will fill me with joy and delight, as you can well imagine. The second part of this missive consists of asking you what I should do about the School. You have been a good buddy to me and I thank you for it with all "my heart"*, but my face is burning from the mere shame of "depleting" the public coffers without do anything, and frankly, brother, I can't give classes as before, because I simply cannot go there "every day" * with apparatus, that is "corset"* or harp, and all, and the princi-

pal reason is that I only feel I have "atomic" energy enough in "the mornings"*, and in the "afternoons"* I shrink like a deflated balloon and have to proceed urgently to surrendering myself to the arms of Morpheus for a few hours, as prescribed by the Herr Doktor and savior of my trifling existence, Mr. Wilson, in the Newyores. For these reasons and the not-so-burning desire to paint, and still less since you are involved, who have been such an enthusiastic booster of your *cuatezona* who so appreciates it and is so grateful to you. The other day I saw Carlos Chávez and told him you had treated me really nice and swell, but that I was thinking of withdrawing from the class for all of the reasons I'm giving you in this papyrus, and he told me *he doesn't by any means want me to resign*. What should I do, brother? Should I just play dumb and keep shamelessly "filching" the "dough" and enjoying the three hundred "lócodos" that Miguel can't carry off... or should I be *honorable, honorable*! and send you the little document or "papyrus" called a "resignation"? Please* young man, tell me what's in your heart, for I'm very uneasy, think about what I should do in order not to look like a son of a bi... shop in your lovely eyes. Because remember our mothers brought us up very decently and told us we shouldn't "take what doesn't belong to us", not even to teach it to whistle, so I'm really uneasy in my "conscience". Help me get out of this "difficult" fix, will you? Because I'll tell you I don't want the boys themselves to find out that their teacher is a vulgar "cheat". On tenterhooks I await your solution to the crossword puzzle. Keep my words well in mind, and give me a call at the above-mentioned number 19-58-19, or if you're a very good boy, come by and see me whenever you deem fit. Meanwhile and in the interim, I send you a whole sack of kisses and hugs and good wishes that life will treat you sweet and kindly. I have said. Your *cuate* and comrade

Frida

287

P.S. Tell me what you're painting, what you're doing, what surreptitious activities you are involved in and how things are going in your singular, young life. Has sadness, melancholy taken possession of you? It hasn't made you its prey?

<center>↬</center>

Antonio Ruiz, "el Corcito" ["the Young Deer"], (1895-1964) was founding director of the Painting and Sculpture School of the Secretariat of Education. It was he who invited Frida to join the faculty in 1944.

LETTER TO CARLOS CHÁVEZ

Coyoacán, March 25th, 1947

Darling Carlitos:

It's difficult to get hold of you by telephone in your office, and I don't want to bother you at home during the only hours you have to rest. (That's why I'm sending you this fallacious missive.) Yesterday I saw Diego and he told me you visited him a few days ago, it gave him great pleasure.

Listen brother, he also told me you had assured him you would buy my picture *The Two Fridas* for the museum and that you also wanted the picture *The Radishes* that is now in Gabriel Orendáin's gallery.

Personally, and as far as my painting is concerned, I wouldn't even have wanted to mention the matter, but yesterday I saw that Diego doesn't have a cent, and he can barely afford to pay for the hospital, and he doesn't have the money to pay the wages of the workers in El Pedregal (next Saturday).

You can imagine what I feel, knowing what a f.... lipping mess Diego is in. I want to ask you that if it were possible to *hurry up* as much as possible the purchase of *The Two Fridas* you would solve an enormous problem for me.

If the maneuvering seems very difficult to you, *tell me with all frankness* as soon as you read this scrap of paper, because in that case, I'll finish as quickly as I can the two paintings I have in progress to raise the dough. (I don't know if I'll be able to finish them by Saturday but if not, we'll see what other way I find to raise the bucks for Diego.) I hope you can arrange something for I'm just in a hell of a fix.

A thousand thanks darling and you know how I love you

Frida

༄

In the report ("Two and a Half Years of the INBA") submitted in 1950 by the General Direction, the Sub-Direction and the Administrative Department of the Instituto Nacional de Bellas Artes, The Two Fridas was listed among the acquisitions in 1947. The Instituto paid four thousand pesos for the painting, plus thirty-six more for the frame.

Dedication and Letter to Diego Rivera

{a}

[On the Pencil Drawing *Ruin*]

For Diego. Frida.
Deception Avenue number...
Ruin!
House of birds
Love nest
All for nothing
Vain
Ruin
February 1947
F. Kahlo

{b}

Monday, April 21ˢᵗ, 1947. Coyoacán

Apple of my eye, my love:
Emmita called me on the telephone and I feel more tranquil
because she says you are much better, that you have a really swell
room where you paint all day, and you seem in a much more
relaxed mood and, in general, happy. I miss you more than I
can explain, but the only thing I want is for you to get better so
you can come back soon to live with me and with Señor Xólotl
and Señorita Xolotzin. I won't be myself again until I have you
near me.

I have felt so-so but no worse; I get tired as always, but the days will come when you and I are completely well again; don't you worry *about anything* except your health, which is the only thing that's worth it.

In my last letter I didn't send you all the details about the construction and expenses, because I wanted to wait until this Saturday to be able to give you a more exact account. I'm going to tell you in general terms what they have done and what there's still to do; the new bathroom is finished, as far as the masonry work is concerned; the falsework for the floor is down, and for the terrace as well, and Arámburu says they'll lay the slabs within *two days*; they're going to do the placement of the bathroom furniture today so they can leave a list of where the outlets go. Really all that's left for that room is planing the walls inside and outside and polishing the floor. The other two rooms, that is, the bedroom and the study, are ready, only the doors are left to paint. The downstairs rooms of the little house at the back of the big garden, where Liborio and Cruz are going to live, are now completely *ready*, with bathroom and all, the same goes for the storeroom. I think this week they're really going to finish *the principal work* and only small details will be left, such as painting doors, polishing floors and moving furniture to its definitive place. All of the electrical installation is in place, from the patios to the rooms of the big and small house. In San Ángel they finished the wall and the servants' room, all that's left is the painting and plastering where the planks from the small house are, the ones they're going to bring to Coyoacán to place in the empty rooms when I move next door. The bedroom where the furniture of my study is being kept for the time being I'm going to fix up as *your bedroom*, and I think you'll be very comfortable there because you'll have a direct exit to the terrace and you'll be close to your idols, don't you think? They still have to do the little vestibule where the

storeroom is now, but that will be done last so they can put in the door the same day they open the bay. Since there is *no one* to help me supervise *technically* everything that's been done, for Juan O'Gorman only comes occasionally, I don't know if the work will be entirely to your taste; but Arámburu has done everything he can, and you know the foreman José is very good, as is the foreman Isabel. Let's hope you like everything when you arrive.

Emma and I discussed the question of where you're going to return to, whether to Coyoacán, San Ángel, or where you were before, and we decided, despite the fact that I won't have you near me for longer, that the most practical thing would be for you to go back to your apartment in Mexico City, for since you have to take your penicillin and finish fixing up your mouth, it would be very difficult to do it in Coyoacán or in your studio; but naturally you'll be the one to decide what seems best to you, taking into account *nothing but* your health and your convenience with regard to the nurse and dentist and David's visits; and I'll go and see you whenever you want, *wherever you are*.

Ortega is leaving for San José at eight in the morning on Sunday, so he'll be there by twelve, according to the instructions Emma gave me from you, and you'll be coming back the same Sunday or Monday morning, right? I am looking forward *enormously* to seeing you.

Now I'll explain about the expenses. First of all I want to tell you I was paid the money from the Colegio Nacional, but they only paid me *two months*, because Sr. Cisneros told me you had already been paid January and were owed two back months, that is, February and March, and the month in progress will be paid on the first of May. So he gave me a check for $1579.34, which I included as *income*, as I will specify later in complete detail. I think I'll have enough this week to pay the workers' wages, but for next week, that is, Saturday, May 3rd, which is

unfortunately the Feast Day of the Holy Cross, there's no "dough" and it's when they [...]

❧

Diego Rivera's relationship with Emma Hurtado (his "small house" or "second front", as this type of relationship is called colloquially in Mexico) was established in 1946, the year the painter signed an agreement with Emma to market his work. They were married in 1955, after Frida's death. Señor Xólotl and Señorita Xolotzin were a couple of escuincle dogs.

Notes for Diego Rivera

{a}

My child,
Please tell Sr. Benjamín that if they can't publish the letter complete then better not publish it at all, because it could give margin for lots of false interpretations if it's cut up. Don't you think?

Millions of kisses from your little girl

Frida

{b}

My child,
You'll say I'm a real nag, but don't forget Amelia's weekly wages (125.00). If you don't have it I'll give it to you and you can make it up to me later, because I feel bad she might think we're not giving her anything because she's doing a bad job.

Tell Riquelme she's rather touchy.

You didn't even ask her how she felt.

LETTER TO CARLOS PELLICER

July 12th, '47

Darling Carlitos,

I'm sending the little book I gave you as a present the other day. I beg you, if you have a copy of the poem you gave me, to send it to me. I so much want to have it with me!

Give my affection to your mother, and to you, everything you think I can send to you.

Frida

The friendship between Carlos Pellicer Cámara (1897-1977) and Diego Rivera began in the early 1920s, when the Tabasco-born poet was secretary to José Vasconcelos. Diego painted a portrait of him in 1946, his last year as director the Fine Arts Department of the Secretariat of Education. It was around this time that his friendship with Frida developed. In August and October of 1953 he dedicated three moving sonnets to her. In 1958, at the request of Diego Rivera shortly before his death, Frida's house in Coyoacán was converted into the Frida Kahlo Museum.

LETTER TO ARCADY BOYTLER

August 31st, 1947

Lovely Arcasha,

I wanted to do a drawing of your beautiful effigy and it came out a bit "horrid"; but if good intentions are any use, it's full of them, as well as all my affection.

If the eye-symbol I put in your forehead surprises you, it's only my desire to express plastically what I believe you have inside you and don't often say: a prodigious imagination, intelligence and a profound observation of all of life. Isn't it true?

Today, on your birthday, and for the rest of your life I wish you happiness.

Your Little Deer
 Frida

I spilled some ink here.

ᘔ

The Russian-born movie director Arcady Boytler (1985-1965) was a kind and disinterested friend to Frida.

LETTER TO CARLOS PELLICER

November, 1947

I don't know how I dare to write you, but yesterday we said it would do me good.

Forgive the poverty of my words, I know you will feel I'm speaking to you with my truth, which has always been yours, and that's what counts.

Can verbs be invented? I want to say one to you:

I *sky* you, so my wings stretch out enormously to love you without measure.

I feel that we have been together from our place of origin, that we are of the same matter, of the same waves, that we carry the same sense inside. Your whole being, your prodigious genius and humility are incomparable and enrich life; in your extraordinary world, what I offer you is only one truth more that your receive and that will ever caress the deepest part of you. Thank you for receiving it, thank you for living, because yesterday you let me touch your innermost light, and because you said with your voice and your eyes what I had been waiting for all my life.

To write you my name will be *Mara*, agreed?

If you ever need to give me your words, they would be the strongest reason for me to keep seeing you, write me without fear to… Poste Restante, Coyoacán. Will you?

Marvelous Carlos,

Please call me when you can.

Mara

The last words were written on the wrapping paper that contained two natural flowers and the letter.

[99]

Letter to Doctor Samuel Fastlicht

Coyoacán, November 13th, 1947

Dear *compañero*,

I know you're going to "commend" me to all my ancestors, because I've stopped going to see you for three weeks, but I beg you to understand that it's not out of indolence or laziness; I've been working (whenever my spine lets me), and I've made a lot of progress with your portrait. I want to finish it between this week and next, because last week I had to stay in bed for a few days, for I feel "sublimely" tired, that is: *an absolute wreck*. That's why I can't go *today*, as I had promised, but *by the end of next week* I *assure* you I'll have finished the portrait and I'll take it to you. My *molars** have felt just fine thanks to you.

Frida Kahlo

Forgive me, and lots of regards.

Frida

Don't be angry with me, O.K.?
I'm sending you the little flowerpot I promised you.

༄

Frida had made an arrangement with the dentist Samuel Fastlicht to pay him with paintings for his professional services. She fulfilled her side of the bargain by giving him two still lifes, one from 1951 (oil on canvas, 28.2 cm x 36.0 cm), with the following inscription on the banderole: "I belong to Samuel Fastlicht. Frida Kahlo painted me with great affection in 1951. Coyoacán"; and another from 1952 (oil on canvas, 25.8 cm x 44.0 cm) whose banderole reads: "Painted for Samuel Fastlicht by Frida Kahlo with all her love. In the city of Puebla, 1952". Earlier, in the

year of the above letter, the dentist commissioned a self-portrait from her. Frida took pains to depict herself as a Tehuana in gala attire (1948, oil on canvas, 50.0 cm x 39.5).

Card for Diego Rivera on His Birthday

December 8th, 1947. Coyoacán

Apple of my eye,
You know what I would like to give you today, and all your life.
If it were in my hands, you would have it.
 At least I can offer to be with you in all… my heart.
 Your little girl
 Fisita

Letter to Doctor Samuel Fastlicht

January 9th, 1948. Coyoacán

Sr. Dr. Samuel Fastlicht

Dear *compañero*,

Here finally is your painting. I took much longer than we agreed because lately I've had a period of double trouble that I don't have words to describe. This whole mood is naturally reflected in my self-portrait. Perhaps you won't like it at all, and you have every right to tell me so sincerely. I do like it, because it is the exact expression of my emotion and that's what any sincere painter is interested in. But since you're the one who's going to buy it, things are different. Anita Brenner told me the price seemed high to her. Listen, *compañero*, I beg you not to think I'm taking advantage, but on the contrary, I sell my paintings for 3000 eagles and for you, because you've been so kind to me, I'm letting it go at $2500.00, from which you will discount the 500 I owe you for my molars and that leaves me *2000* even, which goes through one's hands like water these days. But I don't want to force anything on you. If you don't like the deal, later on I can do you a smaller one requiring less work and we'll sell this one somewhere else. It's just that right now I'm as "broke" as can be, and I do need the centavos. That's why I've dared to send it to you still *fresh*. In a week I'll go by and varnish it. You know *compañero* that between you and me there's frankness and you can say anything you feel like to me. If you send me the centavos, please give them to my sister Cristina who is the short little one who has brought you

the picture. I can't go personally because I feel like a drenched cat.

A million thanks and I hope you understand clearly that I'm not taking advantage of you or anything at all like that.

I send you lots of regards and don't send to have me scolded because I haven't gone. If you were in my place, the whole cathedral would have collapsed by now.

May life treat you gently in 1948 and always: that's what your *compañera* and sincere friend wishes for you.

<div align="right">Frida Kahlo</div>

LETTER TO PRESIDENT MIGUEL ALEMÁN VALDÉS

Strictly personal and confidential

Coyoacán, October 29th, 1948

To the President of Mexico
Sr. Lic. Miguel Alemán Valdés

Miguel Alemán:
This letter is a protest of justified indignation which I wish to place in your hands against a cowardly and denigrating attack that is being committed in this country.

I am referring to the intolerable and unprecedented action that the landlords of the Hotel del Prado are carrying out in covering up the mural painting of Diego Rivera in the dining room of said hotel, a painting which, because it reproduces *the controversial, but historical phrase* of Ignacio Ramírez "El Nigromante", caused some months ago the most shameful and unjust attack against a Mexican artist in the history of Mexico.

After that dirty, under-handed and publicity-grabbing attack, the gentleman who own the hotel put the "crowning touch" on *their exploit*, by covering up the panels of the mural and... nothing at all has happened! No one in Mexico protests! As the common people say: "They buried the matter".

I do protest, and I want to remind you of the enormous historical responsibility your government is assuming by permitting the work of a Mexican painter, internationally recognized as one of the most eminent exponents of Mexican Culture, to be covered up, hidden from the eyes of the people

of this country and from those of an international public for *sectarian, demagogic and mercenary* reasons.

This kind of crime against the culture of a country, against the right every man has to express his thoughts; these murderous attacks against freedom have only been committed under regimes such as that of Hitler and continue to be committed under the government of Francisco Franco, and in the past, in the obscurantist and negative age of the "Holy" Inquisition.

It is not possible that you, who represent at this moment the will of the people of Mexico, with democratic liberties won by the incomparable effort of a Morelos or a Juárez, and with the shedding of the people's own blood, permit a few shareholders, in connivance with other Mexicans of bad faith, to cover the words of the *History of Mexico* and the work of art of a Mexican citizen whom the civilized world recognizes as one of the age's most illustrious painters.

It is shameful even to think of such an outrage.

I amiably addressed myself to the director of the Instituto Nacional de Bellas Artes, our mutual friend Carlos Chávez; with the utmost zeal, he brought the matter officially to the attention of National Property, an entity whose responsibility it would seem to be to protect works of art in conflicts such as the present one.

All these bureaucratic measures generally end in silence, in spite of the good will of friends and government officials.

I also know that the law, unfortunately, does not duly guarantee anyone's artistic property, but you, as a lawyer, know perfectly well that the law is and always has been elastic.

There is something that is not written in any code, which is the cultural consciousness of nations, which does not allow Michelangelo's Sistine Chapel to be made into an apartment house.

It is for this reason that I address myself to you, speaking plainly and simply, not as the wife of the painter Diego Rivera,

but rather as an artist and a Mexican citizen, and with the right that such citizenship confers upon me I ask:

Are you going to permit that the *Presidential Decree that you yourself gave* to protect works of art executed in buildings belonging to the nation (such is the case of the Hotel del Prado, which belongs to Pensions, that is, to the public service employees of the country, though "legally" a simulated company appears as owner) be trampled upon by a group of clerical sectarian merchants?

Are you, as a Mexican citizen and above all as President of your people, going to permit the History, the word, the cultural action, the message of genius of a Mexican artist to be silenced?

Are you going to permit freedom of expression, public opinion, the vanguard of any free people, to be destroyed?

All this in the name of stupidity, obscurantism, bribery and *betrayal of democracy*.

I beg you to answer yourself honestly and to consider your historic role as leader of Mexico before a matter of such importance.

I formulate the problem before your conscience as the citizen of a democratic country.

You must support this cause, common to all those of us who do not live under regimes of shameful and destructive oppression.

By defending culture, you show the nations of the world that Mexico is *a free country*. That Mexico is not the uncivilized and savage nation of Pancho Villa. That since Mexico is democratic, *the blessings of Archbishop Martínez and the historical words of "El Nigromante" are both respected. That saints and Virgins of Guadalupe are painted as well as paintings with revolutionary content on the monumental staircases of the Palacio Nacional.*

Let the whole world come to learn how freedom of expression is respected in Mexico!

You have the obligation to demonstrate to the civilized peoples of the world that you are not for sale, that in Mexico blood has been shed in the struggle and the struggle continues to free the

country from colonizers, even if they have a lot of dollars.

It is time to take the bull by the horns, and to assert your status as a Mexican, as the President of your people, and as a free man.

A word from you to these landlords of hotels will be a strong example in the history of freedom won for Mexico.

You must not permit them to engage in "gangster" demagogy with the dignity of one of your decrees and the cultural patrimony of the entire country.

If you, at this decisive moment, do not act as an authentic Mexican and defend your own decrees and rights, then let them come to burn books of science, of history, to destroy works of art with stones and with fire, to expel the free men from the country, let the tortures come, the prisons and the concentration camps!! And I can assure you that very soon and without the slightest effort, we will have a new fascism, *made in Mexico*!

You called me on the telephone once, precisely from the studio of Diego Rivera, to greet me and to remind me that we were schoolmates in the Preparatoria.

Now I write you to greet you and to remind you that before anything else we are Mexicans and we shall not permit anyone, and still less a few Yankee-style hotel owners, to strangle the culture of Mexico, the *essential root of the life of the nation*, denigrating and belittling the national values of world importance, and making of a mural painting with universal significance, a dressed flea (*Mexican curious*).

Frida Kahlo

In his answer of November 2 Miguel Alemán stated that the matter raised by Frida did not fall within the competence of the President but rather of the Secretariat of National Property and the Administration of Bellas Artes. "I appreciate –he wrote– the vigor of the concepts expressed in your letter, and recognize that if there is passion in it, that passion is inspired by a noble end."

LETTER TO DIEGO RIVERA

December 4th, 1948

Apple of my eye,
I'm at Cuquita's house, for I didn't think you would arrive last night.

I cashed the check yesterday because I needed to buy d'Harnoncourt's medicine and I didn't have a cent. (You owed me $50.00 and I gave Ruth $40.00), so forgive me for having dared to cash it, but there was nothing else to do.

I'm sending you $685.00 (six hundred and eighty-five *eagles*).

From here Cuca's chauffeur is going to take me home. Do you want to have lunch with me? I would so like to see you, because without you life isn't worth a damn.

The little truck is a mess and hardly starts up. I hope it gets there on time. I'll see you at noon at the house. Did you arrive alright? You didn't get too tired on the road?

I hope you're happy and feeling better.

I'm as skinny as ever and as sickly and as *pen*... sive.

Your little girl

Fisita

෭

René d'Harnoncourt, of Austrian origin, had arrived in Mexico in the mid-1920s, when his boss Fred Davis opened a Mexican handicrafts store in the capital. As assistant to Alfred Barr in the Museum of Modern Art in New York, he collaborated with Miguel Covarrubias on the exhibition Twenty Centuries of Mexican Art, *held in the MOMA in 1940. A friend of Mexican artists and archaeologists, he would spend long periods in Mexico.*

PORTRAIT OF DIEGO

I must warn that this portrait of Diego will be painted in colors I am unfamiliar with: in words, and it will be the poorer for that; besides, I love Diego in such a way that I cannot be a "spectator" of his life, but rather a part of it, so that -perhaps- I will exaggerate the positive aspects of his unique personality by trying to soften what could, even remotely, wound him. This will not be a biographical account: I consider it more sincere to write only of the Diego I believe I have come to know a little in these twenty years I have lived near him. I will not speak of Diego as "my husband", because that would be ridiculous; Diego has never been, nor will he ever be, anyone's "husband". Nor as my lover, for he embraces much beyond sexual limitations, and if I spoke of him as of a child, I would only describe or paint my own emotion, almost my self-portrait, not that of Diego. With this warning, and with the utmost clarity, I will try to speak the only truth: my own, in order to trace an outline, within my powers, of his image.

HIS FORM: with his Asiatic head and dark hair, so thin and fine that it seems to float in the air, Diego is an immense, enormous child, with a friendly face and a rather sad gaze. His large protuberant eyes, dark and extremely intelligent, are barely restrained -almost leaping from their orbits- by the swollen, bulging batrachian eyelids, and are set far apart from one another, more so than other eyes. They permit his gaze to embrace a wider visual field, as if they were constructed specially for a painter of spaces and multitudes. Between these eyes, one so far from the other, can be glimpsed the invisibility of Oriental wisdom, and but very seldom does there disappear

from his full-lipped Buddha-like mouth a tender and ironic smile, the flower of his image.

Seeing him nude one thinks immediately of a frog child standing on its hind legs. His skin is greenish-white, like that of an aquatic animal. Only his hands and face are darker, burned by the sun.

His narrow, rounded, infantile shoulders continue down without angles into feminine arms and end in marvelous, small, finely-drawn hands, sensitive and subtle as antennas that communicate with the entire universe. It is astonishing that these hands have served to paint so much and still work indefatigably.

Of his chest it must be said: if he had disembarked on the island governed by Sappho, he would not have been executed by her warriors. The sensitivity of his marvelous breasts would have gained him admittance. Though his virility, specific and singular, also makes him desirable in dominions of empresses avid for masculine love.

His belly, enormous, smooth and tender as a sphere, rests on strong legs, as beautiful as columns, that end in large feet, splayed outward at an obtuse angle as if to embrace the whole earth and stand upon it without contradiction, like an antediluvian being, from which might emerge, from the waist up, an example of future humanity, two or three thousand years distant from us.

He sleeps in the fetal position and during his sleep he moves with elegant slowness, as if he were living in a liquid element. For his sensibility, expressed in his movements, it would seem that air is denser than water.

Diego's form is that of an affectionate monster, which the grandmother, the Ancient Concealer, the necessary and eternal matter, the mother of men, and all the gods invented by them in their delirium, out of fear and hunger, THE WOMAN, and among all of them -I MYSELF- would like

always to hold in her arms like a newborn child.

HIS CONTENT: Diego exists to one side of all personal, limited and precise relations. Contradictory like everything that moves life, he is at once an immense caress and a violent discharge of powerful and unique forces.

He is experienced within himself, like the seed treasured up in the earth, and without, like the landscapes. Probably some of you expect a very personal, "feminine" portrait of Diego from me, anecdotal, entertaining, full of complaints and a certain amount of gossip, of that "decent" gossip that can be interpreted and used in accordance with the morbidity of each reader. Perhaps you expect to hear laments from me of "how much one suffers" living with a man like Diego. But I don't believe the banks of a river suffer from letting it flow between them, nor that the earth suffers because it rains, nor that the atom suffers releasing its energy... for me, everything has a natural compensation. In my role, difficult and obscure, as ally to an extraordinary being, I enjoy the reward of a spot of green in a mass of red: the reward of *equilibrium*. The sorrows and joys that regulate life in this lie-infested society in which I live are not my sorrows and joys. If I have prejudices and am wounded by the actions of others, even those of Diego Rivera, I accept responsibility for my inability to see clearly, and if I don't have them, I have to accept that it is natural for red blood cells to fight against white ones without the slightest prejudice and that this phenomenon only signifies health.

I will not be the one to undervalue Diego's fantastic personality, which I deeply respect, by saying stupid things about his life. I would like, on the contrary, to express as it deserves to be expressed, with the poetry I do not possess, what Diego really is.

Of his painting, his painting itself speaks -prodigiously enough.

I will leave it to the men of science to speak of his function as

a human organism. Of his valuable social and revolutionary contribution, his objective and personal work, all those who know how to measure its incalculable importance in time may speak; but I, who have watched him live for twenty years, do not have the means to organize and describe the living images that might faintly, but deeply, trace the most basic lines of his figure. My ineptness can only produce a few opinions and they will be the only material I can offer.

The profound roots, the external influences and true causes that condition Diego's matchless personality are so vast and complex that my observations will be but small shoots on the many branches of the gigantic tree that is Diego.

There are three principal lines or directions I consider basic in his portrait: the first, that of being a constant, dynamic, extraordinarily sensitive and vital revolutionary combatant; a indefatigable worker at his trade, which he knows as few painters in the world do; a fantastic enthusiast for life and, at the same time, ever unsatisfied with not having succeeded in knowing more, building more and painting more. The second, that of being eternally curious, a tireless student of everything; and the third, his absolute lack of prejudices and, as a result, of faith, because Diego accepts -as Montaigne did- that "where doubt ends, stupidity begins", and that whoever has faith in something admits his unconditional submission, without the freedom to analyze or to vary the course of events. As a result of this utterly clear concept of reality, Diego is a rebel, and knowing so marvelously the materialist dialectic of life, Diego is a revolutionary. From this triangle, upon which the other modalities of Diego are erected, there emanates a sort of atmosphere that envelopes the whole. This mobile atmosphere is love, but love as a general structure, a movement that constructs beauty. I imagine that the world he would like to live in would be a great fiesta in which each

and every being took part, from men to stones, suns and shadows: all cooperating with their own beauty and creative power. A fiesta of form, of color, of movement, of sound, of intelligence, of knowledge, of emotion. A global fiesta, intelligent and amorous, that would cover the entire surface of the earth. To create this fiesta, he struggles constantly and offers all he has: his genius, his imagination, his words and his actions. He struggles, at every moment, to eliminate fear and stupidity in man.

Because of his profound desire to help to transform the society in which he lives into a more beautiful, healthier, less painful and more intelligent one, and because he puts at the service of this ineluctable and positive Social Revolution all of his creative strength, his constructive genius, his penetrating sensibility and his ceaseless work, Diego is continually attacked. During these last twenty years I have seen him struggle against the complicated machinery of negative forces contrary to his push for freedom and transformation. He lives in a hostile world because the enemy is in the majority, but this does not daunt him, and for as long as he lives, new living energies of combat, courageous and profound, will emerge from his hands, his lips and his whole being.

All those who have brought a light to earth have struggled as Diego has; like them, he has no "friends", but only allies. Those who emerge from themselves are magnificent; their brilliant intelligence, their profound and lucid knowledge of the human material within which they work, their solid experience, their wide culture, not gained from books, but inductive and deductive; their genius and their desire to construct, on the foundations of reality, a world cleansed of cowardice and lies. In the society in which he lives, all those of us are all allies who, like him, realize the imperative need to destroy the false bases of the present world.

Against the cowardly attacks directed at him Diego always reacts with firmness and a great sense of humor. He never compromises nor yields: he openly faces his enemies, most of them concealed, some courageous, counting always on reality, and never on "illusory" or "ideal" elements. This refusal to compromise and this rebelliousness are fundamental in Diego; they complement his portrait.

Among the many things said about Diego, these are the most common: they call him a chronic liar, a publicity-seeker and, most ridiculous of all, a millionaire. His alleged lying is in direct relation to his powerful imagination, that is, he lies as much as poets do, or children who have not yet been idiotized by school or by their mothers. I have heard him tell all kinds of lies: from the most innocent ones, to the most complicated tales of characters that his imagination combines in fantastical situations and behavior, always with a great sense of humor and a marvelous critical sense; but I have never heard him tell a stupid or banal lie. By lying, or playing at lying, he unmasks many people, he learns the interior workings of others who are much more candidly untruthful than he is, and the most curious thing about Diego's alleged lies is that, sooner or later, those involved in the imaginary combinations get angry, not because of the lie, but rather because of the truth contained in the lie, which always rises to the surface. That is when the "hen house goes into an uproar", for they see themselves exposed on the very terrain where they thought themselves protected. What really happens is that Diego is one of the few who dare to attack at its foundation, directly and without fear, the structure called the MORALITY of the hypocritical society in which we live, and since the truth doesn't sin but makes people uncomfortable, those who are exposed in their most hidden secret motives can only call Diego a liar, or at least, an exaggerator.

They say he seeks publicity. I have noticed rather that others try to do so through him, for their own interests, only they do it with misapplied Jesuitical methods, because generally it "back-fires" on them. Diego doesn't need publicity and still less the kind offered him in his own country. His work speaks for itself. Not only for what he has done in the land of Mexico, where he is shamelessly insulted more than anywhere else, but also in every civilized country in the world, where he is recognized as one of the most important men and greatest geniuses in the cultural field. It is incredible, to be sure, that the meanest, most cowardly and stupidest insults against Diego have been vomited out in his own home: Mexico. Through the press, by means of acts of barbarism and vandalism aimed at destroying his work, using everything from the innocent parasols of "decent" ladies who hypocritically scratch his paintings, just in passing, to acids and kitchen knives, not to forget simple, everyday spitting, worthy of those who have as much saliva as they lack brains; by means of signs on street corners bearing words little suited to such a Catholic people; by means of groups of "well-bred" young people who throw stones at his house and his studio, destroying irreplaceable works of pre-Hispanic Mexican art -which form part of Diego's collections-, and who run off after "playing their tricks"; by means of anonymous letters (useless to speak of the worth of those who send them) or by means of the neutral, Pilatian silence of the powerful, in charge of caring for and imparting culture for the sake of the good name of the country, who give "no importance" to these attacks against the work of a man who with all of his genius, his creative efforts, alone, tries to defend, not only for himself, but for all, freedom of expression.

All of these maneuvers in the shadows and in the light are carried out in the name of democracy, of morality and of Long Live Mexico! —Long Live Christ the King! is also used at times—.

All this publicity that Diego neither seeks nor needs proves two things: that the work, the entire oeuvre, the unquestionable personality of Diego are of such importance that they have to be taken into account by those whose hypocrisy and shameless arriviste plans he denounces; and the weak and deplorable state of a country -a semi-colonial one- that allows things to happen in 1949 that could only take place in the Middle Ages, at the time of the Holy Inquisition or while Hitler ruled in the world.

In order to grant recognition to the man, to the marvelous painter, to the brave fighter and upright revolutionary, they await his death. For as long as he lives, there will be plenty of "machos", the kind schooled in the libel, who will continue to throw stones at his house, insult him anonymously or in the press of his own country and others, still more "macho", who say nothing, but will wash their hands of it all and go down in history wrapped in the flag of prudence.

And they call him a millionaire... The only truth in this matter of Diego's millions is this: that since he is an artisan, and not a proletarian, he possesses his tools of production -that is, of his work-, a house to live in, some rags to throw on and a ramshackle truck that he makes use of as a tailor his scissors. His treasure is a collection of marvelous works of sculpture, jewels of indigenous art, the living heart of true Mexico, which with indescribable economic sacrifices he has succeeded in collecting over more than thirty years to place in a museum that he has been building for the last seven. He has erected this work by his own creative effort and his own economic effort, that is, with his marvelous talent and with what he is paid for his paintings; he will donate it to the country, bequeathing to Mexico the most prodigious source of beauty that has ever existed, a gift for the eyes of those Mexicans that have them and an incalculable admiration for those from other places. Except

for this, he has nothing economically; he has nothing but the strength of his work. Last year he didn't have enough money to be released from the hospital, after suffering a bout of pneumonia. Still convalescent, he started to paint to cover daily expenses and the wages of the workers who, as in the Renaissance guilds, collaborate with him in constructing the marvelous work in the Pedregal.

But insults and attacks do not change Diego. They form part of the social phenomena of a world in decadence and nothing else. All of life continues to interest and astonish him, because it changes, and everything surprises him by its beauty, but nothing *disappoints* him or daunts him because he understands the dialectic mechanism of phenomena and facts.

A keen observer, he has accumulated an experience that, together with his knowledge -I might almost say, his internal knowledge of things- and his intense culture, allows him to disentangle causes. Like a surgeon, he opens in order to observe, to discover what is deep and hidden and to achieve something certain, positive, that improves the circumstances and functioning of organisms. That is why Diego is neither defeatist nor sad. He is fundamentally a constructor, and above all an architect. He is an architect in his painting, in his thinking processes and in his passionate desire to structure an harmonious, functional and solid society. He always composes with precise, mathematical elements. It doesn't matter whether his composition is a painting, a house or an argument. The foundations are always reality. The poetry his works contain is that of numbers, that of the living sources of history. His laws, the solid, physical laws that govern the whole of life from atoms to suns. There is a magnificent proof of his genius as an architect in the murals that are linked, and live, with the very construction of the building that contains them, with their own organized and material function.

The stupendous work he is constructing in the village of San Pablo Tepetlapa, which he calls *el anahuacalli* (the house of Anáhuac), intended to house his matchless collection of ancient Mexican sculpture, is a link between ancient and new forms, a magnificent creation that will preserve and revive the incomparable architecture of the land of Mexico. It grows out of the incredibly beautiful landscape of the Pedregal like an enormous cactus looking towards the Ajusco, sober and elegant, strong and refined, ancient and perennial; it cries out, with voices of centuries and days, from its entrails of volcanic rock: Mexico is alive! Like the Coatlicue, it contains life and death; like the magnificent terrain on which it is erected, it embraces the earth with the firmness of a living and permanent plant.

Always working, Diego does not live what could be called a normal life. His capacity of energy breaks clocks and calendars. Materially, he lacks time to struggle, without rest, constantly planning and executing his work. He generates and receives waves that are difficult to compare to others, and the results of his receiving and creative mechanism, being so vast and so immense, never satisfy him. Images and ideas flow through his brain at a different rhythm than usual and thus his intensity of fixation and his desire always to do more are uncontainable. This mechanism makes him indecisive. His indecisiveness is superficial because, finally, he manages to do whatever he wants with a sure and determined will. Nothing better exemplifies this modality of his character than a story his Aunt Cesarita, his mother's sister, once told me. She recalled that when Diego was a small child he went into a store, one of those sundries stores full of magic and surprises that we all remember with affection, and standing before the counter with a few centavos in his hand he surveyed the entire universe contained within the store and shouted in fury and exasperation: What do I want! The store

was called "El Porvenir" ["The Future"], and this indecision of Diego's has lasted all his life. But though he seldom makes up his mind to choose, he carries a vector line inside him that goes straight to the center of his will and his desire.

Ever curious as he is, he is at the same time an eternal conversationalist. He can paint for hours and days without resting, chatting while he works. He discusses and talks about everything, absolutely everything, taking pleasure, like Walt Whitman, in those who want to listen to him. His conversation is always interesting. He forms phrases that astound, and that wound at times; on other occasions they move one, but they never leave the person listening with an impression of uselessness or emptiness. His words are tremendously disquieting, because they are living and true. The crudity of his ideas unnerves and disorients the listener because none of them conform to established norms of behavior; they always cut through the bark to let the bud sprout forth; they wound to create new cells. To some people, to the strongest, Diego's conversation and truth content seem monstrous, sadistic, cruel; others, the weakest, are annulled and annihilated by it, and their defense consists of calling him a liar and a fabulist. But all try to defend themselves much as those who defend themselves against a vaccine when they receive it for the first time in their lives. They invoke hope or something that will free them from the danger of the truth. But Diego is stripped of faith, of hope, of charity. He is extraordinarily intelligent by nature and does not accept phantasms. Tenacious in his opinions, he never yields, and he defrauds all those who shield themselves behind beliefs or false goodness. That is why they call him amoral and -really- he has nothing to do with those who accept moral laws and norms.

In the midst of the storm that the clock and the calendar represent for him, he tries to do and let others do what he considers just in life: to work and to create. He considers other

directions important enough to contend with, that is, he never despises the worth of others, but he defends his own, because he knows that it means rhythm and proportional relation with the world of reality. In exchange for pleasure, he gives pleasure; in exchange for effort, he exerts effort. More talented than others, he gives a much greater quantity and quality of sensibility and asks only understanding in return. Often he does not even get that, but he does not therefore submit himself or surrender. Many of the conflicts his superior personality causes in daily life come of this natural disturbance provoked by his revolutionary ideas with regard to those subject to rigidity and norms. The "household" problems that various women have had near Diego consist of the same thing. Diego has a profound class consciousness and awareness of the role other social classes play in the general functioning of the world. Among those of us who have lived near him, some have wanted to ally themselves to the cause for which he works and struggles, and others have not. This has originated a series of conflicts in which he has been involved, but for which he is not responsible, since his position is clear and transparent. His human unity, without prejudices, whether from genius, upbringing or transformation, is not responsible for the incapacity of others, nor for the consequences this incapacity might have on social life. He works for all forces to be used and organized with greater harmony.

What weapons can be used to struggle in favor of or against a being who is closer to reality, more within the truth, if these weapons are moral, that is, conditioned by the expedience of a certain individual or human sector? Naturally they have to be amoral, not subject to what has been established or accepted as good or evil. I believe -in the fullness of my responsibility- that I cannot be against Diego, and if I am not one of his

staunchest allies, I would like to be. From my position in this attempted portrait many things can be deduced, depending on who is making the deductions; but my truth, the only one I can give about Diego, is here. Limpid, not to be measured by sincerometers, which do not exist, but with the conviction of what concerns me, my own experience.

No words can express Diego's immense tenderness for things that possess beauty; his affection for beings without a place in the present class society; or his respect for those oppressed by it. He holds special adoration for the Indians to whom is he linked by blood; he loves them intimately for their elegance, their beauty and because they are the living flower of the cultural tradition of America. He loves children, all animals, with special predilection for Mexican hairless dogs, and birds, and plants and stones. He loves all beings, without being docile or neutral. He is very affectionate, but never surrenders himself; for this reason, and because he barely has time to dedicate himself to personal relationships, he is called ungrateful. He is respectful and refined and nothing makes him angrier than lack of respect for others and abuse. He cannot bear cheating or underhanded deception; what in Mexico is called "tomadura de pelo". He prefers intelligent enemies to stupid allies. By temperament he is rather cheerful, but it irritates him enormously to have time taken away from his work. His recreation is work itself; he detests social gatherings and is enchanted by truly popular fiestas. At times he is timid, and just as he delights in conversing and talking with everyone, he loves to be absolutely alone at times. He is never bored because everything interests him; studying, analyzing and going more deeply into all manifestations of life. He is not sentimental but he is intensely emotional and passionate. Inertia exasperates him because he is a continual current, living and potent.

Possessed of extraordinarily good taste, he admires and appreciates everything that contains beauty, whether it vibrates in a woman or a mountain. Perfectly balanced in all his emotions, his sensations and his actions, moved by materialist dialectic, precise and real, he never surrenders himself. Like the cactuses of his birthplace, he grows strong and astonishing, even on sand or stone; he blossoms with the most vivid red, the most transparent white and solar yellow; clad in thorns, he keeps his tenderness within; he lives on his strong sap amidst ferocious surroundings; he illuminates in solitude like the sun that avenges the gray of the stone; his roots live in spite of being torn from the earth, surviving the anguish of solitude and sadness and all the weaknesses that subdue other beings. He rises with surprising strength and, as no other plant, blossoms and bears fruit.

◈

Written specially for the catalogue-book of the exhibition Diego Rivera, Fifty Years of Artistic Labor *held in the Palacio de Bellas Artes in Mexico City from August to December of 1949, published extemporaneously in 1951.*

Letter to Doctor Samuel Fastlicht

English Hospital, January 12th, 1950

Dear Dr. Fastlicht,

Forgive the nuisance I'm going to cause you. I'm still in the hospital, because "just for a change" they operated on my backbone again and I won't be able to go to my place in Coyoacán until tomorrow Saturday. Still corseted up and just a f...rigging mess! But I'm not discouraged and I'll try to start painting as soon as I can.

Well, Doctor, the nuisance I'm going to cause you consists of this: I broke my upper bridge. I can't send it to you because I look like a skull without it! What should I do? And I'm sending you the lower one because it's been a while since I was able to use it, because it hurts a lot where the little hooks hang onto the teeth. So I also want to ask you: What should I do? I can't eat properly and I'm a complete wreck.

I can't go to see you, and it would be too much to ask you to make a house call because I know how busy you always are. So I leave it to your good will and kindness.

As of Sunday I'll be in Coyoacán. Allende 59 (your home). Be good enough to send me a message or call me at 105221.

A thousand thanks and very affectionate regards from your friend

Frida

Letter to Doctor Leo Eloesser

Coyoacán, February 11th, 1950

My dearest *Doctorcito*:

I got your letter and the book; a thousand thanks for all your marvelous tenderness and your immense generosity to me.

How are you? What plans do you have? I'm in the same state you left me the last night I saw you.

Doctor Glusker brought a Doctor Puig to see me, a Catalan bone surgeon, educated in the United States. His opinion is the same as yours, to amputate the toes, but he thinks it would be better to amputate as far as the metatarsi, in order to obtain a more rapid and less dangerous cicatrization.

Up to now, the five opinions I've received have been the same: *amputation*. It's only the place of amputation that varies. I don't know Dr. Puig well and don't know what to decide, because this operation is so fundamental for me that I'm afraid of doing something stupid. I want to implore you to give me your sincere opinion as to what I should do in this case. It's impossible to go to the United States for reasons you know and moreover it would mean a great deal of money which I don't have and I hate asking Diego, for I know it represents a much greater effort for him at the moment, because the peso is worth *shit*. If the operation itself is not out of this world, do you think these people could perform it? Or should I wait until you can come, or should I find the "dough" and do it there with you? I'm desperate, because if it really has to be done the best thing would be to face the problem as soon as possible, don't you think?

Sitting up in bed here, I feel I'm vegetating like a cabbage, and at the same time I think I'll have to study in order to achieve a positive result from a purely mechanical point of view. That is: to be able to walk, to be able to work. But they tell me that since the leg is such a mess, the cicatrization will be slow, I'll spend a few months without being able to walk.

A young doctor, Julio Zimbrón, proposes a strange treatment I want to consult you about, because I don't know how positive it might be. He says he guarantees that the gangrene will *disappear*. It's a question of some *subcutaneous* injections of *light gases*, helium, hydrogen and oxygen... Just off the cuff, do think there's anything to all that? Couldn't embolisms form? I'm pretty scared of it... He says that with his treatment he doesn't think I need amputation. Do you think it's true?

They're driving me crazy and desperate. What should I do? I'm just rendered imbecilic and very tired of this fucking hoof, and I would like to be painting and not worrying about so many problems. But tough luck, I just have to put up with it until things are worked out...

Please, my darling, be good enough to advise me what you think I should do.

The book by Sitwell looks fantastic, let's hope you can find me more about Tao, and the books by Agnes Smedley on China.

When will I see you again? It does me such good to know you really love me and that wherever you are you sky me (from the verb "to sky"). I'm sorry I only saw you for a few hours this time. If I were healthy I would go and help you, to turn people into truly useful beings for others and for themselves. But the way I am, I wouldn't even make a good sink plug.

I adore you
 Your Frida

Letter to Diego Rivera

For Sr. Diego Rivera from Frida

Coyoacán, Feb. 17th, 1950

Diego, apple of my eye; here's the receipt Coqui sent (in the very envelope that you sent).

The x-rays are very well done. You'll see them tonight.

I made you a copy of the report so you can read it, please don't lose it.

Eat well love and come home early.

Your ancient bedridden concealer.

Your

 Frida

Letter to Doctor Samuel Fastlicht

Coyoacán, February 1st, 1951

Dear comrade,
Here are the molars. The part I painted red is what hurts most.
The gum almost has an ulcer, and you can imagine how it's
companion is! Throwing sparks! But I'm so grateful for your
kindness that I don't have words to express my feelings to you.

Listen *compañero*, would it be a great nuisance for you to give
me two prescriptions to buy two capsules of Demerol to be able to
sleep well tonight and tomorrow? They only sell it to me with a
prescription.

You can't know how grateful I would be if you were kind enough
to give them to me. You've had enough of bothers, right?

A thousand thanks and lots of affectionate regards with a
kiss from
Frida

༈

Gabriela, Samuel Fastlicht's daughter, recalls that her father preferred to destroy his prescription
book so that his sympathy for Frida would not lead him to do something he shouldn't.

Portrait of Wilhelm Kahlo

I painted my father Wilhelm Kahlo, of German-Hungarian origin, a photographic artist by profession, intelligent and refined, of a generous character, a brave man because he suffered from epilepsy for sixty years but never ceased to work and he struggled against Hitler.

 With adoration, his daughter

<div align="center">Frida Kahlo</div>

<div align="center">ℑ</div>

Written at the bottom of the painting (1951, oil on masonite, 60.5 cm x 46.5 cm).

Notes for Diego Rivera

{a}

My Dieguito, love of all hearts:
Miguel the chauffeur called to say that tomorrow Wednesday he can't come because he's very sick. Make sure General Trastorno can come for the time being or if not, Ruthy, to take you and care for you.

Your Fisita, Frida

{b}

My child:
Thank you for the marvelous flowers, that is, our flowers. Sweetheart, if I can see you it doesn't matter that you wake me up, but what concerns me is that you get enough rest.

Sleep wherever is most convenient for you. I'll wait until you can come with more calm. Don't work too much, take good care of your eyes.

I send you, as always, all my heart

your little girl
ancient Concealer
Fisita

Note for Elena Vázquez Gómez and Teresa Proenza

Saturday, June 21st, 1952

Elenita and Tere, the dearest of my heart.

Forgive me for having left so hastily, proceeding to a distancing from Coyoacán, *without seeing you*. But I carry you with me inside, *always*. It's only for two days, though Clemente Robles wanted it to be eight, but I'm going to give him a powerful surprise. And you'll have me back on Monday or Tuesday.

In my absence perhaps Dieguito will marry some haughty princess or whoever he picks up on some common boat. He is forgiven *for ever**.

For the sake of the most marvelous thing you love in this worldly turmoil, I implore you to stay *near* him, our great big magnificent child, for only that way will I be tranquil.

I leave you my love. Behave yourselves, and may life treat you gently.

Your sister who adores you.

Frida

Presentation for Antonio Peláez

Antonio Peláez, a painter who has captured the essence of what is Mexican and whose work I consider prodigious for its content, human and social quality.

The people can be proud to have such an admirable painter, skilled in his trade, and conscious of his role in society, aware of the beauty he offers to the eyes of Mexico and of the world with the most honest and limpid humility.

<div align="right">Frida Kahlo</div>

In Lola Álvarez Bravo's gallery Antonio Peláez (1921-1994) exhibited primarily portraits (painting and drawings), including those of Frida Kahlo, Ruth Rivera, Lupe Marín and Guadalupe Amor.

[113]

Note for Carlos Chávez

Coyoacán. December, 1952

Carlitos,

Alma Reed called me just now and she tells me you are quite willing to lend me your painting. You can't know how grateful I am, for it's the first time Lola Álvarez Bravo is holding a complete exhibition of my things. (As you know, there has never been one in Mexico.) Let this letter serve as a receipt for you to get back your painting. How are you? I've been living imprisoned in bed for ages, except for certain days when some friends take me out and around.

My affectionate regards to everyone in your family. And to you, as always, my special affection.

Frida Kahlo

You can give the painting to the bearer of this letter with complete confidence.

༄

Frida requested the painting for the only individual exhibition of her work held in Mexico during her lifetime. It opened on April 13, 1953 in the gallery of the photographer and cultural promoter Lola Álvarez Bravo. On December 15, Chávez answered Frida's note very affectionately: "Frida: As I told you by telephone, I received your letter of a few days ago in which you asked me to lend to the Lola Álvarez Bravo gallery your painting entitled Still Life, *in my possession, for a complete exhibition of your work. I gave the painting to the fellow who brought me your note. [...] These lines are just to confirm my great wish to cooperate, though it be in this small way, to the success of your Exhibition".*

The Still Life *of 1942 was never returned to Carlos Chávez, in spite of his having asked for it back*

in a brief letter to Frida dated October 9, 1953 and a longer one on February 6, 1954. The failure to return the painting must certainly have been a consequence of the quarrel between Diego Rivera and Carlos Chávez over the transportable mural Nightmare of War and Dream of Peace, painted in the lobby of the Palacio de Bellas Artes, which was surreptitiously removed from its place on March 17, 1954 to prevent its being included in the exhibition "Twenty Centuries of Mexican Art" to be held in Paris, Stockholm, London and other European capitals. The Still Life is on exhibit in the Frida Kahlo Museum. In a letter to Fernando Gamboa dated February 24, 1978, referring to the loan of another work, Chávez writes: "Diego Rivera stole Frida's painting from me".

Card for Diego Rivera on His Birthday

My sincere congratulations to my child Diego

Coyoacán, December 8th, '52

My child,
I remain here, your *compañera*, gay and strong, as should be; I await your prompt return to help you, to love you always in PEACE.

Your ancient concealer
Frida

[115]

Note for Guadalupe Rivera Marín

[*Undated*]

Darling Piquitos,
What bad luck for me that you couldn't come, but I hope to see you very soon. Meanwhile I send you millions of kisses. The same to Pablito and affectionate regards to Ernesto.

Listen honey, the article about me seems *very foul*, don't you think the same? But if they've already accepted it in the magazine then let them publish it. Thanks for having notified me, because Loló hadn't even showed it to me. Your Dad thinks it's fine.

A thousand kisses from your

Frida

༄

Piquitos or Pico was the nickname of Guadalupe Rivera Marín, the daughter of Diego and Lupe Marín. Loló de la Torriente, a Cuban journalist and writer, was the author of Memoria y razón de Diego Rivera.

On a Sheet with Surrealist Drawings

To feel in my own pain
the pain of all those who
suffer and inspire me
in the need
to live in order to struggle
for them
 Frida

On and Old X-Ray Plate

[A blue and red ink drawing of herself, with full torso and feet drawn
up to the ribs. At the center a vagina. Drops of blood fall from the breasts.
The hands stuck to stumps of arms. At her left a watery star.]

Diego my love
An utter farce, not even Freud would be interested.

Why did I draw this thing that impels me to destroy it?

I want to build. But I am only an insignificant but impor-
tant part of a whole of which I am not yet aware. There is
nothing new in me. Just the old and stupid things my parents
left me.

What is joy?

Creation as one discovers.

Knowing the rest

Is an empty inheritance

When one doesn't have talent but is restless, better to dis-
appear and let the others "try"

NOTHING

SHIT

Everything can possess beauty, even the most horrible
things.

Better to be silent.

Who knows anything of chemistry?

„ „ „ „ biology?

„ „ „ „ life?

„ „ „ „ of building things?

How marvelous life with Frida is.

Text and Note for Diego Rivera

{a}

Matter microed
martyrdom *membrillo*
machinegun micron
Branches, seas, bitterly entered my deranged eyes. Great
Bears, silent voice, light.

Diego:
A very great truth it is that I would like neither to speak nor to
sleep, nor to hear, nor to want. To feel myself confined without
fear of blood, without time or magic, within your very fear and
within your great anguish and in the very noise of your heart.

I know all this madness, if I asked you for it, would be only
turmoil for your silence.

I ask of you violence in irrationality, and you give me grace,
shelter, light, heat.

I would like to paint you, but there are no colors (because
there are so many) in my confusion! The concrete form of my
great love.

Every moment he is my child. My child born daily of myself.

{b}

My child,
a thousand thanks for what you sent with Sixto.

The lovely Lupe Prieto, of Cuernavaca, called me. It's very
important for her and Manuel Reachi that you call him at the

following number: 1240. But it's very urgent, you know why.

I finished the painting.

David and Parrés came, they found me much better, that's good! They were on their way to Cuernavaca.

I'm starting on another painting this afternoon.

All my life for you.

Your ancient Concealer

Frida

ॐ

In 1953 Diego Rivera painted some mural panels in the Cuernavaca home of the movie producer Santiago Reachi.

[119]

LETTER TO MACHILA ARMIDA

February, Saturday 14th, 1953

María Cecilia, fruity and marvelous:

You, your work, all that moves you to live, is in celestial harmony, you are full of genius and the expression of your life in your extraordinary paintings, so intimate and so vast, so traditional and so beautiful, revolutionary to the marrow, which are the universe for me. I hope my love that you never feel *alone* because before anyone there is your *life* and that of your little girl.

Send all of stupid society, rotten with lies, with capitalism and U.S. imperialism, to the devil. You, Diego and I await peace the world over. The revolution is inevitable.

May you live many years María Cecilia. Because few people posses your genius.

Take good care of my Diego, the apple of my eye, in my heart and in yours. Thank you for the two skies in your eyes. I too *sky you*, I shelter you within my life, I rain on you when you are thirsty, I place your heart near my Diego so that you can protect him. Always.

Diego I'm not alone anymore because Machila is near me and near you.

�bπ

María Cecilia Armida Baz was born on March 6, 1921. On November 19, 1945 she married Leender van Rhijn, a Dutchman; a son Patricio was born of this marriage in 1949, two years before the couple separated. Machila then began to make some Surrealist compositions in boxes that she converted into small tables or windows. Her work was exhibited in 1952, presented by Diego Rivera, with whom Machila was romantically involved. The relationship was celebrated by the painter in the portrait he executed of her in the same year.

Invitation from Frida Kahlo to Her Individual Exhibition in the Galería de Arte Contemporáneo on April 13, 1953

Con amistad y cariño
nacido del corazón
tengo el gusto de invitarte
a mi humilde exposición.

With friendship and affection
coming from my heart
I am pleased to invite you
to my humble exhibition.

A las ocho de la noche
-pues reloj tienes al cabo-
te espero en la Galería
d'esta Lola Álvarez Bravo.

At eight o'clock in the evening
-you have a watch, after all-
I'll expect you in the gallery
of this Lola Álvarez Bravo.

Se encuentra en Amberes 12
y con puertas a la calle,
de suerte que no te pierdes
porque se acaba el detalle.

It's located at Amberes 12
with doors open onto the street,
so don't get lost:
I shan't tell you more.

Sólo quiero que me digas
tu opinión buena y sincera.
Eres leído y escribido;
tu saber es de primera.

I only want you to tell me
your fair and sincere opinion:
you're well-read and well-written,
your knowledge is first-class.

Estos cuadros de pintura
pinté con mis propias manos
y esperan en las paredes
que gusten a mis hermanos.

These painted canvases
I painted with my own hand,
and they wait on the walls
to please my brothers and sisters.

Bueno, mi cuate querido:	*Well then, my dear cuate,*
can amistad verdadera	*With true friendship*
te lo agradece en el alma	*I thank you from my heart:*
Frida Kahlo de Rivera.	*Frida Kahlo de Rivera.*

Coyoacán - 1953

Letters to Dolores del Río

Coyoacán, October 29th (1953?)

Marvelous Dolores,
I beg you to accept the painting you commissioned from me.
I'm painting a lot. The day before yesterday I arrived from
Puebla and there I painted your picture in bed on my chest.

My health is better, but I'm terribly anxious. María, the lit-
tle sister of Vidalito, the nine-year-old painter from Oaxaca
(do you remember him?) is seriously ill, in a coma since yes-
terday afternoon.

Diego's not here, he went to Pátzcuaro and I have no one to
turn to but you. I implore you to give me the amount ($1,000)
you me promised me for your picture. I have nothing to pay the
doctors or for medicine, neither for the girl nor for myself.
Manolo Martínez, Diego's principal assistant, is going to deliv-
er the painting to you. If you are at home be kind enough to
send me the money with him, who enjoys my complete trust
(whether by check or in cash).

Forgive me for having bothered you.

Thousands of kisses.

Your Frida

Coyoacán, October 29th

Dolores:
When Diego arrived he was extremely upset that I had written
you as I did, for he gives me everything he earns from his work
and I lack for nothing. And he was outraged.

Many thanks for your kindness.

<div align="right">Frida</div>

[*On the same sheet Diego Rivera added:*]

Lolita:

I was outraged because Frida accepted the thousand pesos you sent for the "sick child" and should have returned it to you immediately, which I am doing by means of the attached check No. 609912 drawn on the Banco Comercial de la Propiedad. Excuse an invalid and accept the most attentive regards from your affectionate friend.

<div align="center">Diego Rivera</div>

<div align="center">ᔧ</div>

Judging from Diego's anger and the quotation marks around "sick child", it can be assumed that the letter was a ploy on Frida's part to obtain urgent money to purchase drugs.

LETTERS TO LINA BOYTLER

Marvelous Lina,
In the black world of my life your paintings arrived to call me to
the light, to the tenderness of your virgin world full of butter-
flies, suns, new worlds, all images of your limpid childhood of
10,000 years.

 I admire and love you

 Frida

Darling Lina,
Here I'm leaving you some doodles I drew to see if they're any
use to you.

 I send you millions of kisses with them.

 Frida

Poem

in the saliva.
on paper.
in the eclipse.
In all the lines
in all the colors
in all the pitchers
in my breast
outside. inside —
in the inkwell — in the difficulties of writing
in the marvel of my eyes — in the last
lines of the sun (the sun has no lines) in
everything. To say in everything is imbecilic and magnificent.
DIEGO in my urine — Diego in my mouth — in my
heart, in my madness, in my sleep — on the blotting paper
— on the tip of the pen — in the pencils — in the landscapes
— in the food — in the metal — in the imagination.
In the illnesses — in the windows — in his deceit
— in his eyes — in his mouth.
in his lie.

<div align="right">Frida Kahlo</div>

Juan Coronel Rivera published this poem in the literary magazine El Faro (No. 1, August, 1983), which he edited. In a letter addressed to me and dated February 9, 1998, he explained: "The handwriting of the verses is that of Teresa Proenza and the signature is Frida's". On the copy in the CENIDIAP archive there is a greeting for Diego Rivera dated November 13, 1957: "Beloved Dieguito: I would like to give you, on this Feast Day of Saint James, all the best in the world, health, joy. I can only give you this poem by Fisita that is love and beauty. And a kiss. Tere".

Text for Isabel Villaseñor on the First Anniversary of Her Death

March 13ᵗʰ, 1954

one more year

Marvelous Chabela
You will always be on the living earth of Mexico.

To all those of us who love you, you left your beauty, your voice, your painting, your *Olinka* and your own image.

My memory is full of your gaiety, of your extraordinary self. Forgive me if I do not go to your homage.

Frida

ᘓ

Isabel Villaseñor (Guadalajara, Jalisco, May 18, 1909–Mexico City, March 13, 1953), an engraver, painter, actress, writer and singer of corridos, was the wife of the painter and cultural promoter Gabriel Fernández Ledesma. Olinca was born of the marriage. Isabel's friendship with Frida was very close. On March 13, 1953, Frida wrote in her Diary: "You have left us, Chabela Villaseñor". After these words, she added in two parallel columns

"But your voice	*Crimson*
your electricity	*Crimson*
your enormous talent	*Crimson*
your poetry	*Crimson*
your light	*Like the blood that flows*
your mystery	*When they kill a deer.*
your Olinka	*all of you remained alive. Painter poet singer*
ISABEL VILLASEÑOR	
FOREVER ALIVE!"	

Sources and Original Publication
of Texts and Letters

I

El Universal Ilustrado, November 30, 1922.

2, 18, 29
Donated to Raquel Tibol by Isabel Campos, through the good
offices of the latter's godson Marco Antonio Campos.

3a, 3b, 3c, 3d, 3e, 3f, 3g, 3h, 3i, 3l, 3n, 3q, 3r, 3s, 3t, 3v, 3w,
3y, 3z, 3aa, 3bb, 5a, 5b, 5c, 5d, 5f, 5j, 5k, 11f, 13f, 20a, 20b,
24a, 24b, 25, 35b, 37c, 43a, 43b, 43c, 47, 51, 57, 65, 76,
106
Original Spanish versions in Hayden Herrera, *Frida: una
biographía de Frida Kahlo* (México, Editorial Diana, 1984).

4, 5h, 5i, 6, 7a, 7b, 7c, 9a, 9b, 9c, 11a, 11b, 11c, 11d, 11e, 11g,
11h, 12, 13a, 13b, 13c, 13e, 85
Raquel Tibol, *Frida Kahlo. Crónica, testimonios y aproximaciones*
(México, Ediciones de Cultura Popular, 1977).

3j, 3m, 3o, 3p
Erika Billeter, *The Blue House. The World of Frida Kahlo*, exhibition presented at the Schirn Kunsthalle, Frankfurt (March 6-May 23, 1993) and the Museum of Fine Arts, Houston (June 6-August 29, 1993).

3k (copy), 5e
Museo Estudio Diego Rivera.

3u, 33, 48
Raquel Tibol, *Frida Kahlo: una vida abierta* (México, Editorial Oasis, 1983; UNAM, 1998).

3x, 35a, 35c, 81
Hayden Herrera, *Frida Kahlo. Las pinturas* (México, Editorial Diana, 1997).

5g
Adelina Zendejas, "Frida Kahlo", *El Gallo Ilustrado*, supplement to the newspaper *El Día* (July 12, 1964).

8
Collection Enrique García Formentí.

10a
Huytlale, little magazine edited by Miguel N. Lira and Crisanto Cuéllar Abaroa (Tlaxcala, 1954).

10b
Frida Kahlo. Das Gesamtwerk (Verlag Neue Kritik, 1988).

13d
Catalogue of the exhibition *Frida Kahlo*, Galería Arvil, May 1994.

14, 22a, 22b, 23, 26a, 26b, 27a, 27b, 32, 46, 49 (defective copy), 61, 69, 75, 87, 111, 116 (copies, except for 111)
Collection Martha Zamora

15, 28, 30, 31, 34, 36 (copy), 39, 41, 74, 82, 84
Bertram Wolfe Collection of the Hoover Institution Archives, Stanford, California.

16a, 16b, 16c, 16d, 60, 77a, 94b, 95a, 95b, 115, 118b
Archives of the Centro Nacional de Investigación de Artes Plásticas/INBA-CENIDIAP.

19, 50a, 50b, 52, 54, 56a, 56b, 56c
Nickolas Muray papers in the Archives of American Art, Smithsonian Institution, Washington, D.C.

21 (copy), 103, 117 (copy)
Collection Ignacio M. Galbis, Santa Monica, California.

22a, 22b
Rockefeller Center Archives.

37a, 37b, 44 (copies), 59a, 59b, 68a, 68b (copies), 100, 114, 123
Collection Juan Coronel Rivera.

38
Collection Elsa Alcalá de Pinedo Kahlo.

40, 42, 53, 91, 93, 113
Epistolario selecto de Carlos Chávez, ed. Gloria Carmona (México, Fondo de Cultura Económica, 1989).

55
Hayden Herrera, *Frida: A Biography of Frida Kahlo* (New York, Harper & Row Publishers, 1983).

58, 121
Centro de Estudios de Historia de México (CONDUMEX), Dolores del Río archive.

62, 64 (defective copy), 67, 97, 102, 118a, 120, 122 (copies except for 120)
Collection Raquel Tibol

63, 110a, 110b
Martha Zamora, Frida Kahlo. *El pincel de la angustia* (privately published, México, 1987).

66a, 66b
Teresa del Conde, Frida Kahlo. *La pintora y el mito* (Instituto de Investigaciones Estéticas, UNAM, 1992).

70
Emmy Lou Packard papers in the Archives of American Art, Smithsonian Institution, Washington, D.C.

71, 73
Collection Marte Gómez Leal.

72

Florence Arquin papers in the Archives of American Art, Smithsonian Institution, Washington, D.C.

77b

Donated to Xavier Guzmán Urbiola by Juana Luisa Proenza.

78, 107

Printed in the brochure accompanying the exhibition *Frida Kahlo. The Unknown Frida. The Woman Behind the Work*. Louis Newman Galleries, Beverly Hills, California (October 12-November 9, 1991).

79

Catalogue of the first individual exhibition of Fanny Rabinovich.

80

Así no. 249 (México, August 18, 1945).

86

Catalogue for the auction of Latin American art at Sotheby's, November 20 & 21, 2000.

88, 89

Collection Mariana Morillo Safa.

92

Collection Luisa Barrios Honey Ruiz. Reproduced in *Arena*, cultural supplement of the newspaper *Excélsior*, October 28, 2001.

94a

Museo Frida Kahlo.

96, 98
Collection Carlos Pellicer.

99, 101, 105
Collection Jorge Fastlicht Ripstein.

104
Catalogue for the exhibition *Diego Rivera, cincuenta años de labor artística*, held in the Palacio de Bellas Artes, Mexico City, from August to December 1949.

108
Collection Graciela Fastlicht de Beja.

112
Catalogue of the exhibition held in the Galería de Arte Contemporáneo, October 23-November 8, 1952.

119
Collection Patricia van Rhijn Armida.

124
Collection Olinca Fernández Ledesma Villaseñor.

Table of Contents

Forward...5
Translator's Note..9

[1] Memory...13
[2] Note for Isabel Campos.................................14
[3] Letters to Alejandro Gómez Arias.......................15
[4] Card from 1926..43
[5] Letters to Alejandro Gómez Arias.......................44
[6] Letter to Alicia Gómez Arias............................52
[7] Letters to Alejandro Gómez Arias.......................53
[8] Letter to Alicia Gómez Arias............................57
[9] Letters to Alejandro Gómez Arias.......................58
[10] Letter and Dedication to Miguel Nicolás Lira.........61
[11] Letters to Alejandro Gómez Arias.......................62
[12] Letter to Alicia Gómez Arias............................72
[13] Letters to Alejandro Gómez Arias.......................73
[14] Letter to Guillermo Kahlo...............................76
[15] Corrido for Antonio Pujol and Ángel Bracho........78

[16] Paragraphs of Letters...79
[17] Ribbon on the Painting *Frieda and Diego Rivera*............81
[18] Letter to Isabel Campos....................................82
[19] Letter to Nickolas Muray..................................84
[20] Letters to Doctor Leo Eloesser............................85
[21] Letter to Matilde Calderón de Kahlo.....................88
[22] Letters to Abby A. Rockefeller............................92
[23] Letter to Clifford and Jean Wight........................94
[24] Letters to Doctor Leo Eloesser...........................98
[25] Letter to Diego Rivera...................................104
[26] Letters to Abby A. Rockefeller..........................105
[27] Letters to Clifford Wight...............................108
[28] Letter to Ella Wolfe....................................114
[29] Letter to Isabel Campos.................................115
[30] Letter to Ella and Bertram D. Wolfe....................118
[31] Letter to Ella Wolfe....................................119
[32] Text on the Letterhead of the "Pro-Cárdenas"
 National Students' Party...............................126
[33] Letter to Alejandro Gómez Arias.........................127
[34] Letter to Ella and Bertram D. Wolfe....................129
[35] Letters to Doctor Leo Eloesser..........................134
[36] Letter to Diego Rivera..................................136
[37] Notes for Alberto Misrachi.............................137
[38] Letter and Dedication to Her Sister Luisa
 Kahlo Calderón...139
[39] Letter to Ella Wolfe....................................140
[40] Missive to the Composer Carlos Chávez..................143
[41] Letter to Bertram D. Wolfe..............................146
[42] Letter to Carlos Chávez................................148
[43] Letters to Doctor Leo Eloesser..........................151
[44] Note for Alberto Misrachi..............................153
[45] Dedication to Leon Trotsky on a Self-Portrait......154

[46] Letter to Lucienne Bloch.............................155
[47] Letter to Ella Wolfe.................................160
[48] Letter to Alejandro Gómez Arias.....................164
[49] Letter to Diego Rivera..............................165
[50] Letters to Nickolas Muray...........................169
[51] Letter to Ella and Bertram D. Wolfe.................178
[52] Letter to Nickolas Muray............................181
[53] Letter to Carlos Chávez.............................184
[54] Letter to Nickolas Muray............................187
[55] Letter to Edsel B. Ford.............................189
[56] Letters to Nickolas Muray...........................191
[57] Letter to Sigmund Firestone.........................195
[58] Telegram and Letter to Dolores del Río..............196
[59] Notes for Alberto Misrachi..........................198
[60] Letter-Report to Diego Rivera.......................200
[61] Letter to Emmy Lou Packard..........................210
[62] Letter to Sigmund Firestone.........................213
[63] Note for Diego Rivera...............................216
[64] Letter to Sigmund Firestone.........................217
[65] Letter to Emmy Lou Packard..........................219
[66] Letters to Doctor Leo Eloesser......................220
[67] Voucher for the Central de Publicaciones............232
[68] Notes for Alberto Misrachi..........................233
[69] Dedication to the Daughters of the Venezuelan
 Ambassador, Sr. Zawadsky............................235
[70] Letter and Telegram to Emmy Lou Packard.............236
[71] Letter to Marte R. Gómez............................239
[72] Letter to Florence Arquin...........................243
[73] Letter to Marte R. Gómez............................245
[74] Letter to Bertram and Ella Wolfe....................247
[75] Note with Gift for Alejandro Gómez Arias............250
[76] Letter to Doctor Leo Eloesser.......................251

[77] Note and Postcard for Diego Rivera...................252

[78] Letter to Ruth Rivera Marín...........................253

[79] Presentation for Fanny Rabel.........................254

[80] Speaking of One of My Paintings, of How,
 Starting from a Suggestion by José D. Lavín and
 a Text by Freud, I Made a Picture of Moses...........255

[81] Congratulations for Diego Rivera.....................261

[82] Letter to Ella and Bertram D. Wolfe..................262

[83] Corrido for A and L..................................265

[84] Telegram for Ella Wolfe..............................267

[85] Letter to Alejandro Gómez Arias......................268

[86] Letter to José Bartolí...............................270

[87] Letter to Ella Wolfe.................................272

[88] Letter to Eduardo Morillo Safa.......................274

[89] Letter and Corrido for Mariana Morillo Safa.......278

[90] Declaration Solicited by the Instituto Nacional
 de Bellas Artes......................................282

[91] Letter to Carlos Chávez..............................284

[92] Letter to Antonio Ruiz, "El Corcito".................286

[93] Letter to Carlos Chávez..............................289

[94] Dedication and Letter to Diego Rivera................291

[95] Notes for Diego Rivera...............................295

[96] Letter to Carlos Pellicer............................296

[97] Letter to Arcady Boytler.............................297

[98] Letter to Carlos Pellicer............................298

[99] Letter to Doctor Samuel Fastlicht....................300

[100] Card for Diego Rivera on His Birthday...............302

[101] Letter to Doctor Samuel Fastlicht....................303

[102] Letter to President Miguel Alemán Valdés...........305

[103] Letter to Diego Rivera...............................309

[104] Portrait of Diego....................................310

[105] Letter to Doctor Samuel Fastlicht....................324

[106] Letter to Doctor Leo Eloesser.........................325

[107] Letter to Diego Rivera.................................327

[108] Letter to Doctor Samuel Fastlicht.....................328

[109] Portrait of Wilhelm Kahlo.............................329

[110] Notes for Diego Rivera................................330

[111] Note for Elena Vázquez Gómez and Teresa Proenza..331

[112] Presentation for Antonio Peláez.......................332

[113] Note for Carlos Chávez................................333

[114] Card for Diego Rivera on His Birthday...............335

[115] Note for Guadalupe Rivera Marín.....................336

[116] On a Sheet with Surrealist Drawings..................337

[117] On an Old X-Ray Plate................................338

[118] Text and Note for Diego Rivera.......................339

[119] Letter to Machila Armida.............................341

[120] Invitation from Frida Kahlo to Her
 Individual Exhibition in the Galería de Arte
 Contemporáneo on April 13, 1953...................342

[121] Letters to Dolores del Río...........................344

[122] Letters to Lina Boytler..............................346

[123] Poem...347

[124] Text for Isabel Villaseñor on the
 First Anniversary of Her Death......................348

Sources and Original Publication of Texts and Letters.....349
Table of Contents...355

❧ F R I D A ❧ B Y ❧ F R I D A ❧
WAS PRINTED IN JULY 2003 IN
WISCONSIN FOR EDITORIAL RM
❧ ❧ ❧ ❧ ❧
❧ ❧ ❧ ❧ ❧
❧ ❧ ❧ ❧ ❧
BY THOMSON-SHORE, INC.,
WITH A PRINT RUN ❧ ❧ ❧ OF
FIVE ❧ THOUSAND ❧ COPIES.
❧ ❧ ❧ ❧ ❧
❧ ❧ ❧ ❧ ❧
❧ ❧ ❧ ❧ ❧
❧ ❧ ❧ ❧ ❧
❧ ❧ ❧ ❧ ❧
❧ ❧ ❧ ❧ ❧
❧ ❧ ❧ ❧ ❧

THE BOOK IS SET IN MRS EAVES
❧ (ZUZANA LICKO, CA. 1996), ❧
POETICA (ROBERT SLIMBACH,
❧ ❧ 1992),
B A U E R
B O D O N I
(BAUER TYPES, S.A., 1926) ❧ ❧
❧ ❧ ❧ AND ❧ ❧ ❧ AVENIR ❧ ❧
(ADRIAN FRUTIGER, 1988), ❧
❧ A N D ❧
PRINTED
❧ ❧ ❧ O N
D E X T E R
O F F S E T
NATURAL
P A P E R ❧